MAKING POTTERY YOU CAN USE

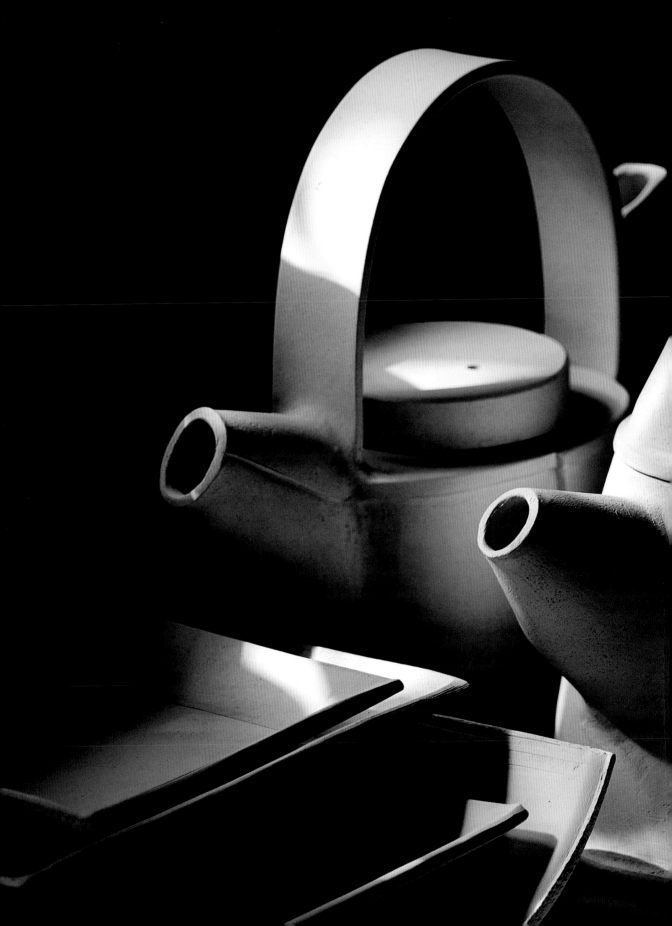

MAKING POTTERY YOU CAN USE

Jacqui Atkin

BARRON'S

Making Pottery You Can Use

First edition for North America published in 2017
by Barron's Educational Series, Inc.

A QUARTO BOOK

All inquiries should be addressed to:
Barron's Educational Series, Inc.
250 Wireless Boulevard
Hauppauge, New York 11788
www.barronseduc.com

ISBN: 978-0-7641-6873-4

Library of Congress Control No: 2016955587

QUAR.FLPY

Conceived, designed, and produced by
Quarto Publishing plc.
The Old Brewery
6 Blundell Street
London N7 9BH
www.quartoknows.com

Senior editor: Chelsea Edwards
Designer: Karin Skånberg
Photographers: Phil Wilkins (step-by-step
photographs), Simon Pask (still lifes)
Picture researchers: Sarah Bell and Susanna Jayes
Thrown samples: Kevin Millward
Templates: Kuo Kang Chen
Art director: Caroline Guest

Creative director: Moira Clinch
Publisher: Paul Carslake

Color separation by PICA Digital Pte Ltd, Singapore
Printed by 1010 Printing International Ltd, China

9 8 7 6 5 4 3 2 1

Contents

Chapter 1:
BEFORE YOU BEGIN

Chapter 4:
PLATES & PLATTERS

Chapter 5:
BOWLS, DISHES & CASSEROLES

Chapter 6:
TEAPOTS

Chapter 7:
MAKING METHODS

Clockwise, from top left: the view from my window; me in my studio; one of next-door's hens makes an appearance.

Clay is not just my way of making a living, but also my obsession; indeed, many a friend has described me as "driven" in my work and asked what it is that makes me so. The answer is complicated because it could be argued that it is just the way of the artist—but, then, the people asking are often makers themselves! Maybe for me it is the "time's winged chariot" thing—I am simply conscious that there is still so much to learn and worried that I will miss something. I believe we should never stop challenging ourselves, no matter how experienced we may be. Enthusiasm and excitement keep me searching. I feel these emotions even more keenly now than when I first started, and I struggle to understand why people ask where inspiration comes from because the answer is everywhere—just look around you.

Welcome to my world

I love the challenges of working in new ways with familiar materials, even though I have been working with clay for over 20 years now. My training was in design/ceramics, and the focus was very much on the design element, which taught me to think through the things that I wanted to make—to have a plan. As a teacher and author, I have strived to impart as much information as possible for people to be successful in their clay endeavors. I see no point in leaving information out. My greatest hope is that students will use the information as a starting point for their own unique ceramics and will become as consumed by their passion for it as I am.

About this book

This book is about making functional ceramics and the focus is predominantly on the "making." The practical considerations are the main topic—the things that make something fit for a purpose and the details that make it pleasing to use or even store in the cupboard. The content has been pared back, concentrating on the basic making methods of throwing, coiling, and slabbing, using molds sometimes and other props to aid construction, but leaving out surface decoration, except a little about glazing. You will find that certain making methods, such as slip casting and jigger/jolly, have been omitted because these are considered semi-industrial processes, which demand a different level of making skill and either a lot of expensive equipment or a lot of space.

Ultimately then, all the projects in this book have been devised for the maker in a small studio environment, with minimal equipment and tools, and basic making skills. All the information needed to make individual and unique ceramics is here, but it is by no means a definitive guide—simply a place to start from. Details of surface are what will make the items truly your own, plus the little tweaks we all make in our personal interpretations of things.

At the beginning, you will find an overview of clay and kilns (**Chapter 1: Before You Begin**) and, toward the end, a refresher course in the main making methods (**Chapter 7: Making Methods**). The final part is a resource section containing a glossary of tools and one of terms, and some useful templates for making pots.

Chapters 3 through 6: These are organized by vessel. Each vessel is explored via the three different making methods: throwing, coiling, and slabbing. The opposite page looks at the page "architecture" for a sample vessel. The way this is explored is representative of the content for the other vessels.

CHAPTERS 3 through 6

Design decisions

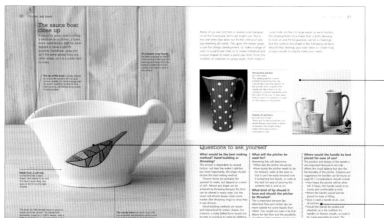

A representative vessel with all the attributes of a well-made pottery piece.

Examples from international makers show other functional examples.

Annotations call out the key design features that the maker should consider.

Questions to think about when planning a piece.

Variations

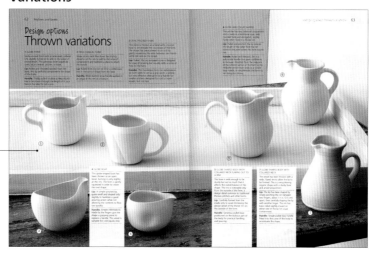

For each of the vessel types and each of the making methods, several specially made pieces are shown on the page to enable comparisons and useful observations about both form and function.

Each piece is analyzed for functionality and its features called out.

Techniques

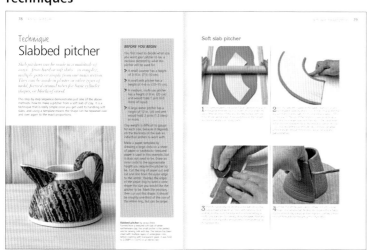

Step-by-step sequences demonstrate how to make one of the examples, showing the key techniques used for the making of that particular vessel.

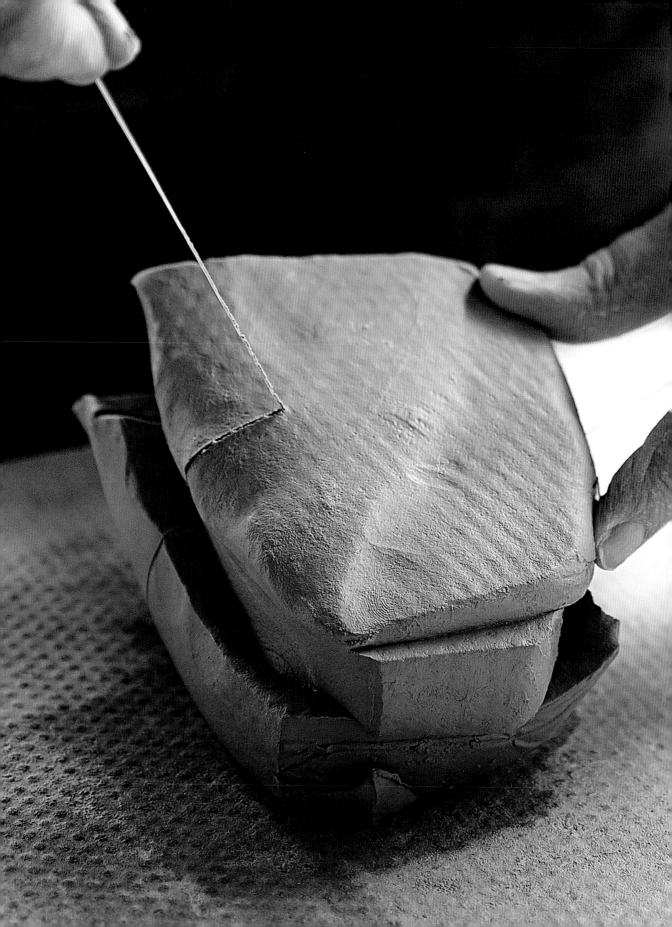

Chapter 1

BEFORE YOU BEGIN

Health and safety

Hand building pottery is not considered a dangerous pastime, but a few basic rules must be observed for safe practice.

When setting up your workshop, give some thought to the passage of materials and techniques through the workspace. Large workshops tend to have separate areas for each activity, which simplifies the health and safety issues related to each technique. If your working area is limited and consequently multifunctional, you will need a well thought-out working process in which dust, toxic materials, water, glaze, and clay are managed safely. This is entirely possible if you plan your working day and clean up properly between each activity. Make sure all individual containers and equipment can be moved to clean spaces on a regular basis.

Risk assessment
When you are working with any substances that may be hazardous to your health, it's important to make a proper risk assessment of your work environment. Consult official guidelines for advice on how to do this.

A risk assessment is an analysis of all the factors involved in undertaking a particular activity and formally logging the level of risk. It is good practice to carry this out in your own workshop. Look at the space you are using and at who is using it. Think about things like the risk of tripping, receiving an electric shock, fire and burns, handling hazardous materials, flying particles,

and shelving collapse. Look at how you are going to use equipment in particular spaces. Does your work space have appropriate storage? Can materials and containers be placed on wheeled boards (dollies) to aid easy moving for daily cleaning? Are there any trip hazards in passageways? Are materials correctly labeled and are you aware of the risks involved in using them? In each case, record whether you think the risk of an accident is low, medium, or high; if it's high, work out what you can do to lessen the risk.

Observe the following rules:
1. Always work in a suitably ventilated room, with readily cleaned, impermeable work surfaces and washing facilities close by.
2. Never eat, drink, or smoke in the workshop.
3. Avoid generating airborne dust—it is better to prevent dust than to try to control it. To minimize dust hazards:
• Clean up spillages when they occur. This applies to slurries as well as powders, because plastic clays and slips that dry become a source of dust. Spillages on floors also increase the risk of slipping.
• Clean all equipment and tools at the end of a day's work.
• Use a vacuum cleaner with a filter for fine dust, not a brush, to clean work surfaces and floors. After vacuuming, wash the surfaces.
4. Wear gloves when using any coloring agents or oxides.
5. Wear a respirator (face mask) when using any powders.
6. Wear protective clothing, but try

not to wipe dirty hands on aprons because dried residue will flake off and cause dust. Wash aprons and overalls regularly.
7. If sanding or fettling (trimming or cleaning) dry- or bisque-fired pots, wear a respirator and goggles.
8. Check that your tetanus immunization is up-to-date. Clay is dug from the ground and may carry bacteria that can cause infection in open wounds.
9. Keep a first-aid kit on hand, and protect cuts and scratches from contact with any ceramic materials.

Beware
Certain colorants and materials can be added to clay for hand building, to change its properties or color. Extra care must be taken when using the following materials:

Highly toxic
Lead, cadmium, antimony, barium.

Use with care
All colorants, especially copper oxide and carbonate, cobalt oxide and carbonate, chromium oxide, lithium oxide, zinc, strontium, nickel oxide, slip, glaze stains, borax, boron, boric acid, silica, quartz, flint, feldspar, china clay, ball clay, whiting, and dolomite.

All of the above materials must be used with caution. Pottery suppliers can provide the relevant health and safety data for their products. Information relating to each material is printed on its container—be sure to read it.

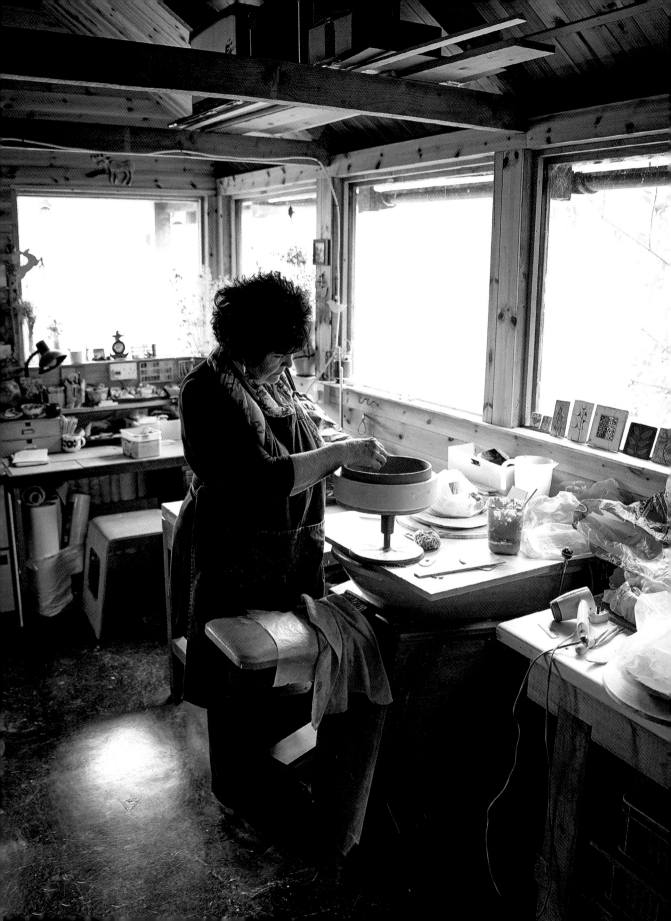

Getting ideas down

One of the hurdles that many makers face is finding inspiration to develop their work. We can all get into a rut sometimes; it often happens when you have been making the same things for a long time and you suddenly find yourself bored by the repetition. So how do we resolve this?

Where to find inspiration
Inspiration is all around us—everything has a shape, color, or texture, in both nature and the manmade world—the key is learning to look and record the things that excite us.

Start with obvious resources
Books, the Internet, dedicated sites such as Pinterest and Etsy, etc., ceramic association websites, galleries, art centers, museums, ceramic fairs and markets, and pottery studios.

Other potters' work
Another obvious resource is other potters' work. This is not to say that you copy it, but you record the things that you like about it: the things that really work for you (shape, color, texture, balance), the small details like the position of a handle or spout, the angle of a rim, the way a lid fits, etc. Learn to ask yourself why one thing pleases you more than another.

Keep a file
Gather images if you can—either on your computer, mobile phone, or in paper form—and create files that record specific details that you would like to incorporate into your own work.

Be aware that you may not always be allowed to photograph things in museums and galleries, and you should always ask permission before photographing makers' work at fairs and markets. The potter will often ask what you want the images for; be honest and tell them that you are recording details of work that you like in order to develop your own style—you will most often find that they will suggest things that had not occurred to you. Potters are generous people, but do not like others copying their work, especially when it may have taken years to develop, so do stress that this is not your intention.

Carry a sketchbook
A pocket sketchbook is invaluable for recording small details when you are out and about. Perhaps considered old-fashioned now and superseded in many ways by the mobile phone, a sketchbook is still a better way to record details because it requires the viewer to look for a longer period of time and consider what they are recording, locking an idea into the brain. Feel free to stick things into your sketchbook and make notes alongside them to remind yourself what you were thinking about.

Draw the things that you like
Using your resource files, start to draw the things you like. You do not need to have amazing drawing skills (nobody else needs to see your workings), but as you start to record ideas you will find yourself making small adjustments to all the details. Working through problems on paper will help resolve issues before you start to make them.

Put lots of images together on sheets of paper: shapes that please you, variations of one shape with different details. Make notes alongside your drawings: things that have occurred to you, alternative ideas, or details that will help to develop the shape even further if required. Let your mind roam and record everything that occurs to you—you will be amazed by how much this will help you develop your own style.

Recording ideas in clay
The final part of developing a style of your own involves testing your ideas in clay. This is vital, because you cannot plan for all eventualities on paper. Often, details that could not have been anticipated only occur in the making process, so it is good practice to iron these out before committing to a full body of work.

Keep your experimental test pieces and record all details relating to them—for example, weights of clay, type of clay, making method, firing temperature, etc. If things don't work the way you had envisioned, you will then have all the information you need to make adjustments.

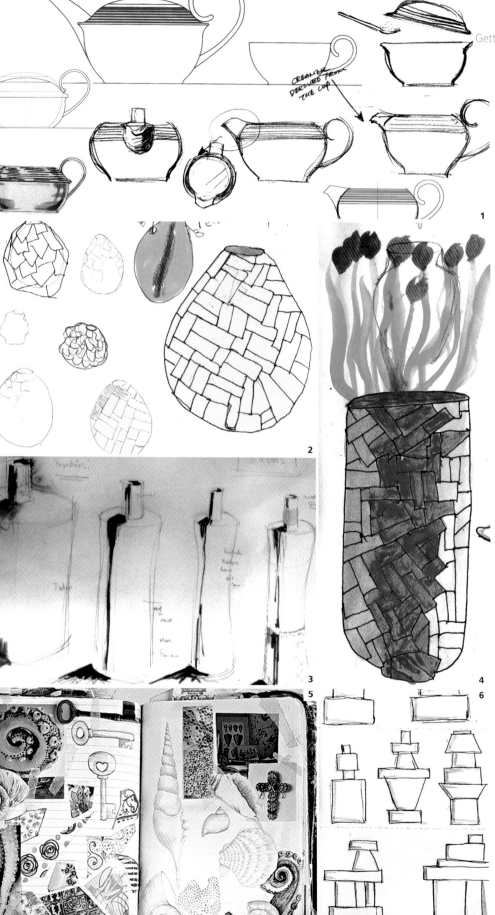

1. A general arrangement drawing is a carefully considered three-dimensional drawing that seeks to explain your object in an annotated and representational format. This drawing by Chia-Ying Lin is very useful for describing how something works. Planning the functionality of the form is as important as any single design feature.

2 & 4. Quick sketches are often made on table napkins, receipts, and even the back of travel tickets, but they capture the essence of an idea as the inspiration strikes, which is usually unexpected. This example of thumbnail sketching comes from Miranda Holms. Remember, a thumbnail sketch is not about accuracy. Instead, the function of this type of sketch is to get ideas out of your head and onto the paper.

3. This form of drawing evolves an idea through iteration and has been used here by Miche Follano. Repetitive drawing of the same form or idea will lead to it evolving in an incremental way, in small steps. This is a particularly valuable approach to developing designs with an attention to detail. You can also add notes to remind you of particular idea details that might affect or improve function when you get to the making stage—optional ideas.

5. Preliminary studies contained in the pages of a sketchbook by Claire Prenton.

6. These exploratory sketches by Ellen Horne explore scale, line, and the proportions of an object before you make a model or maquette. Notice how the lines have been drawn a number of times, trying to find the right ones. This is a resource file in many ways, so can include pictures from magazines or quick photographs taken on your mobile phone of details that you think affect functionality particularly well when you are out and about—be squirrel-like in collecting detail.

The right clay

Clay is generally classified into three main categories—earthenware, stoneware, and porcelain—each is defined by the temperature it is fired to and the consequent density and strength of the clay.

However, when you look in your clay catalog you will see lists of clays that have a very wide firing range, enabling them to be fired at earthenware 2,012–2,102°F (1,100–1,150°C), middle temperature 2,156–2,228°F (1,180–1,220°C), or stoneware 2,228–2,372°F (1,220–1,300°C). So how do you choose?

CHOOSING A CLAY
Here are some basic questions to ask yourself to help narrow down your options.

What temperature do you want to fire to?
This choice will be dictated by the firing capability of your kiln. However, be conscious that the higher the temperature, the more expensive it will be, no matter what fuel is used.

Electric or gas?
Do you want to fire in oxidation (electric) or reduction (gas)? Some clays are more suited to reduction firings than others—use the manufacturer's catalog to guide you to suitable clays for each type.

What clay color?
Base your choice on the surface decoration to be applied.
Red bodies will influence glaze color response. If you seek a contrast between clay and glaze color, this can be overcome by applying a light slip background.

Alternatively, if you want a vibrant color response, choose a white clay and you will not need to apply a slip as a base.

Alternatively, there are clays that have additions that give them a speckled appearance when fired. The speckles react with the glaze to produce a very distinctive surface. Manufacturers often suggest glazes that work well with this type of clay.

Making method?
The making method will influence the type of clay you choose.

For throwing, use a smooth, plastic clay.

Hand-building clays benefit from the addition of some grog, which gives increased resistance to warping and cracking. However, be aware that fine detailing or turning can be compromised as a result, adding yet another factor to be considered.

Using catalogs
Most catalogs have a suitability code to help you decide. It may read something like this:
• Clays good for domestic ware
• Clays suitable for larger domestic ware
• Clays suitable for big pots—bread crocks, etc.
• Clays for general-purpose use—throwing, slabbing, coiling, etc.
• Especially good for throwing
• Especially good for slabbing and hand building
• Clays for larger constructions and tiles needing good warp resistance

Here is an example scenario: "I want to fire to earthenware temperatures, in my electric kiln, using a white body, which will form a great backdrop for color decoration on my handbuilt ware."

From here, you would check the suitability chart and note all the clays that meet your needs. There will probably be fired examples for you to look at before making your final choice.

BUYING AND STORING CLAY
Having chosen your clay, you will then need to decide how much to buy. This will depend on your intended output and the way you work. Throwers generally get through clay much quicker than hand builders because the process is faster. In contrast, hand builders can make a few bags of clay last quite a long time, especially if they reclaim all their scraps.

One of the main factors dictating the quantity of your purchase will be storage space. You will find that clay is generally cheaper to buy in large quantities. But, if you have not tested the clay, resist the temptation to do this. First ask for a sample and test it to check that it meets your requirements—then buy in quantities that you can practically store.

Keep clay in tightly sealed bags to retain moisture, preferably in a dark, frost-free place.

A basic selection of ready-made clays with simple, transparent, and opaque glaze treatments.
1 Standard red earthenware
2 Grogged red earthenware, half-covered in clear glaze
3 Low temperature white body, half transparent-glazed
4 Buff stoneware, one quarter transparent-glazed, one quarter tin-glazed
5 Smooth white stoneware, half transparent-glazed
6 Standard porcelain, half transparent-glazed

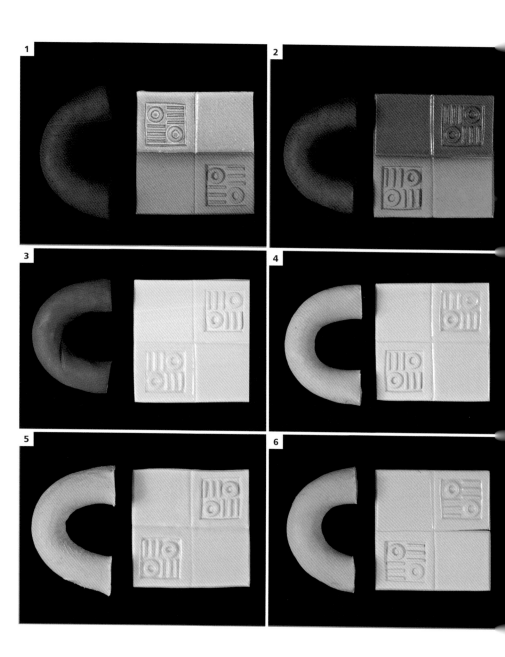

PREPARING CLAY

Most potters wedge or knead their clay before commencing work to make sure there are no pockets of trapped air that could cause work to blister, crack, or even explode during firing.

Overhead wedging

This method is a useful way of mixing big lumps of clay. The name is derived from cutting the block at an angle into a wedge shape.

Form the clay into a wedge shape and cut the block up from the base to the top at an angle of 45 degrees (1).

Lift the clay above your head and slam it down onto the block so that the cut, flat side comes down and hits the top of the ridge. As the flat surfaces connect, the air should be knocked out. Pick up the block and rotate it through 90 degrees. Repeat this process at least five times, until the mix is even in consistency (2).

Ox-head kneading

With ox-head kneading you push the clay away from you and pull it back in a rocking motion, while at the same time applying pressure at the sides to keep the shape compact. This is useful for small to medium amounts of clay.

Make sure the clay is "putty" soft. Select a lump of clay that forces your hands apart. Knock the lump into a rough ball shape. Position yourself so that you can rock backward and forward. Place one hand on each side of the top of the clay ball and push forward (3).

As you push the clay forward, apply inward pressure from the sides; this will help to keep the clay compact. From your shoulders it should feel as if you are pushing forward to a point in a "V" shape. Rock the clay back and push forward again. If you are not

applying enough pressure from the sides, the clay will quickly turn into a long roll (4).

Spiral kneading

This is similar to ox-head kneading, but involves kneading with one arm at a time—one arm takes over while the other relaxes. This method is good for larger lumps of clay.

Make sure the clay is "putty" soft and knock it into a rough ball shape. This method allows you to control large lumps of clay; you only need to hold a small amount of it as you push down, turn, and repeat. Layers should emerge, which turns the lump into a spiral shape (5).

If you are preparing the clay for wheel throwing, then, as you knock it into a ball, make sure the spiral is visible at the top before you place it on the wheel head to avoid trapping air underneath. Some wheel throwers find that this spiral makes it easier to center the clay on the wheel (6).

SLAKING OR RECYCLING CLAY

This process should become part of your making routine and adds to your understanding of the material and best consistency for particular techniques.

Collect scraps of the same clay together in an appropriately sized container; you need one with a lid to prevent dust particles from flying around. Before adding water the clay should be bone dry and broken into small lumps (7).

Cover the clay with water and allow the mixture to break down over a few days; this process is known as slaking. You can continue adding both clay and water to this mixture for a number of months before slopping out; the downside will be the rotten smell (8)!

Slop the clay out onto a plaster bat. Form ridges in the slurry to

increase the surface area, so that the clay dries more quickly. Keep checking to see how the slurry is drying; if it dries out too much, you will need to repeat the process from the beginning. You can pull the soft clay to one side, pull away the stiffer clay on the bottom, and spread the slurry out again. Alternatively, cover it with plastic and let it dry overnight, so that you can check the condition the following day (9).

As the base dries it should easily come away from the bat. The larger and heavier the mass, the easier it will compress and collect together. At this stage, if the clay is going to be stored for any length of time, it should be softer than if needed for immediate use (10).

Pick up any remaining residue and scrape the bat clean with a rubber kidney. Do not use anything that will scratch the bat, since you do not want the clay to be contaminated with any other material—especially plaster. The bat should always be cleaned with a wet sponge to eliminate any leftover clay, because dry lumps will break down into dust particles.

RE-CLAIMING CLAY

Clay should always be worked at its optimum consistency. Once it goes beyond this point it will need to be recycled. The great thing about clay is that it never needs to be wasted and can be recycled with very little effort, even if it has been hanging around the studio for a while.
Tips:
• Reclaim clay regularly in smallish amounts to avoid the job becoming a mammoth chore.
• Using hot water will help the clay slake down much faster.

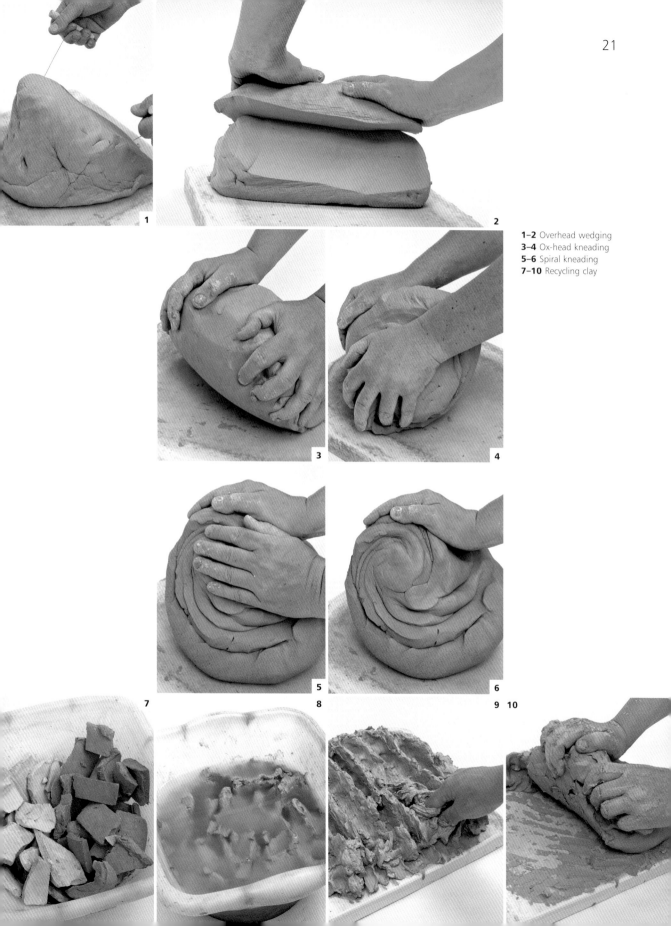

1–2 Overhead wedging
3–4 Ox-head kneading
5–6 Spiral kneading
7–10 Recycling clay

1

2

3

4

5

6

7

8

9 10

Firing

Kilns are usually fired in two stages — the first stage is known as the "bisque" (or "biscuit") firing and it is at this stage that the clay is made permanent by irreversible chemical changes, although it remains porous. The purpose of bisque firing is to make the clay handleable for glaze application. The second stage, known as the "glost" (or "glaze") firing, melts and seals a glaze onto the surface of the clay. It is possible to single fire — this relies on glaze being applied to green-ware and the firing process altered to accommodate both types of firing. It is tricky to master this technique, but does save on fuel by cutting out one of the firing stages.

BISQUE FIRING

Bisque firing should be started slowly so that the temperature rises at 210–300°F (100–150°C) per hour until it reaches 930°F (500°C). At this temperature the chemically held water in the clay molecules is driven off so the rate of temperature rise can be increased to reach the final temperature quickly. Most potters bisque fire at 1,760–1,830°F (960–1,000°C).

Make sure your work is completely dry before firing. It does not matter if pots touch for bisque firing, so stack pots on top of or inside each other to maximize space. However, make sure they are equally weighted—heavy pots sitting on lighter-weight pots can cause problems. And don't wedge the bases of pots inside the rims of others—the clay needs space to shrink and will crack if restricted.

GLOST FIRING
Oxidation

Oxidation describes the process of firing a glaze in the presence of oxygen. This is normally done in an electric kiln. It is a simple and controllable method, which means many potters fire their work in this way. The oxygen present during the firing means that any oxides in the glazes remain intact and oxidation color responses occur—for example, copper oxide will produce green.

Reduction

A reduction atmosphere is created by the burning of carbonaceous material. This type of firing is achieved in a gas-fired kiln. The reduction phase of a firing usually starts at 1,800–1,950°F (1,000–1,060°C) and involves cutting off the supply of oxygen to the kiln as the temperature increases to about 2,330°F (1,280°C). As the carbon in the burning materials exceeds the oxygen present in the firing chamber, incomplete burning occurs and carbon and carbon monoxide form. These then take oxygen from the oxides present in the clay and glazes to create a "reduced" effect that directly influences the colors obtained from oxides: for example, copper oxide will produce red.

EARTHENWARE
Bisque firing

Increase the temperature by 210°F (100°C) per hour until it reaches 1,110°F (600°C), then increase by 300°F (150°C) per hour to reach the top temperature. A higher bisque temperature is used with low-firing clays to reduce crazing in the glaze.

The clay remains sufficiently porous for glazing at this temperature. There may be some variations in the maturing temperature of some low-fire clays, but your clay supplier will be able to advise you on this.

Glaze firing

Most earthenware glazes fire at 1,940–2,080°F (1,060–1,140°C). Start firing slowly at 210°F (100°C) per hour until you reach 840°F (450°C), then turn the kiln to full power and heat to the required temperature. Most clay bodies fired to earthenware will remain porous so need to be covered in glaze to make them waterproof. This is an important consideration if making domestic ware because good hygiene is essential.

STONEWARE AND PORCELAIN
Glaze firing

Fire slowly at 210°F (100°C) per hour to 840°F (450°C), then turn the kiln to full power and heat to 2,190–2,370°F (1,200–1,300°C).

Stoneware glaze firing

Pots must not touch each other or the kiln walls when glaze firing because they will stick together. Leave enough space between your pots for your hand to pass sideways when packing the kiln—this will also be enough space for glaze bubbling or dripping not to affect surrounding items. A coat of bat wash (50% china clay, 50% alumina) will help protect the kiln shelves from glaze drips or runs.

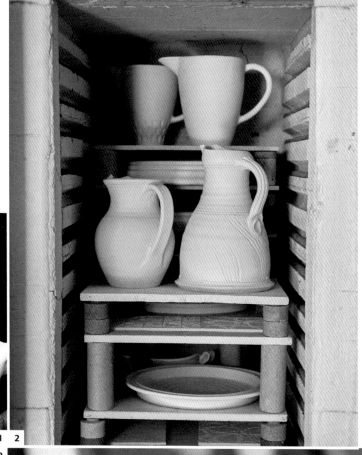

1 Inspecting a pitcher post-bisque fire.
2 The bisque kiln partially loaded.
3 Bisque-fired teapots waiting to be decorated and glazed.

1 2
3

Glazes

Whether it is decorated or not, functional ware usually has a glazed surface. Having a basic understanding of how glazes work and the materials used to formulate them is vital for creating successful work. It is especially important when making functional ware because the glazed surface must be smooth, non-porous, hygienic, and—most importantly—food-safe.

Make your own or ready made
Glaze is a science and subject in its own right. Experimentation is an exciting process, but not without its disappointments, and it is also time-consuming.

Most ceramic suppliers have a huge range of ready-made glazes that are designed to work well with the clay, come in dry and slop form, and are tested for food safety. These are a good starting point because the outcome is guaranteed. If you want to experiment, try firing some tests alongside the commercial glaze.

How glaze works
In simple terms, glaze is a powder that is mixed with water, where it is held in suspension. When it is applied to a bisque-fired item, the porous surface absorbs the water, leaving the powder on the surface. Most glazes consist of three basic ingredients:
Silica: The glass-forming element.
Alumina: Acts as a stabilizer by stiffening the liquid nature of silica.
Flux: Defines the melting point of the glaze. Silica and alumina melt at temperatures higher than a normal kiln, so a flux is added to reduce the melting point of the glaze.

The proportions of all these ingredients can be adjusted to make the glaze melt at a particular temperature and, of course, different sources of each ingredient can be mixed together to further adjust the behavior of the glaze.

Generally, glaze recipes will list materials that supply a mixture of the basic ingredients in proportions that will melt at a given temperature to produce a particular surface quality and color. If you want to make your own glazes, look for recipes that state the glaze is suitable for domestic ware.

MIXING GLAZE
How to mix a glaze
Mixing a glaze is straightforward, but your measurements must be accurate.

Find a suitable glaze recipe and make sure that you have all the base materials listed. You will need two plastic bowls, accurate scales, a fine sieve, a brush, and a rubber kidney. Using the scales, measure the ingredients one by one into a container. Add each ingredient to an adequate-sized bowl **(1)**.

Cover the ingredients with water and allow to slake down for 30 minutes or more. The quantity of water is something of a guess; add it in small quantities, a cup or pitcherful at a time. Using a stick, mix all the ingredients together and allow to soak for a short time **(2)**.

Pour the glaze through the sieve into the other bowl, using a brush and a rubber kidney to force the materials through the sieve. Try to ensure almost all the material passes through the mesh **(3)**.

The consistency of the glaze should be that of heavy cream. If it needs it, add more water; if it is too thin, let stand for three or four hours and it will separate. At that point, decant some water from the top before mixing again **(4)**.

Health and safety
Weighing and mixing glaze ingredients in their powder form can be hazardous as it creates dust, so take adequate precautions to protect yourself.

Always wear a dust mask, even if you have an extraction system. Some glaze ingredients are caustic or an irritant to skin, so wear latex gloves. Mop up spillages right away and try to mix your glazes away from things that may be contaminated by dust particles.

Storing glaze
Store mixed glaze in clean plastic pails with an airtight lid. Glazes will last in good condition for a considerable time if the pail is properly sealed.

METHODS OF APPLICATION
Glazes can be applied to pottery in several ways; dipping, pouring, painting, and spraying are the most commonly used methods. Many factors will determine the best method of application, such as the size of the pot, the way it can be held, and the intended decorative effect.

Dipping
When dipping, the pot is immersed in the glaze for a few seconds. It can be dipped again for a further second or two, known as double-

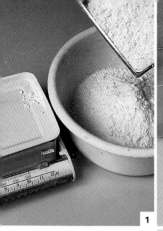

1 **2** **3** **4**

1–4 How to mix a glaze
5–7 Sample glazes

5

Percentages/parts per 100

If the glaze is written in percentages or parts per 100, then you simply measure material to a quantity that relates to each percentage or part. For example:

Ingredient		Mix x 10
A	35 percent/35 parts	350 oz (350 g)*
B	40 percent/40 parts	400 oz (400 g)
C	25 percent/25 parts	250 oz (250 g)

If the glaze is written in parts that add up to a figure that is not 100, simply multiply each part by the same factor, so that you are increasing each quantity by the same amount.

Ingredient parts = 86		Mix x 10
A	12	120 oz (120 g)*
B	21	210 oz (210 g)
C	53	530 oz (530 g)
Total		860 oz (860 g)

Conversion equation

As a general rule, glaze is easier to measure in parts per 100.
If the glaze recipe does not add up to parts per 100, you can use the following conversion equation:
known part value \times 100 = unknown part total
In the example below, the original recipe has the following parts:

6

Glaze recipes
Glaze recipes list the ingredients in proportions that may be referred to as a weight, percentage, or number and are referred to as "parts." Often, but not always, the parts add up to 100. Often a base recipe will add up to 100—but the addition of an oxide or other coloring agent will take it to a higher number like 102.

Original glaze		New recipe**
50	50 x 100 = 66	66
20		26
4		4.5
3		3.5
Total 77	Total	100

7

*These are not direct conversions. Please choose either the metric or imperial measurement.
**Figures have been rounded up/down to simplify the explanation.

dipping. Double-dipping is often done partially and using a different glaze to produce a particular effect.

When glazing larger items, it often helps to glaze the interior first. Pour the glaze into a pitcher, then fill the vessel to approximately half way. Pour the glaze out, rotating the vessel as you do so to get an even coating. Allow the glaze to dry before continuing (1).

If possible, put your hand inside the vessel (2), then, ensuring the pail contains enough glaze, immerse the pot to the rim—do not allow the glaze to run inside (3).

Alternatively, you can use glaze tongs to fully immerse the pot, coating the interior and exterior at the same time (7).

Pouring
Grip the vessel between your fingers and thumb, hold the item over the glaze pail or a bowl, then pour the glaze around the outer surface (4). Finger marks can be touched up later. If the item is too large to hold in one hand, suspend the rim on sticks across the glaze pail, then pour the glaze in the same way.

Painting
It is possible, although more difficult, to paint glaze on a bisque surface—this offers enormous scope for decoration. Any brush can be used, but glaze mops, flat lacquer brushes, and Japanese hakes are particularly useful for covering large areas.

If possible, place the pot on a banding wheel so that you can rotate it as you apply the glaze. Work on the outside first to avoid damaging the interior. You can wax the base to resist the glaze, but often this is not necessary (5).

When the outside is dry, apply the glaze to the interior. Work in short strokes with a loaded brush.

You will probably need to apply several coats to get the correct thickness of glaze and to avoid visible brush marks after firing (6).

Spraying
To spray glaze, the glaze will need to be sieved through a 120 mesh to allow it to pass through the nozzle of the spray gun. The glaze must always be sprayed within a dedicated booth with extraction facilities that conform to COSH health and safety standards to ensure the surplus is extracted properly. Very subtle surfaces can be created using this method, but spray booths and equipment are costly and take up a large amount of space.

Trailing
Experiment using a slip trailer or simple ladle. This is a great method for glaze-on-glaze decoration to produce a pattern or special effect.

Sponging
Use a natural sponge for block covering certain areas, or cut and shape sponges for specific designs.

EARTHENWARE GLAZING
Generally speaking, earthenware pottery remains porous after firing; therefore the entire pot will need to be glazed to seal the surface. This is vital for domestic ware to be used for food preparation or drinking. If bases are left unglazed, liquid and food will be absorbed into the clay, making then unhygienic.

Earthenware that is completely covered in glaze will need to be fired on three-pronged stilts to prevent the items sticking to the kiln shelf. After firing, the stilts can be tapped off and the tiny, sharp marks left behind ground flat for safety.

All glazes in the earthenware category usually incorporate commercially fritted compounds

rendering lead safe to handle and alkaline materials non-soluble. There are exceptions and, generally speaking, fritted lead with additions of copper or chrome oxide should be used with caution on functional vessels.

Lead warning: Potters using lead-based glazes for functional ware should always have them tested for lead release because variations in materials from different sources or the individual firing method used could affect the safety of the glaze.

STONEWARE GLAZING
Stoneware pots are fired with a thin layer of bat wash, silica sand, or alumina to prevent them from sticking to the kin shelf. The bases must always be glaze-free and care should be taken to ensure all traces are removed to avoid the glaze melting and fixing the item to the shelf. An alternative is to apply wax to the base before applying glaze, but it is still advisable to check the base before stacking in the kiln.

Do not support stoneware items on stilts; place them directly on the kiln shelf. The clay can bend and slump at high temperatures if it is not on a firm base and will sink over stilts.

At stoneware temperatures, the glaze fuses with the clay. Most stoneware glazes will work on porcelain as well, but with different finishes. The large variation in stoneware clays will also produce different results and tests should always be carried out to ensure the clay and glaze work well together for your particular method of firing.

There are fewer problems with regard to materials not meeting food safety standards at stoneware temperatures, but, again, if making functional ware, get the glaze tested for safety first.

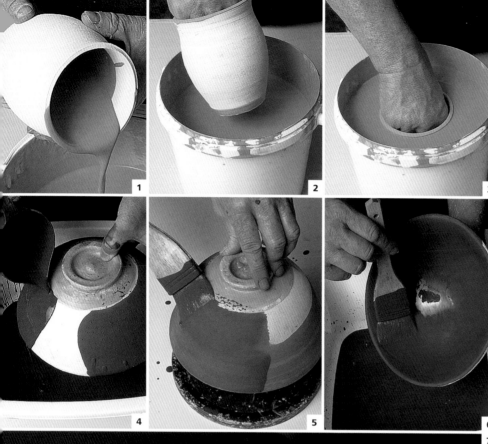

1–3 Dipping by hand
4 Pouring
5–6 Painting
7 Dipping with glaze tongs

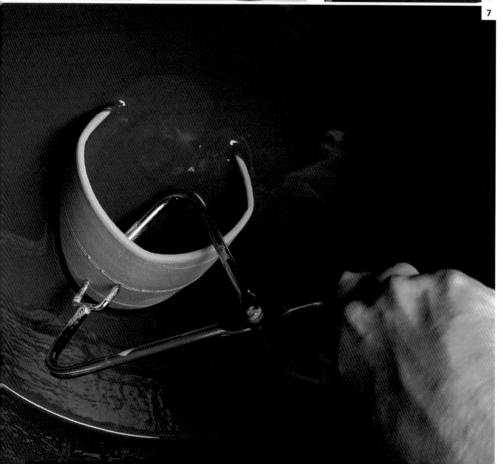

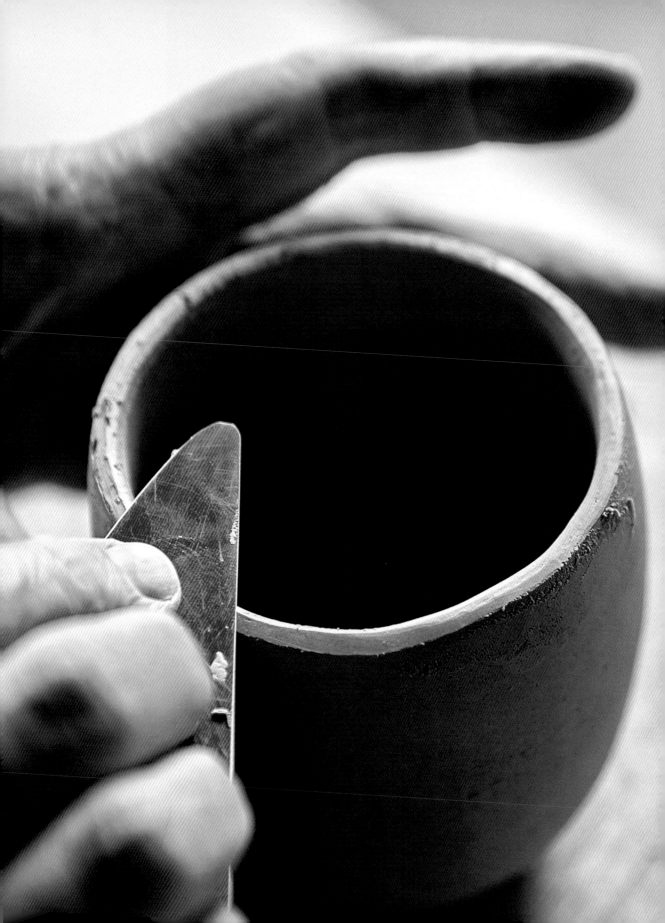

Chapter 2
CUPS & MUGS

Cups and mugs

Design decisions

We all have a favorite cup or mug, one that we choose above all others, but what exactly makes it special? Exploring the reasons behind our decisions is a valuable exercise to inform your own making.

The cup close up

In our minds the tradition of serving afternoon tea, with delicate little sandwiches and cakes, conjures up images of fine and delicate tableware. Lovely cups and saucers are essential for this—somehow a mug just wouldn't cut it.

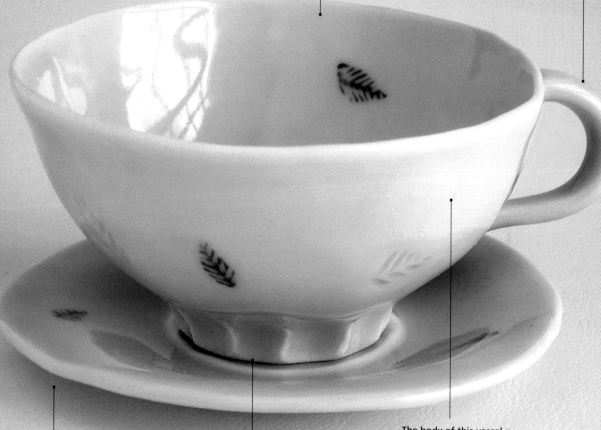

The slab used to build this cup is beautifully thin—a testament to the skill of the maker, which proves that handbuilt tableware can be just as fine as items made by other methods.

A finger-sized handle is perfect for this cup—situated at the top of the piece to allow it to sit in the saucer comfortably, it also makes for easy handling.

Proportionally, the diameter of the saucer is about the same as that of the rim of the cup. Made from the same thin slab of clay, it perfectly holds the cup in its center and is sufficiently wide to hold in the hand without burning the fingers on the cup.

The stylized foot ring nicely elevates the cup from the saucer, giving the whole ensemble a sense of lift and lightness. The elevation would comfortably allow for a teaspoon to sit on the saucer.

The body of this vessel is open and generous—a design that allows the tea to cool so that it reaches the right temperature to drink quite quickly.

Slab-built cup and saucer
by Yasuharu Tajima-Simpson
The simple surface decoration and delicate, pale blue Seiji glaze adds to the visual delicacy of the cup and makes it absolutely fit for the purpose of serving the perfect cup of tea.

The mug close up

A mug should be pleasing to look at, pleasing to handle, and suit the beverage being served in it. Sometimes one mug can fulfill nearly all of these criteria and that is the one that becomes the favorite—the special one!

The mug has been finely made with a thin wall that is especially evident at the rim. Drinking from a thick-walled cup is unpleasant, but not so much so if the rim is slender.

The lovely surface decoration adds a delicacy and refined quality to the mug. The repeat patterning is carefully measured to fit the form and skilfully applied with great accuracy.

The handle is well positioned to balance the form. It is large enough to allow for comfortable handling, but not so large that it is disproportionate to the rest of the shape.

The perfectly rounded shape bellies out from a sturdy base, then closes in very slightly toward the rim, giving the mug a strong visual sense of containment. This is a great shape for keeping beverages hot.

The shape lifts from a solid base which is offset by the perfectly balanced body. The skill of the maker is evident when a form is practically functional but also aesthetically appealing.

Thrown stoneware mug
by Dawn Dishaw
This mug is delightful on so many levels—it has a lovely shape, and looks both functional and comfortable to hold in one hand and nestle in the other. The surface decoration perfectly suits the shape and the clear glaze shows off the whiteness of the clay beautifully.

Cups and mugs can be made in any number of shapes and sizes; we all have a favorite, but how often do we ask ourselves why it is special? It can be helpful to do a bit of research on the subject—just asking friends and family to get an idea of what really works before you begin to make your own mug can be useful.

Once a shape and size has been decided on, the next and probably most important decision to make is about the actual making process. If you only intend to make one or two for your own personal use, then the way they are made is really not so important. However, if you need to make them in large numbers, then a speedy making method is essential. Discounting slip casting or the jigger/jolley process, which are making methods not included in this book, throwing is by far the quickest making method.

The hand-building methods are a little slower, but a great deal of accuracy can be achieved with the use of certain aids—working to a template shape, using molds, and outline formers, etc.

Linda Bloomfield This mug has a very pleasing shape. Hand thrown in porcelain, the outer surface is covered with a satin matt glaze and the interior a transparent colored glaze.

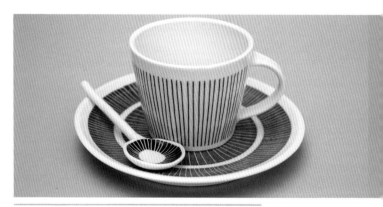

Cup, saucer, and teaspoon by Vicky Hageman
The cup and saucer were wheel thrown in porcelain, while the matching teaspoon was handbuilt. The surface decoration is cleverly designed using simple lines in monochrome. The sgraffito technique on the saucer shows lines drawn through black slip to reveal the clay beneath. In contrast, lines are drawn directly into the clay of the cup, then inlaid with slip.

Questions to ask yourself

What makes a good mug?
It is often the shape and size that make a particular cup stand out—the way it sits in the hand and the comfort of holding it. The answer will be different for everyone, so make a list of the things you require from a cup, asking yourself the following questions:

What beverage will it be for?
Certain cups are more suited to some beverages than others—tea is nice when it is served in a delicate cup and saucer, but if you like it in large quantities, then a large mug is more suitable. Espresso is usually served in a very small cup, but sometimes a double shot-sized cup would be better. Maybe you just want a good, all-purpose cup that will hold anything—size really matters here—it should be your first decision.

What clay type would be most suitable?
Fine clays are great for anything that will come into contact with the mouth; avoid heavily grogged clays because they can be rough to the touch.

White firing clays are good for color response in decoration and later surface treatments like decals.

Higher firing clays are the most robust for items that will get a lot of use, but this does not rule out the earthenware clays.

Making method will determine clay type
Throwing best suits a fine-grained clay to avoid damage to the hands and so earthenware, stoneware, or porcelain are good choices.

Handbuilt cups can be made with any plastic clay
Although some (like porcelain) are more difficult to work with. Whatever clay is chosen, the key factor is that you should be able to work with it in fine sections because there is nothing worse than a thick-walled cup.

Design options
Thrown variations

1 ADAPTED CYLINDER

Thrown as a simple cylinder shape and with a slight flare at the rim.

Handle: The pulled strap handle is centrally located for ease of lifting.

Foot: The base is flat and slightly wider than the body. A feature added at the making stage uses a finger to create regular indentations around the base, thus giving a pleasing ripple effect.

2 BELLIED CONE-SHAPED CUP AND SAUCER

The surface of this cup is perfectly smooth, making it suitable for many styles of decoration. The slight narrowing at the rim accentuates the shape and creates a pleasing visual tension.

Handle: The pulled strap handle is classically shaped to fit the form.

Foot: Standard turned foot.

Saucer: The deep saucer is a standard shape and is great for the containment of spillages.

3 GENEROUS, OPEN MUG

The body of this bellied mug has defined throwing lines from the base to two-thirds of the way up, and a deep rim section for comfort when drinking.

Handle: A simple pulled strap, shaped into a loop and positioned at a high angle on the side of the mug, perfectly balances this form.

Foot: Standard turned foot ring.

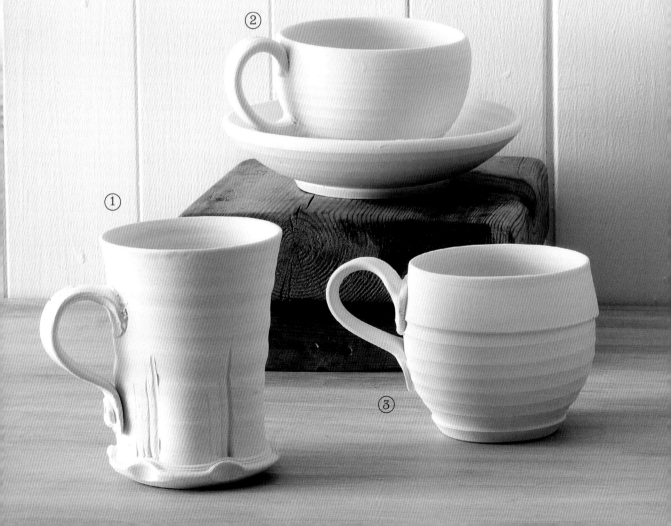

4 SIMPLE CYLINDER

This reliable, standard shape is the quickest and easiest form to throw for production methods.

Handle: This pulled strap handle is positioned from midpoint to the base on the body and demonstrates that something as simple as a handle can be enough to add character to a pottery form.

Foot: None: flat base.

5 CONICAL CUP AND SAUCER

A traditionally shaped cup showing the throwing lines on the outside, but perfectly smooth on the inside for practical purposes.

Handle: The pulled strap handle has a traditional, ear-like shape that perfectly suits the form.

Foot: Standard turned foot ring.

Saucer: The saucer is made at the same time as the cup to ensure a good fit. It has a deep shape with a well-defined rim for ease of holding.

6 MUG WITH ROUNDED BASE

This mug has been bellied out from a slightly narrow base to give the form a pleasing rounded shape that closes in slightly toward the rim, giving a sense of containment. This shape will keep fluids hotter for longer.

Handle: A small, pulled loop handle positioned at the top of

the mug allows for it to rest comfortably in the opposite hand.

Foot: Standard turned foot ring.

7 FLARED MUG

Adapted from the basic cylinder, this mug has a slight outward flare at the rim, giving an open and generous aesthetic to the form.

Handle: A pulled and twisted feature gives this handle character and is neatly positioned to allow the cup to be cradled in the other hand while holding.

Foot: A turned foot extends to give character to the lower section of the mug.

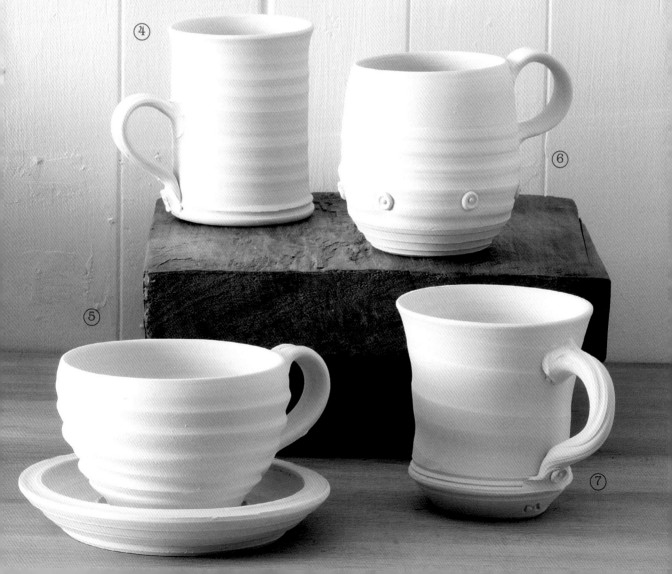

Technique
Thrown cup

Many thrown forms are adapted from the basic cylinder, which is one of the first techniques taught when learning to throw. Throwing cups and mugs gives the maker an opportunity to develop the shape on a small scale before moving on to larger forms.

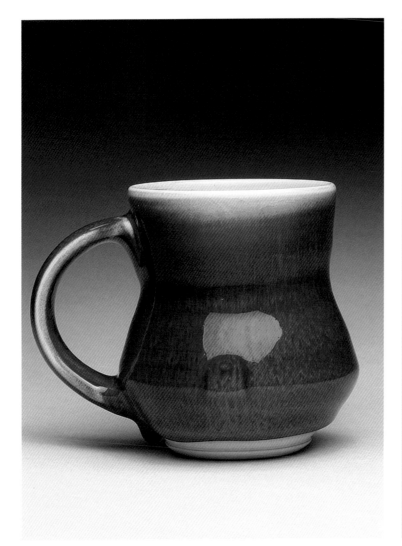

Thrown porcelain mug by Ray Morales
This beautiful red mug has been wheel thrown in porcelain with a copper red glaze fired in reduction to cone 10. The way the color breaks at the rim to show the whiteness of the clay is particularly pleasing to the eye.

BEFORE YOU BEGIN

> Prepare your clay and divide it into equal-sized balls for however many cups you want to make—it is useful to make a few extra cups just in case of mishaps.

> Keep the clay balls under plastic until you are ready to throw.

> For a cup 4 in. (10 cm) high and 3½ in. (9 cm) wide, you will need approximately 10 oz (300 g) of clay.

> Prepare your wheel so that everything you will need— tools, clay, water, towel, etc.— is at hand.

> Use water sparingly—enough to allow smooth action but not so much that the wheel head is constantly flooded. Sponge away excess from time to time.

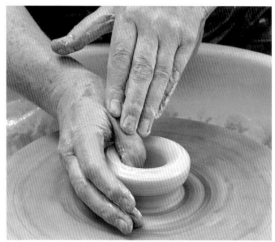

1 Center a ball of clay on the wheel (see page 188). With the right hand supporting the outer wall of the clay, press down into the center of the ball with the thumb, leaving enough clay at the base to later turn into a foot ring. Use the left hand as demonstrated, to support and steady the right hand as the wheel spins and the clay begins to open up.

Throwing a simple cup

To throw a cup on the wheel involves creating a cylinder shape with even walls. It is essential throughout the process that the thickness of the clay walls is monitored. When deciding on the shape of your vessel it is important to consider where your handle will attach to the body.

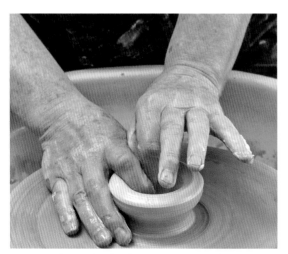

2 Keeping the right hand in place around the wall of clay, move the forefinger into the center, which will help keep the rim level as the clay is lifted. Using the forefinger and thumb of the left hand in a gentle pinching action, lift the wall of the cup upward.

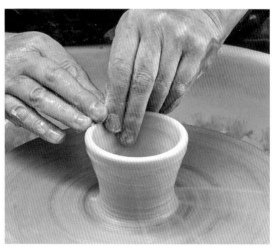

3 Keep the thickness of the clay wall even between the fingers and thumb of the left hand as you compress and even out the rim with the fingers of the right hand. Remember to do this regularly.

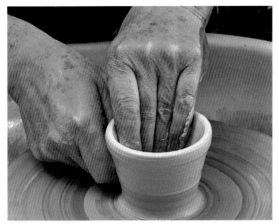

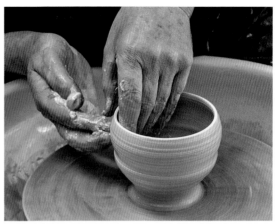

4 Curl the forefinger of the right hand around the thumb to form a knuckle. With the left-hand fingers inside the cup and the thumb supporting the outside, gently press the knuckle into the base on the outside and, applying pressure from the inside, belly out the wall to about two-thirds of the way up. Close in again slightly as you reach the rim.

5 Refine the wall of the cup with the left hand in the same position inside but using the fingertips of the right hand instead of the knuckle to lift the clay wall to its final shape.

Turning the base of the cup to make a foot ring

A foot ring is turned into the base of a cup for several reasons: to provide a raised platform for firing and thus prevent sticking to the kiln shelf; to minimize contact with a surface when full of hot liquid; to provide an exact measurement and lift to fit a saucer; or simply to give the cup visual lift—a foot ring adds delicacy to a form.

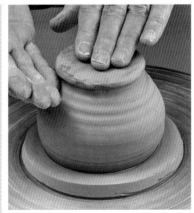

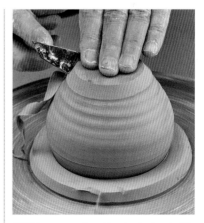

1 Begin by throwing a flat disk of clay onto the wheel head. Level and smooth over the surface with a rib to remove excess water. Using the tip of the rib, score a circle into the surface of the disk to the approximate size of the rim of the cup.

2 Position the cup on the disk of clay on the wheel so that it sits in the scored circle. With the wheel rotating, look at the edge of the cup on the left side, then, when you see a wobble, strike the opposite side of the cup with the other hand. Repeat until the cup runs true to center.

3 Using your preferred turning tool and with the wheel rotating at medium speed, remove the clay around the edge at the base of the cup until the correct outline shape is achieved. Keep the fingers of the left hand in the center of the base to keep the cup steady as you work.

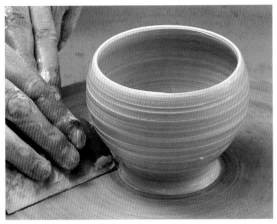

6 Using a rib or similar tool, remove excess clay from the base of the cup. Sponge the inside of the cup carefully to remove any water. Wire off the cup on the underside and carefully transfer to a board, lifting from the base in order to avoid distorting the shape.

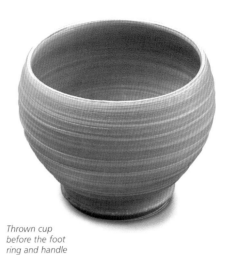

Thrown cup before the foot ring and handle have been added.

BEFORE YOU BEGIN

> Allow all items to dry to leather-hard before attempting to turn the bases into foot rings; otherwise the shape will collapse.

> Turning tools are available in many types, sizes, and shapes— sometimes it is useful to have more than one type and this choice is down to individual preference, but all will work much better if kept sharp.

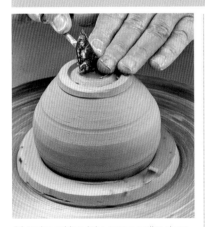

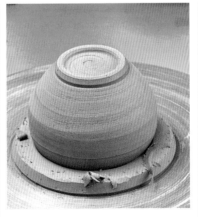

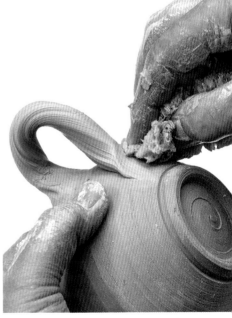

4 Having achieved the correct outline shape, score a circle on the base, in from the edge to the approximate size you wish the foot ring to be. Carefully turn the clay within the line until enough is removed to leave a foot ring. Work from the center to the outside. Slightly miter the foot ring on both the inside and outside edge.

5 After you have turned your foot ring, there will be a small mound of clay left in the center. Remove this in stages using your turning tool. Lift your work off of the wheel ready for adding your handle.

6 Add a handle of your choice (see page 51) by following the relevant instructions on pages 52–55.

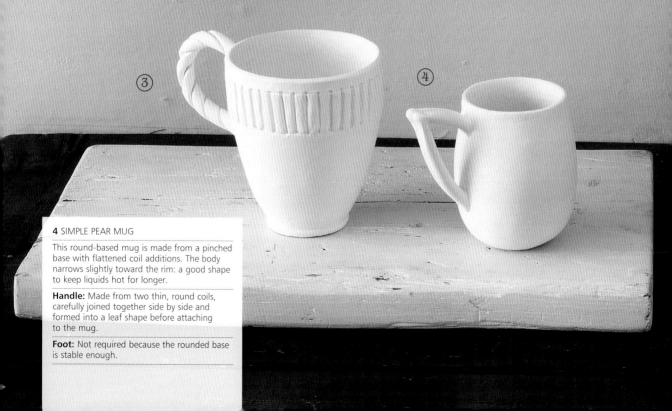

1 CAPPUCCINO CUP

The base mold is made from a soft slab and the body built up using flattened coils. A large cup like this would suit a saucer (ideally made at the same time).

Handle: A thinner round coil, slightly flattened, is attached to the rim and curves around and down to the base.

Foot: The foot ring is made from a disk of clay, attached to look like a foot ring from the outside.

2 TEA BOWL

A very simple shape can sometimes be the most pleasing. This cup is made from a pinched base and built up with flattened coils. The unusual rim adds a small visual detail that gives the shape character.

Handle: Tea bowls are designed to sit in the hand comfortably, removing the need to make a handle.

Foot: The rounded base of this cup is wide enough to be stable when on a surface.

3 LARGE INVERTED CONE-SHAPED MUG

The body of this mug is made in a mold using flattened coils for the lower section and decorative vertical coils, blended on the inside only, for the panel at the top.

Handle: Made from a twisted round coil.

Foot: A disk of clay attached to the base gives the appearance of a foot ring from the outside, but is flat for extra stability.

4 SIMPLE PEAR MUG

This round-based mug is made from a pinched base with flattened coil additions. The body narrows slightly toward the rim: a good shape to keep liquids hot for longer.

Handle: Made from two thin, round coils, carefully joined together side by side and formed into a leaf shape before attaching to the mug.

Foot: Not required because the rounded base is stable enough.

Design options
Coiled variations

5 GOURD-SHAPED CUP

This shape is formed from a pinched base section and built up with thicker flattened coils. The shape is developed later by carving and modeling.

Handle: Made from a short, round coil cut in two for a third of the length, then splayed and modeled into two leaves.

Foot: None. The base is made with a slight indentation but is otherwise quite stable.

6 GENEROUSLY SIZED MUG WITH STRAIGHT SIDES AND ROUNDED BASE

The body is made from a pinched base section and built up with flattened coils: a good shape for keeping liquids hot.

Handle: A flattened coil cut to form a thin strap, then curved to form a number "9" shape before attaching to the body.

Foot: Three clay balls attached to the base give the mug stability.

7 DECORATIVE COIL TEA BOWL/CUP

It is much easier to make designs like this in a mold because it keeps the shape true while allowing the inside surface of the form to be blended and smoothed without distortion. The design is built up using thin coils that have been shaped to make a pattern.

Handle: None.

Foot: None, although one could be added as an extra design detail.

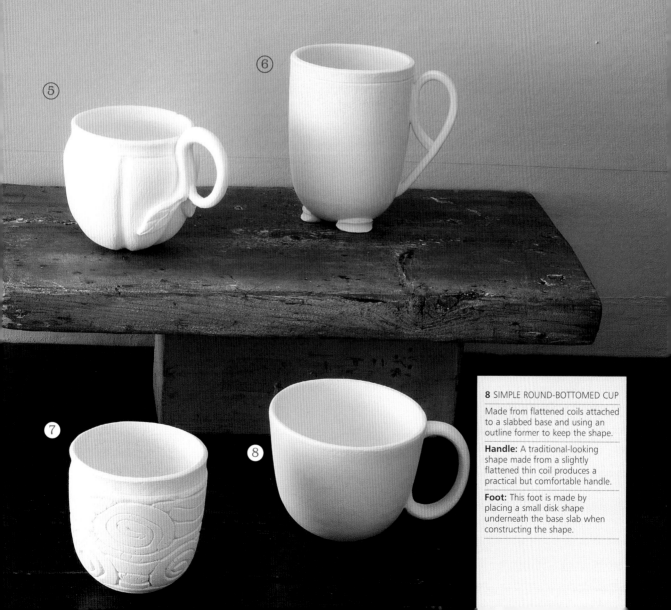

8 SIMPLE ROUND-BOTTOMED CUP

Made from flattened coils attached to a slabbed base and using an outline former to keep the shape.

Handle: A traditional-looking shape made from a slightly flattened thin coil produces a practical but comfortable handle.

Foot: This foot is made by placing a small disk shape underneath the base slab when constructing the shape.

Technique
Coiled mug

Coiling is not the quickest method of making in clay, but many potters like it for this very reason. Coiling is a contemplative process that suits some personalities more than others but, as with all things, the more you practice, the faster you will become.

One of the main issues with this technique is the ability to repeat a shape exactly, but it is important to remember that this is a hand-building process that will always result in slight variations. Accept this, especially when you are first starting out, and think of each piece as being unique and special. A fractional difference in size or dimension will not affect functionality.

That said, however, using an outline template is one way to make coiled mugs approximately the same if you are creating multiples.

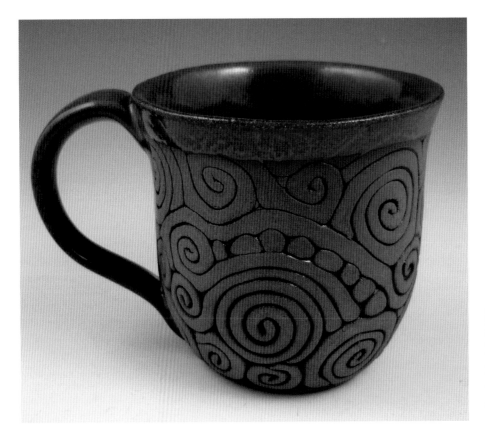

Coiled mug
by Ann Marie Cooper
Made from hand-rolled coils, the shape has been formed in a press mold and only partially glazed on the outside to show the patterning of the coils. Made from stoneware clay, the mug was fired to cone 6 in an electric kiln.

USEFUL TIPS FOR COILING MULTIPLE MUGS

> As with throwing, you can control size and dimension by carefully weighing out your clay in advance so that you always start from the same baseline.

> Base your weights and measurements on the first mug you make. Weigh the clay for the pinched base first (see Step 1) and make a note of it. Roll several coils and form them into the rough shape of the mug, positioning them on the pinched base without blending them. Check the size is correct using the former, then take the coils off again and weigh them. Add the weight of the coils to that of the base and use this for each mug.

Pinching and coiling a mug

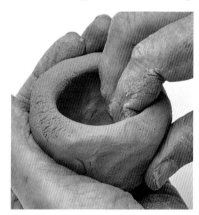

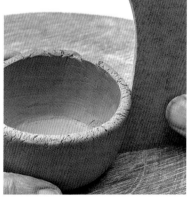

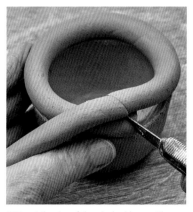

1 Form the clay for the base of the mug into a ball, then, holding it in one hand, press down into the center with a thumb or forefinger until you can feel some pressure in the palm. Don't press too far into the clay. Now start to pinch the clay evenly between fingers and thumb, rotating the shape constantly to make sure the wall is even. Leave a slightly thicker amount at the base to form a foot ring later.

2 Continue to pinch the shape until the approximate dimensions for the base have been achieved, then sit it on a board. To use the former, hold it flat on the board, then carefully draw it around the clay to check that the shape is correct. If the wall is flared too much, make corrections by folding the clay, then repinching to the correct shape. If not open enough, simply pinch a little more until the shape fits the former.

3 Level the rim of the pinched base with a rasp blade, then score and slip ready for the first coil. You can use round or flattened coils. Position the coil on the rim of the base and overlap where the ends meet. Cut through both coils diagonally, discard the excess, then butt the ends together neatly, making sure they are sealed.

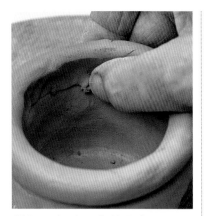

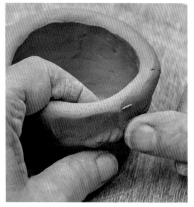

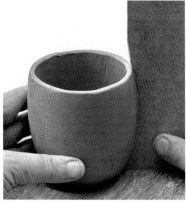

4 Supporting the wall with the fingers, use the thumb to blend the coil in a downward action on the inside of the mug to secure it to the base. Try not to distort the overall shape as you perform this task. If you push the clay too hard, the wall will belly outward excessively, so the key is to support the pressure applied from the other side of the wall. Working with soft clay will also make the task much easier.

5 Repeat the process of securing the coil on the outside wall using one hand to support as the other blends. When the coil is fixed, remove the surplus clay around the edges with a rib or kidney on both the inside and outside until the surface is smooth and the wall an even thickness. Remember to check the shape regularly using the former—you should find the mug distorts less as you build up if the shape is relatively simple.

6 Continue to build up the wall with added coils until the required height is reached. The former can be used to smooth the surface, as well as correct the shape at this stage, if you are careful. Level the rim with a rasp blade, then neaten it up carefully with a rib so that it has a rounded edge that is a pleasant thickness to drink from.

Making an outline former template: things to consider

It is easy to make your own outline former, a useful tool for keeping control of a shape as you build it, especially if you want to make multiple items.

The best material to make a former from is thin fiberboard, which can easily be cut with a strong knife. Thick cardboard or hardboard also work well.

• First consider the pottery item you want to make, and design a shape that you know you will be able to produce. This may sound obvious, but complicated forms can be very tricky to master if inexperienced and will slow down the making process considerably.

• Keep the shape clean, simple, and classic for the best results.

• Cut the former shape out in paper first to see what it will look like, and make adjustments accordingly. Remember that clay shrinks in firing so make the outline a little larger to accommodate this.

• You can make more than one shape from a former if you plan it properly. The example used in the following step sequence shows a former with a convex curve for the basic mug, but the shape could be continued upward to give a different profile if required.

• The former must be wide enough for you to grip it comfortably when in use. Take a rough measurement by holding the board before drawing and cutting out.

• Make sure the former has a level base so that it can sit on the board the item is made on.

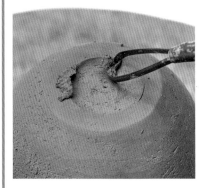

7 Turn the mug over on a bat and mark a circle at the center of the base using a pin and something small to draw around—used sticky tape rings are a useful size. Place the bat on a sculpting wheel, then, using a loop tool, carefully trim away the clay inside the circle to create a foot ring.

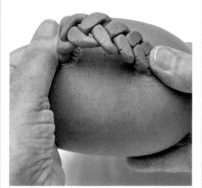

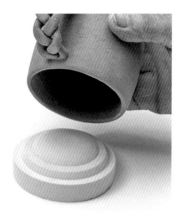

8 Smooth the foot ring with a barely damp sponge.

9 For the handle, roll three equally sized coils of soft clay thin, then braid them in the traditional way, securing them at the top and bottom by squeezing the clay together. Place a wooden batten over the length of the clay braid and flatten it slightly. Cut the handle to the required size, mark the position on the wall of the mug, score and slip both the marked positions and the ends of the handle, and fix into place. Wipe away excess slip with a barely damp sponge.

10 To keep the shape of the mug true at the rim, sit it on something round to dry out, such as the clay ring (or cup setter) that is shown here.

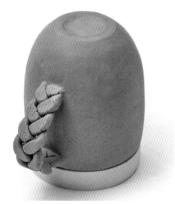

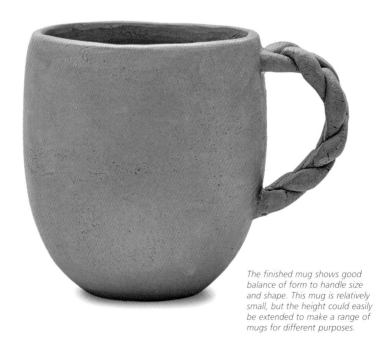

11 Any domed shape will do—I use old lampshades, small upturned bowls, etc., but a good alternative is to make dome shapes in a selection of sizes. Six of each size is a useful number if you are planning to make things in multiples.

The finished mug shows good balance of form to handle size and shape. This mug is relatively small, but the height could easily be extended to make a range of mugs for different purposes.

1 SQUARE MUG

Using firm slabs, this mug is made in sections with the seams reinforced on the inside to soften and round out the corners.

Handle: Made from a slab strap, when joined to the body the handle is flattened slightly to better accommodate the hand.

Foot: Designed to be integral to the shape rather than added, the base of this mug is recessed just above the cutout detail.

2 SIMPLE SQUARE TEA BOWL

Made from a single soft slab cut from a template, this form is a simple exercise in folding clay and joining edges.

Handle: None, although one could be designed as part of the template to fold over when the body has been assembled.

Foot: None. The underside folds of clay are joined and smoothed.

3 LARGE ESPRESSO CUP

Simple forms like this are ideal if choosing to texture the clay prior to constructing. The quick and simple making method allows the seams to be overlapped as a decorative detail if preferred.

Handle: A simple loop handle, cut using pastry cutters in two sizes.

Foot: Flat based for optional use with a saucer.

4 OPEN, GENEROUS TEACUP

The body of this cup is made using soft slabs in a multipurpose press mold that can also be used to make bowls.

Handle: The handle has been notched in two key places to give extra grip for the fingers.

Foot: To match the handle, the standard round foot ring has been notched at intervals around the circumference. A saucer with a similar design would enhance this cup.

5 SMALL ESPRESSO CUP WITH ORNATE HANDLE

Made from a soft slab and formed around a tube, this small cup is quick and easy to make in multiples if required.

Handle: This version of a traditional, ornate handle has been adapted for slabbing by simply using a profile shape.

Foot: None. The absence of a foot better allows this cup to be used with a saucer if preferred.

Design options
Slabbed variations

6 BEAKER

Variation on the tripod mug (**8**) but without a handle. Made from a soft slab, the shape can be manipulated for a more bellied mug if the clay is soft and plastic enough.

Handle: No handle

Foot: Created by pinching the base into three points and squeezing together. The inside of the mug is reinforced with soft clay coils.

7 LARGE TRIANGULAR MUG

This three-sided mug is made from a single soft slab. Formed as a cylinder, the base is manipulated into a triangle, leaving the rim round.

Handle: Cut as a semicircle using pastry cutters.

Foot: Formed from three flattened balls of clay attached to each corner on the underside, then cut level with the sides.

8 TRIPOD MUG WITH ORNATE HANDLE

Made from a soft slab, the shape can be manipulated for a more bellied mug if the clay is soft and plastic enough.

Handle: Cut from a thin slab using a template.

Foot: Created by pinching the base into three points and squeezing together. The inside of the mug is reinforced with soft clay coils.

9 TRADITIONAL TEACUP

Made from soft slabs in a multipurpose plaster mold for quick repeats, this is a versatile shape that can be moderated with different handle or foot designs.

Handle: A traditional-style, slab, strap handle perfectly balances with the style of cup.

Foot: A slabbed circle foot is easy and quick to make and attach.

Technique
Slabbed mug

Soft slabbed mugs and cups are surprisingly easy and quick to make. Many techniques can be used to create different shapes, from the most basic to the positively quirky; here we are adapting the form from a cylinder.

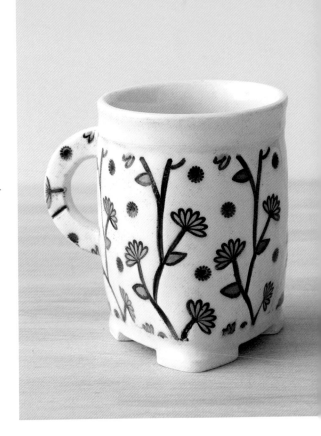

BEFORE YOU BEGIN

> Measure the circumference of your tube, then make a paper template, adding about ½ in. (12 mm) to the measurement to accommodate the thickness of the clay when wrapped around it, and to the height you want your mug to be.

> Roll out a slab of clay as thin as you can handle and cut to the size of the template. Keep the spare for the base and handle.

> Miter the edges to be joined and score—first on one end, then flip the slab over and repeat at the opposite end.

> Roll the tube in a sheet of newspaper—secure by stuffing the surplus into the tube at each end.

Slabbed tripod mug

1 Keep the slab on the plastic sheet it was rolled out on, place the tube to align with the edge, then roll the clay carefully around it. When almost closed, apply a little slip to the scored edges, then seal together and smooth over the join.

2 Sit the clay tube on a board with the former tube still in place. The tube can be removed by ripping the paper away at the top, then sliding the inner out. Carefully remove the paper without distorting the shape.

Slabbed mug by Jacqui Atkin
This mug is round at the rim for ease of drinking, but triangular at the base. Made from white earthenware clay, the design was impressed before construction. Underglaze was used to fill in color before applying a transparent glaze. Fired to 2,048°F (1,120°C) in an electric kiln.

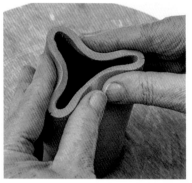

3 To form the tripod, gently squeeze the clay at the top edge between the fingers and thumbs to form three equally sized arms.

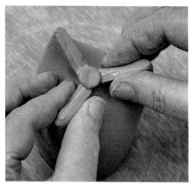

4 If the clay is soft enough, the arms should seal together readily. If in doubt, use a little slip on the edges to be joined, then pinch the seams together securely. Plug the tiny gap at the center with a soft wad of clay and either leave it as a feature or blend it in.

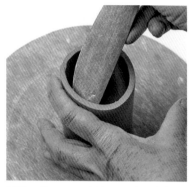

5 Turn the mug upright onto a board, then, supporting the side with a finger at rim level and using a kidney, rib, or wooden tool, gently belly out the shape from the inside, working the tool upward from the base to just below your supporting finger. Repeat this action until the mug is bellied to a shape you are happy with.

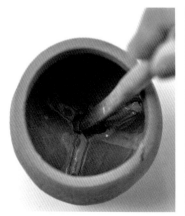

6 Carefully reinforce the tripod seams on the inside with coils of soft clay. Blend the clay in well using a wooden modeling tool or a finger if you can reach inside. Evening out the interior will make stirring liquid content easier and make the mug more hygienic and easier to wash.

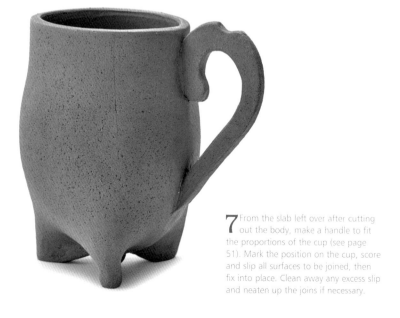

7 From the slab left over after cutting out the body, make a handle to fit the proportions of the cup (see page 51). Mark the position on the cup, score and slip all surfaces to be joined, then fix into place. Clean away any excess slip and neaten up the joins if necessary.

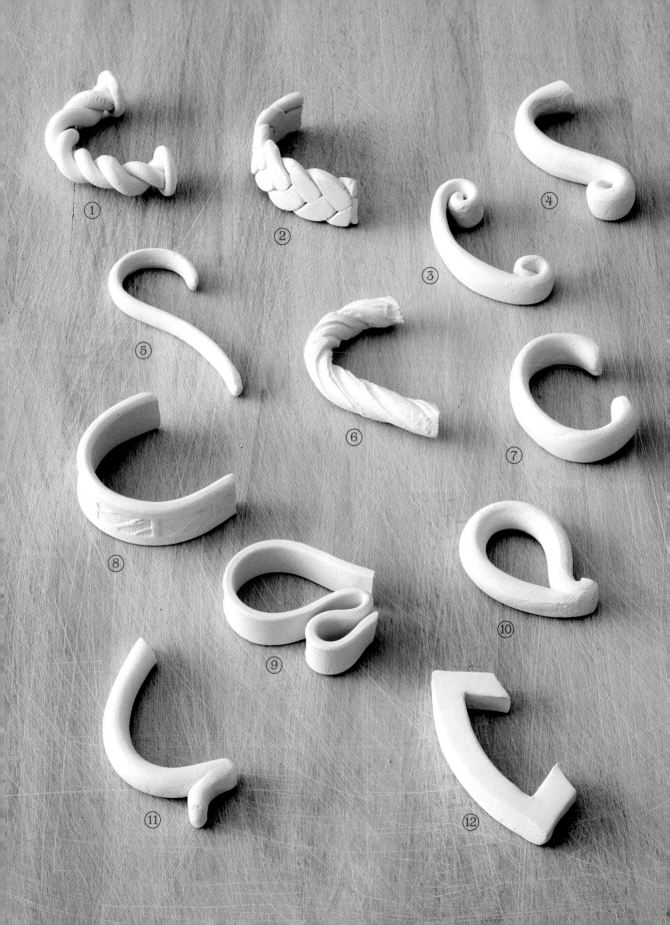

Design options
Coiled, slabbed, and pulled handles

1 TWISTED DOUBLE COIL

Two thin, round coils twisted together and formed into a semicircle. Two very thin coils surround the twisted coils at the point where the handle is attached to the cup.

Suitability: Any cup or mug. The action of twisting coils gives added strength, so this style is particularly suitable for larger pieces.

2 COILED AND PLAITED

Thin, round coils plaited in the traditional way, then flattened by applying pressure over a wooden batten.

Suitability: Any cup or mug. The plaiting action adds extra strength. This handle adds a feature to an otherwise simply styled shape.

3 PULLED AND COILED

Made from a thin, pulled coil rolled inward at each end. The handle is attached at each end where the clay coils. A versatile handle, easy to make in varying sizes to suit the style of cup. Additional shaping can be applied if required.

Suitability: Any thrown cup or mug, also handbuilt versions.

4 PULLED AND CURLED

Pulled to a relatively thin size, which thins as it tapers to the bottom. The thinner end of the handle is curled back upward as a feature detail.

Suitability: Any thrown cup or mug, also handbuilt versions. Good for making multiples, quickly. Pull several in advance and apply when firm enough to hold shape.

5 COILED OR MOLD MADE

This standard-shaped handle is ideal for delicate porcelain cups. Model from a thin coil or make in a two-part mold.

Suitability: Most suited to fine, thinly made, handbuilt cups or mugs. Generally not robust enough for thrown cups.

6 PULLED BARLEY TWIST

Pulled from a thin coil of clay in the traditional manner, this handle is textured along its length and then twisted. Make several in advance and apply to the mug when firm enough to hold shape.

Suitability: Any thrown cup or mug, also handbuilt items.

7 TWO-PART MOLD MADE

Generic cup-handle molds designed for slip casting can also be used as press molds. The two pressed halves have to be joined together in order to make the handle.

Suitability: Any cup or mug. Handles like these suit many shapes, be they hand built or thrown.

8 TEXTURED SLAB STRAP HANDLE

Made from a simple rolled slab of clay, textured to suit the form it is to be applied to. The strap should be shaped and allowed to firm up before attaching to the body.

Suitability: Any handbuilt or thrown cup or mug; size accordingly with the style and dimensions of the cup or mug.

9 DOUBLE-LOOPED SLAB STRAP

Strap handles can be adapted to many stylish shapes to suit the shape of cup or mug they are to be attached to. Here the strap has been double looped: the larger loop would be positioned at the top as it is the lifting part of the handle.

Suitability: Any handbuilt or thrown cup or mug that would suit the style. It works best with rounded shapes.

10 PULLED LOOP

Pulled from a thin coil of clay and looped around to a teardrop shape, then the joined ends are curled together. Most of this handle extends upward and out from the cup: it attaches at the lower end.

Suitability: Ideal for rounded thrown cups or mugs but could be attached to handbuilt versions of a suitable shape.

11 ROUND COIL

Made to a traditional shape, this handle has a small added section of coil at the top to act as a thumb stop: a decorative detail with a practical use in that it prevents the thumb coming into contact with the hot surface of the cup.

Suitability: Ideal for coiled or other handbuilt cups and mugs, also thrown versions. The traditional styling makes it suitable for finer forms.

12 CUT SLAB

Use a paper template to make this type of handle, to ensure you can repeat the shape and size for production runs. The clay slab is rolled slightly thicker to ensure a comfortable grip when lifting the cup.

Suitability: Stylized handles of this sort are best designed to fit slabbed cups and mugs with angular proportions.

Technique
Pulled handle

Thrown cups and mugs usually have a pulled handle. There are two methods of pulling handles. The first forms the shape after attaching one end to a vessel, and is known as pulling on the pot. For the second method, pulling off the pot, the handles are pulled first, then attached.

BEFORE YOU BEGIN

> You will need a bowl of water to keep your hand moist as you pull the shape. Have a practice run—make several handles until you are happy with the results— attach the handles to a trial surface like a table or a test vessel. Experiment with different proportions, thicknesses, and shapes.

Making multiples

If you're making multiple cups at once, it makes sense to pull the handles at the same time.

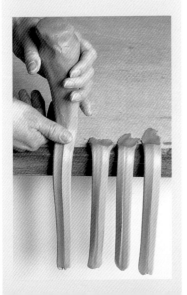

Pulling a handle

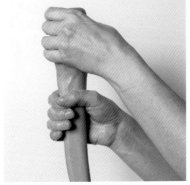

1 Form a fat coil of clay, then, holding it in one hand and using water to lubricate the action, pull the clay down between your fingers and thumb. You can make the coil oval or round by shaping your hand.

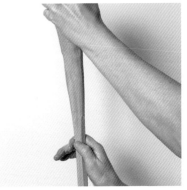

2 Repeat the pulling technique until the coil is the length and thickness that you want it to be, then carefully snip off a length to a suitable size for the cup it is to be attached to.

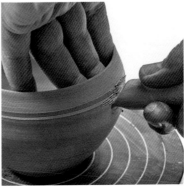

3 Score the position on the cup where the handle will be first attached, then, supporting the inside with one hand, carefully ease the end of the handle into place. It should be moist enough to attach easily, but if in doubt use a little slip.

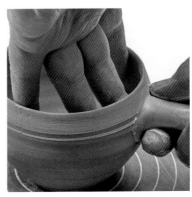

4 Keeping the handle in one hand and still supporting with the other on the inside of the cup, blend and smooth the clay at the join with the thumb until it looks seamless.

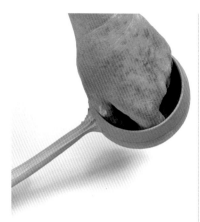

5 Holding the cup with a hand on the inside to maintain the shape, lift the cup and with a lubricated hand pull the handle again to the correct thickness. Try to do this in a minimal number of maneuvers without overwetting the clay.

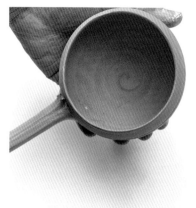

6 Transfer the cup to the palm of one hand, then carefully run your nail along the length of the handle to form a groove. Repeat two or three times more.

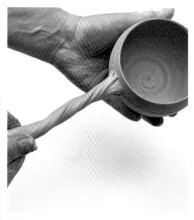

7 Maintaining your hold of the cup in the palm of one hand, now start to twist the handle several times until an even pattern forms. Don't overdo it, otherwise the grooves of the twist will disappear.

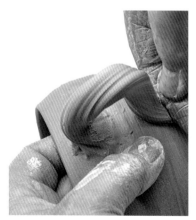

8 Carefully position the bottom of the handle so that it is in line with the top and press it onto the cup using the thumb. Once the handle is secure, pinch off the excess clay between the fore- and second fingers. Smooth the bottom of the handle to form a seamless join to match the top.

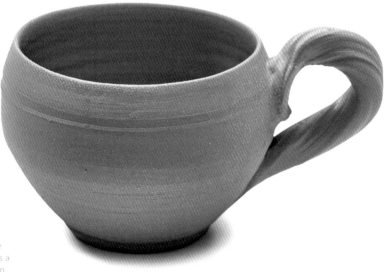

The barley-twist handle perfectly complements the shape of the cup and adds a simple design feature to an otherwise unadorned form.

Molded and slabbed handles

Handles can be quickly and easily made in a mold or by using a cutter. If you don't have the skills to make a two-part plaster mold, then a good alternative is to buy one from your ceramic supplier. These will generally be designed for slip casting, but this does not mean you can't utilize them as press molds. They are usually available in a good selection of sizes and shapes, and it is worth having a selection to accommodate different styles of cup and mug.

Making a handle from a two-part mold

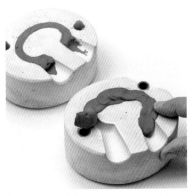

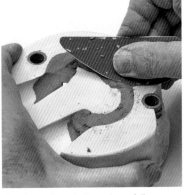

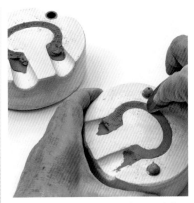

1 Press a thin slab, strip, or coil of clay into each half of the mold. Make sure the cavity is filled properly by applying as much pressure as possible.

2 Using a rib or similar tool, carefully remove the excess clay protruding above the plaster. Be aware that the clay will easily lift out of such a shallow mold, so remove the surplus in small sections rather than dragging the rib over the whole thing at once.

3 With the tip of a serrated kidney or similar tool, score the clay in the mold. Take care not to scrape the plaster because not only will this spoil the mold, but it could also cause damage to the handle if plaster gets into the clay.

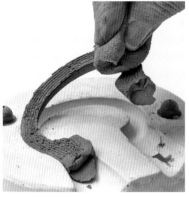

4 Lift each half of the handle out of the mold using a small piece of soft clay. You may find the handle sections will just drop out, but this is a good method of removal if the clay is resistant.

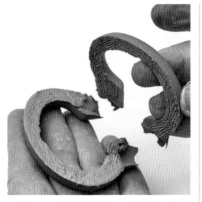

5 Score and slip both halves of the handle, then fit them together neatly and hold in place for a few seconds to make sure that the join is secure.

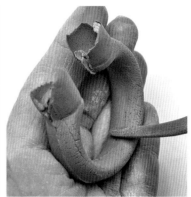

6 Neaten the joins with a wooden tool or rib, then wipe over with a barely damp sponge if required.

Making and attaching a slabbed handle

7 Cut away the excess clay at each end of the handle, which is now ready to attach to a cup or mug. Mark the correct position for the handle on the mug and make sure all joining parts are scored and slipped before attaching.

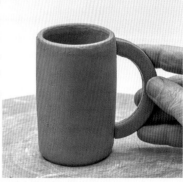

1 Use pastry cutters in two sizes to cut a handle to the required size from the remaining slab used for the main vessel.

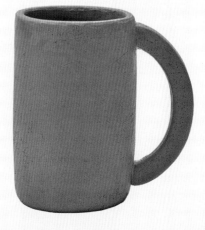

2 Mark the position for the handle on the mug, then score and slip all surfaces to be joined and fix together. Remove any surplus slip and neaten up the clay around the joins.

This classically shaped handle is a good standard for a wide variety of shapes; therefore a mold like this is always useful in the studio.

This simple handle is a good shape for cylindrical forms, but can be adapted in different proportions to fit many different shapes, and by increasing the thickness of the slab you can change the shape further still.

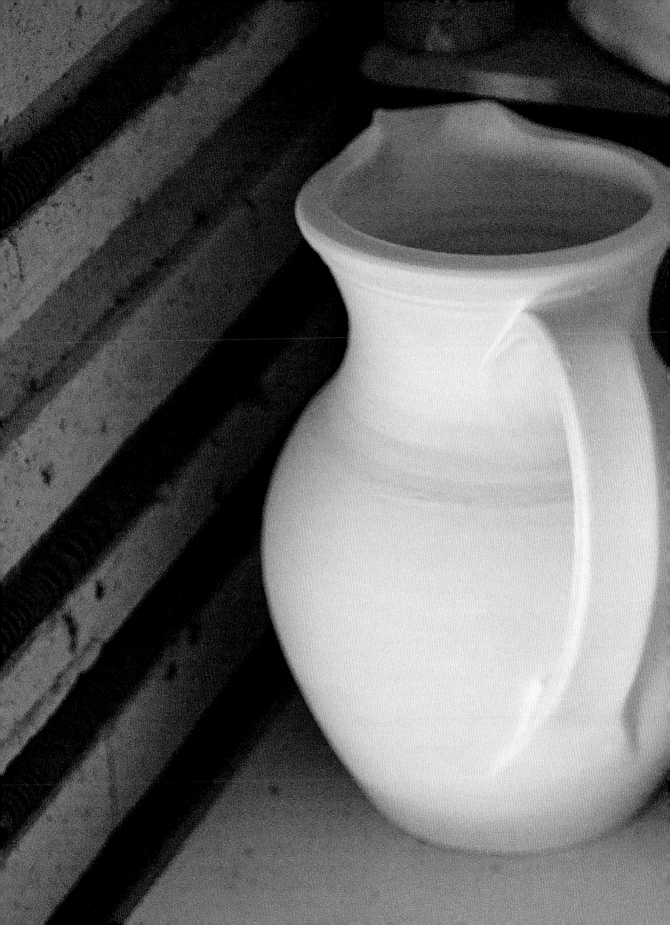

Chapter 3

PITCHERS
& BOATS

Pitchers and boats
Design decisions

Working out all the design details in advance of making your pitcher will ensure you make a product that meets all your requirements.

The pitcher close up

To suggest a form is "the perfect shape" is completely subjective; it depends on so many things pertinent only to the user, but there are times when "perfect" is the only word to describe something that not only pleases the eye but is supreme in its functionality.

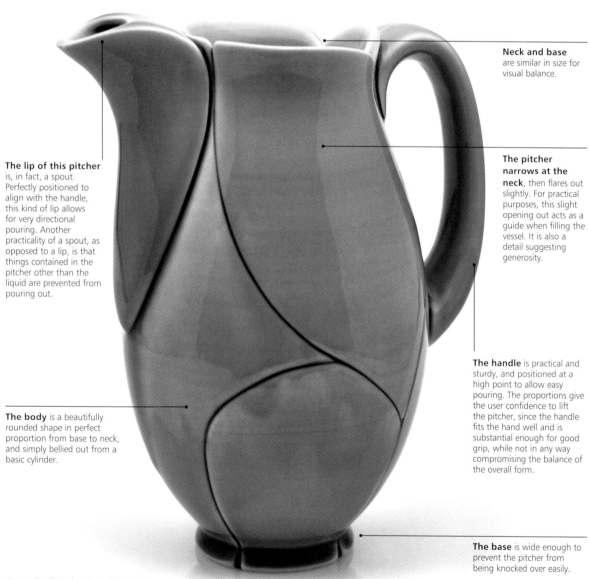

Neck and base are similar in size for visual balance.

The lip of this pitcher is, in fact, a spout. Perfectly positioned to align with the handle, this kind of lip allows for very directional pouring. Another practicality of a spout, as opposed to a lip, is that things contained in the pitcher other than the liquid are prevented from pouring out.

The pitcher narrows at the neck, then flares out slightly. For practical purposes, this slight opening out acts as a guide when filling the vessel. It is also a detail suggesting generosity.

The handle is practical and sturdy, and positioned at a high point to allow easy pouring. The proportions give the user confidence to lift the pitcher, since the handle fits the hand well and is substantial enough for good grip, while not in any way compromising the balance of the overall form.

The body is a beautifully rounded shape in perfect proportion from base to neck, and simply bellied out from a basic cylinder.

The base is wide enough to prevent the pitcher from being knocked over easily.

Green leaf pitcher by Jeff Campana
Thrown, dissected, and reassembled mid-range porcelain, green glazes fired to cone 6 in an electric kiln. The pitcher measures 6 x 6 x 9 in. (15 x 15 x 23 cm).

The sauce boat close up

A sauce, or gravy, boat is simply a variation on a pitcher: a lower, more open version that has been stylized to serve a specific purpose. Somehow, gravy just isn't the same served from any other shape, so it is a useful item to make.

The shaped strap handle has been attached to the inner surface of the boat and loops up and away from the body to prevent the hands coming into contact with a hot surface.

The lip of the boat is simply shaped to ensure the content will not pour out too quickly. An overly exaggerated lip would cause the content to drip after pouring, something to be aware of and avoided.

Made from a soft slab formed first into a bowl shape, then altered to an oval, this boat is quite deep, but open at the rim as the style dictates.

This boat can take enough sauce or gravy to amply serve four people. The stylized leaf decoration, based on a 1950's design, adds a little visual detail to an otherwise plain surface.

The sturdy base has a foot ring to lift the underside and minimize contact with the surface beneath it when the boat is filled with hot content. Many boats have quite elaborate foot rings for this reason.

Many of us own pitchers in several sizes because, of all the functional items we might use, this is the one item that does not fit the criteria of one size meeting all needs. This gives the maker great scope for design development: to make a range of sizes in a particular style or to make individual and unique shapes to meet a particular brief. From the smallest of creamers to gravy boats, from medium -sized milk pitchers to large water or wine holders, the development of a shape that is both pleasing to look at and fit for purpose can be a challenge, but the options for shape in the following sections should help develop your own ideas to create truly unique vessels to exactly meet your needs.

Terracotta pitcher
by Todd Hayes
This striking pitcher is press molded using terracotta clay. Colored slip coats the interior of the pitcher and is used for the simple dot decoration on the outside to contrast beautifully with the color of the clay. A clear glaze fired to cone 3 in oxidation is used on the interior of the pitcher.

Family of pitchers
by Tone Von Krogh
These very functional pitchers are wheel thrown and made in white stoneware. The simple shape makes them practical for a multitude of uses.

Questions to ask yourself

What would be the best making method? Hand building or throwing?

The answer is dependent on several factors, not least the maker's abilities, but most importantly, the shape should dictate the best making method.

Thrown forms are probably the quickest to make, but depend on a level of skill. Almost any shape can be achieved by throwing because the form can be altered in many ways, but the vessel will almost always retain some marker (like throwing rings) to show that it was thrown.

Hand-building methods are slower and impractical for certain shapes. For instance, a really bellied form would not be easy or practical to make by slabbing. Instead it would be much easier to coil, or pinch, if the vessel is small. Similarly, a large pitcher would not be easy or practical to pinch, so coiling would be the best method.

What will the pitcher be used for?

Answering this will determine:
• What size the pitcher should be.
• How sturdy the pitcher needs to be: for instance, wide at the base so that it can't be easily knocked over if containing hot liquids, or wide at the neck for ease of pouring the contents into it, and so on.

What kind of lip should it have and should the pitcher be throated?

This is important because lips determine flow and certain lips are more suitable for some liquids than others. You would not want a lip that allows for fast flow and the possibility of spillage if the contents are hot, for example.

Where would the handle be best placed for ease of use?

The position and design of the handle is very important because it not only affects the visual balance but also the functionality of the pitcher. (Options and suggestions for handles can be found on page 85.) Considerations should include:
• How heavy the pitcher will be when full: if heavy, the handle needs to be sturdy and comfortable to hold.
• Where the handle would best be placed for ease of lifting.
• Does it need a handle at all—not all pitchers do.
• Should the handle be pulled and attached, as is the tradition for handles on thrown vessels, or could it be made separately by hand. The form's function will dictate the possibilities.

Design options
Thrown variations

1 GLOBE FORM

Globe-shaped form with accentuated, collared rim, slightly turned in to add to the sense of containment. This generous form would be useful as a creamer, pitcher, or boat.

Lip: Pulled and throated upward from the body, this lip perfectly complements the shape of the body.

Handle: Thickly pulled to allow a deep thumb line to be drawn through the length of it, as a feature but also for extra grip.

2 OPEN CONICAL FORM

Wider at the neck than base, but slightly closed in at the rim to add to the sense of containment and facilitate a place to attach the handle.

Lip: Pulled from the rim to form a continuous line in the conical shape from the base.

Handle: Wide slabbed strap handle applied at an angle at the rim as a feature.

3 OVAL PINCHED SHAPE

This piece is thrown as a bowl with a turned base to accentuate the roundness of the form. The shape has been altered to an oval by gently squeezing the sides between two hands while still wet on the wheel.

Lip: Pulled, the accentuated curve is designed for ease of pouring but visually adds a sense of flow to the form.

Handle: This handleless form has indentations on both sides to act as a grip point: a simple but very effective alternative to a handle for smaller pitchers designed for cold or warm liquids, but not hot.

① ②

4 GLOBE BOAT

This globe-shaped boat has been thrown as an open bowl, turning in only slightly at the rim. The form is gently squeezed in order to create the oval shape.

Lip: A simple pinched lip, quite small and shaped only slightly to facilitate a good pouring action while not allowing the contents to flow too quickly.

Handle: Simple indentations made by the fingers give the shape a gripping point to replace a handle. This vessel is suitable for cold liquids only.

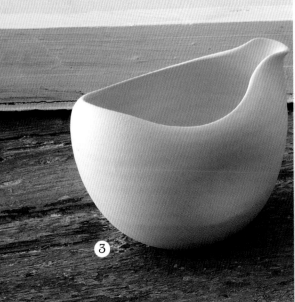

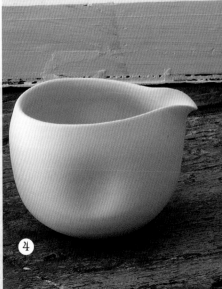

③ ④

6 GLOBE AND COLLAR SHAPED

This pitcher has very balanced proportions and is made in a traditional style, with rounded body and elongated, slightly flared collar rising to a thicker rim.

Lip: Pulled and pinched, the lip extends the length of the collar from the rim down to the point where the form rounds out.

Handle: Pulled and textured, this is a substantial handle that gives confidence to the user. Attached from the midpoint of the collared section of the form to the midpoint on the main body as a simple loop handle, it complements the form by not being too showy.

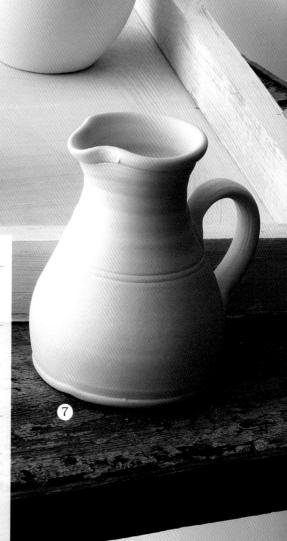

5 GLOBE-SHAPED BODY WITH COLLARED NECK FLARING OUT TO A RIM

The base is wide enough to be sturdy but not so much that it affects the overall balance of the shape. The rim is noticeable only from the outside of the form, a design detail common to traditional thrown pitchers and other forms.

Lip: Carefully formed from the inside only to avoid distressing the design detail of the thicker rim on the outside of the form.

Handle: Generous pulled loop positioned on the bulbous part of the body for practical handling and pouring.

7 GLOBE-SHAPED BODY WITH COLLARED NECK

The vessel has been thrown with a wide, flared rim to allow the lip to be formed. This is a very pleasing organic shape with a sturdy base and ample proportions.

Lip: The lip has been shaped by simply pinching the rim between two fingers, about 1½ in. (3.5 cm) apart, then carefully shaping the lip with another finger. The rim has been rolled slightly inward on either side of the lip for visual containment.

Handle: Simple pulled loop handle fitted into the curve of the body to accentuate the shape.

8 INVERTED CONICAL SHAPE

Wider at the base than rim, but with a long lip for controlled pouring of thicker liquids. The closed shape keeps liquid contents hotter for longer.

Lip: Thrown separately as a cone, then cut and reattached to form what looks like a beak. The lip is quite deep to contain fluids as they are poured.

Handle: Slabbed geometric shape with holes cut out for the fingers. This design is very practical in that it keeps the fingers from touching the pitcher, which is useful when the contents are hot.

9 ADAPTATION FROM A BASIC CYLINDER

Inverted conical form, wide at the base, only slightly bellying out before narrowing at the neck.

Lip: Long, beak-like lip designed to channel fluids very specifically. Thrown separately as a cone, then cut in half and joined to the body. To make this lip work the cone should be made larger than required to give some play in getting the proportion to body correct.

Handle: Pulled and formed into a circle before joining to the body. Perfectly balances with the extended lip and shape of the pitcher.

11 TRADITIONAL WIDE BASE

Wide-based cylindrical body closing slightly at the neck with a small flare outward. The rim is thicker and has been flattened slightly, making it look more substantial and less likely to break if knocked over. This is a very traditional shape that is sturdy and reliable.

Lip: Pulled and shaped upward from the rim with a slight throat.

Handle: Loop, attached and pulled directly from the rim of the body. The lower end is attached at the midpoint of the pitcher wall.

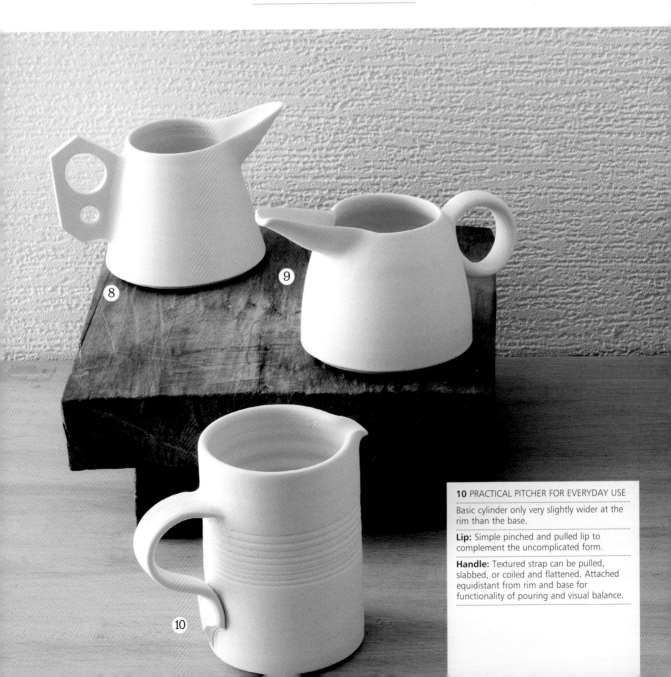

10 PRACTICAL PITCHER FOR EVERYDAY USE

Basic cylinder only very slightly wider at the rim than the base.

Lip: Simple pinched and pulled lip to complement the uncomplicated form.

Handle: Textured strap can be pulled, slabbed, or coiled and flattened. Attached equidistant from rim and base for functionality of pouring and visual balance.

12 SMALL CONICAL PITCHER

Solid at the base but with a wide rim. Simply adapted from a basic cylinder, this is a pitcher with multiple uses.

Lip: The lip has been widened and slightly squared in this example, especially useful for pouring thicker liquids like sauces.

Handle: A wide slabbed strap handle formed into a generous loop so that the hand will not touch the body of the pitcher if the contents are hot.

13 CYLINDER ADAPTATION

Wide, open, conical shape adapted from a basic cylinder. The rim is thrown extra widely to facilitate the simple method of forming the lip.

Lip: Formed by cutting a vertical line from the midpoint of the body to the rim, then, after making small adjustments to the angle of the cuts, rejoining to form a point. When viewed aerially the pitcher is leaf-shaped. This design is most suited to cold fluids because the open shape would allow hot contents to cool too quickly.

Handle: Slabbed strap attached at a slightly jaunty angle that in no way affects functionality but adds character to the pitcher.

14 OPEN CONICAL FORM

Wider at the neck than base, but the base is still wide enough to make the pitcher sturdy. Small adaptation from a basic cylinder.

Lip: Moderately pulled from the rim of the body and slightly throated. This lip perfectly accentuates the conical shape.

Handle: Organic simple handle, attached to the body before pulling to shape. Attached equidistant from base and rim to balance the narrower base.

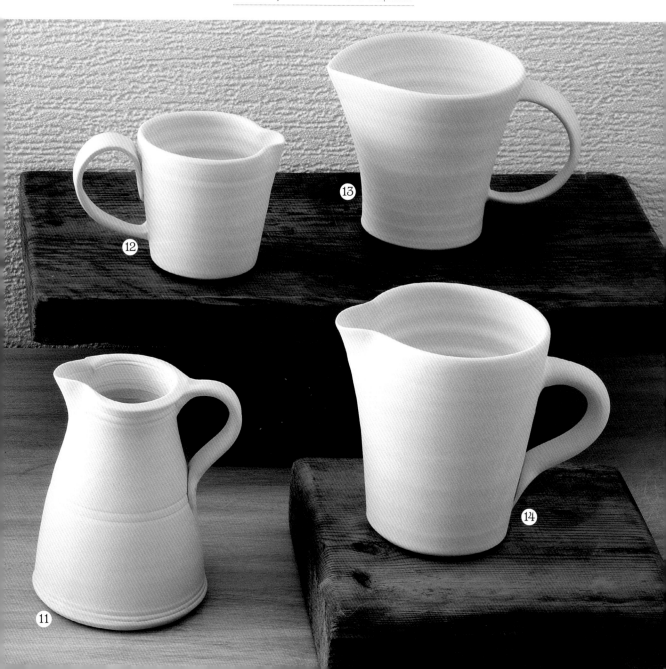

Technique
Thrown pitcher

Thrown pitchers are generally developed from a basic cylinder and in this way they are perfectly functional without any further development of design, but wouldn't it be boring if all pitchers were straight up and down? Fortunately, the possibilities for the development of shape are many, and most are variations on the cylinder. In large part, the shape is what suggests the function of this most useful of vessels; therefore the challenge is to design and make a pitcher that is aesthetically pleasing, easy, and comfortable to use, but also fit for purpose.

Try making some quick sketches with alternative body shapes, lips, and handles. When you find a combination you think you like, you can then decide on the best making method. For thrown pitchers, look at the chart below to work out roughly what weight of clay you will need for your chosen pitcher. Draw it to scale on graph paper, using the given measurements to see if the balance will be right, and make adjustments accordingly.

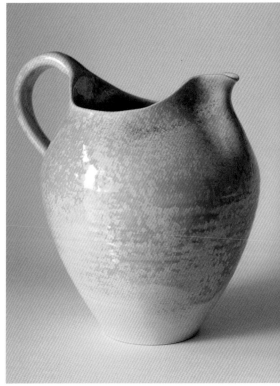

Thrown pitcher by Laima Grigone
This crystalline turquoise pitcher is wheel thrown and altered. Made from porcelain clay, fired to cone 9 in oxidation, the lovely surface is achieved using microcrystalline glazes.

Sizes and weights for thrown pitchers

Item	Weight of clay	Height x width	Suggested use
½ pint (0.3 liter) pitcher	14 oz (0.4 kg)	5 x 3½ in. (13 x 9 cm)	Creamer
1 pint (0.6 liter) pitcher	1½ lb (0.7 kg)	7 x 4 in. (18 x 10 cm)	Milk pitcher
2 pints (1.1 liter) pitcher	2¼ lb (1 kg)	9 x 4½ in. (22 x 11 cm)	Sauce or custard
4 pints (2.3 liters) pitcher	4 lb (1.8 kg)	11½ x 5¼ in. (29 cm x 13 cm)	Water or wine

Approximate weights and measures for pitchers
The information given represents raw clay weight for throwing and approximate minimum fired dimensions.

BEFORE YOU BEGIN

> Make sure everything you will need to make the pitcher is at hand—tools, water, sponge, and a bat to transfer the pitcher to when it is completed.

> Prepare the clay by wedging and kneading to eliminate air bubbles.

> You will need a suitable throwing clay to make this pitcher, but it can be either earthenware or stoneware—red or white in color.

> Have your design sketches somewhere close by to refer to as you throw the pitcher—having a visual reference will help keep the shape and proportion true.

Traditional country-style pitcher

1 Start by centering your clay on the wheel (see page 188), then, holding the right hand around the side, press your thumb down into the center to open it up. Use the fingers of the left hand as added pressure and to steady the thumb as you perform this action.

2 Using both hands in the position shown, continue to open the clay to form a base about two-thirds the width of the wheel head with a thick wall at the side. If you are unsure about the thickness at the base, insert a needle to measure the depth. Once opened to the required width, run a finger over the base several times to compress the clay.

Traditional country-style pitcher continued

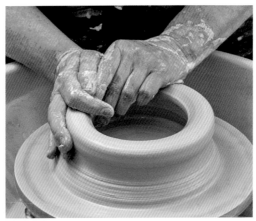

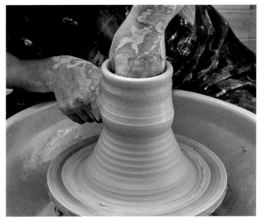

3 Lift the wall of clay between the fingers and thumb of your left hand, using the right hand to push up the clay and support the wall so that it doesn't expand outward too far as you lift.

4 With the fingers of one hand inside the form and the knuckle of the forefinger of the other hand on the outside, begin to lift the clay. Position the knuckle slightly lower than the fingers on the inside and press it inward to gather up the clay and prevent it from splaying out.

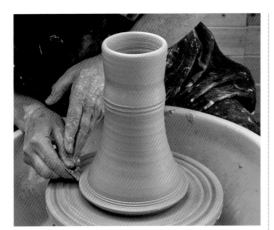

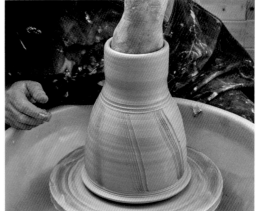

5 Once you have lifted the wall to approximately 12 in. (30 cm), score two lines close together about one-third of the way down from the rim using the tip of a metal or wooden rib. Score another line, about ½ in. (12 mm) up from the base, then, holding the rib at an angle, undercut the clay at the base to form a miter—this will leave the edge at the base as a raised feature.

6 Optionally, at this point you can add textural detail to the lower two-thirds of the pitcher if desired, then using one hand only with the wheel turning quite slowly, belly out the body from the base to the lines scored two-thirds up.

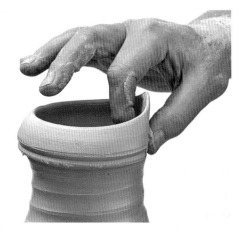

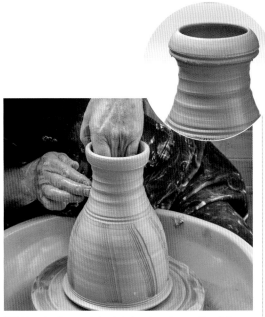

7 Using the fingers of the right hand on the outside of the pitcher to apply pressure inward, lift the remaining one-third of wall between the finger and thumb of the other hand until a slightly thicker rim is left at the top. Now, working on the thicker section only, using the fingers of one hand and a rib in the other, belly the rim outward slightly, then close it in again.

8 To create the lip of the pitcher, moisten your fingers, then gently pinch and lift the clay between finger and thumb on one side of the rim. Repeat the action until the lip is raised in a neat, rounded, half-moon shape.

The finished throated lip is the perfect shape to channel liquids well, and the slightly closed rim not only suggests containment but is actually a practical aid to keeping fluids cold.

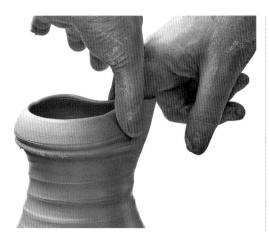

9 Pinch the lip of the pitcher together slightly between the finger and thumb of one hand, then insert the forefinger of the other hand as far as it will go, as shown, and gently belly out the wall to make a throat. As you remove your finger, curl the outer edge of the lip over slightly for good pouring. Wire the underside of the pitcher and lift onto a bat to dry.

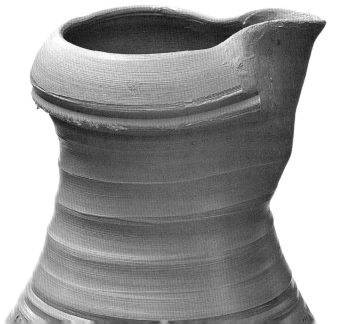

Design options
Coiled variations

1 ROUND-BELLIED MILK PITCHER

The base of this form has been made in a mold, then coiled up to the rim and cut back to form a wavy edge. The foot is a simple round coil.

Lip: The lip has been throated slightly to better channel the liquid content.

Handle: The handle naturally extends from the body and curves around to form a comfortable loop for lifting.

2 TALL, WAISTED PITCHER

The double-cone shape is made in two halves from flattened coils using an outline former to replicate the shapes. The sections are joined at the waist and secured on a slab base.

Lip: This lip incorporates a bar at the rim to prevent solids like ice cubes from escaping.

Handle: The strap handle is shaped and firmed up prior to fixing to the body to prevent it from distorting once in place.

3 TINY, SPOUTED PITCHER FOR OIL OR VINEGAR

This little pitcher is perfect for small volumes of fluid and is made from a pinched base section with added coils.

Lip: A spout like this is simply made by wrapping a thinly flattened coil around a piece of wooden dowel.

Handle: Two flattened and impressed balls of clay attached to each side of the pitcher give a perfect grip for lifting without a handle.

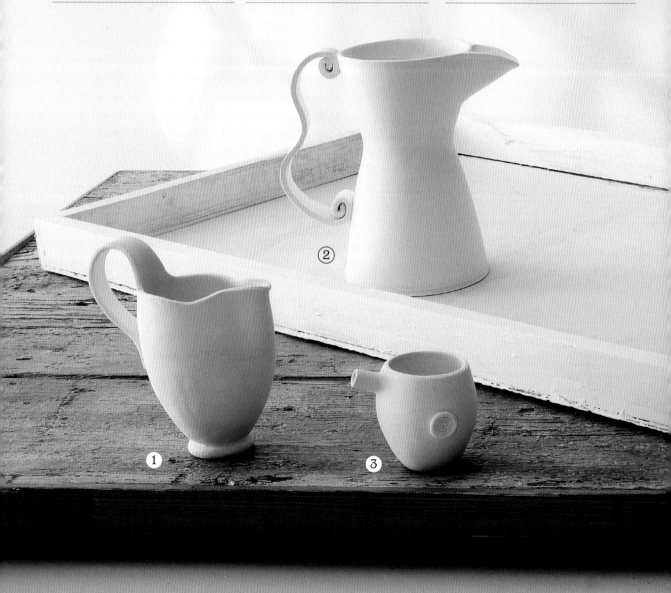

4 AMPLE, ROUNDED PITCHER

This form is built up from a slab base using flattened coils and an outline former to keep the shape. The foot ring is added as a round coil, then turned using a loop tool to create the feature detail.

Lip: Formed just enough to control flow well but not to detract from the overall shape.

Handle: A double-coil handle gives this large pitcher extra strength to lift when full.

5 SAUCE BOAT

Flattened coils attached to a slab base are used to build the walls of this form. The rim is cut in a wavy line and completed with a round coil.

Lip: The small lip is perfect for a container serving thicker liquids.

Handle: The sturdy coil handle is secured to the inside of the boat and then curves around to the base.

6 MILK PITCHER

Built from a slab base using flattened coils and an outline former to keep the shape, a rolled coil completes the rim. A good shape for keeping liquids warm.

Lip: The beak-like lip is made from two sections of flattened coil to minimize drips.

Handle: A thin, decorative coil wrapped around the top of the handle gives a natural grip point for the thumb when lifting.

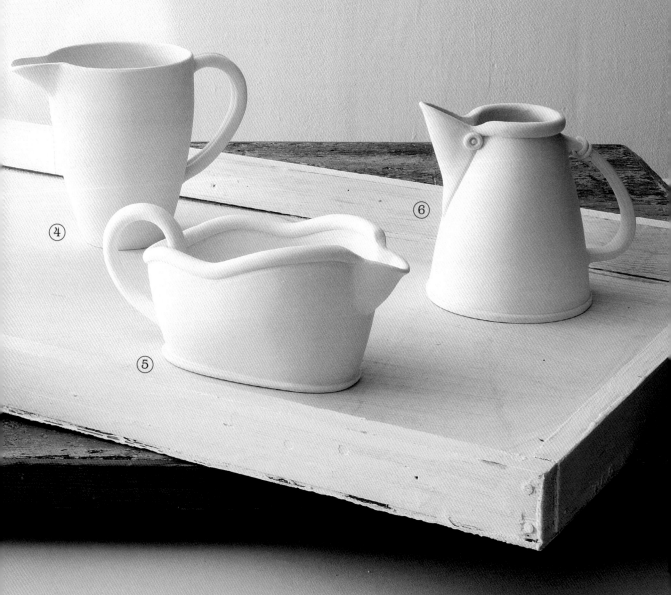

Technique
Coiled pitcher

This pitcher is constructed with the aid of a plaster mold, and is really part slabbed, part coiled. It is perfectly acceptable to combine making methods and many established potters do this, myself included. You can buy ready-made molds from a ceramic supplier if you do not have the skills or time to make your own.

Look for a one-part press type, which may be available specifically for pitchers, although it is more useful to buy a vase or deep bowl shape because it will be multifunctional.

 If you don't have a mold, or are unable to purchase or make one, the pitcher can be made entirely freehand. It will be a little trickier, but the process is the same as for the coiled mug (see pages 42–45). You would need to make a template former to keep the shape up to the point where the decorative coils are applied; thereafter the former cannot be dragged around the wall because it would distort the decorative finish, but it can be used as an indicator of shape by standing it next to the form.

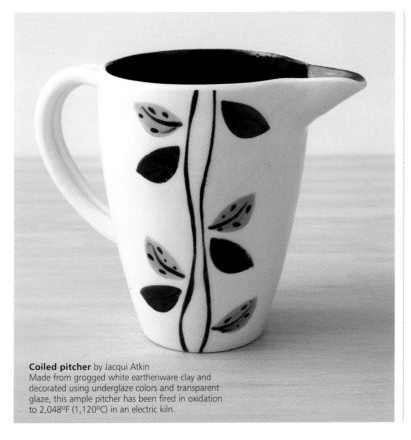

Coiled pitcher by Jacqui Atkin
Made from grogged white earthenware clay and decorated using underglaze colors and transparent glaze, this ample pitcher has been fired in oxidation to 2,048°F (1,120°C) in an electric kiln.

Molded and coiled pitcher

1 Cut two large semicircles of clay from the slab and gently ease them into position in the mold so that the edges overlap. Use a barely damp sponge to ease the clay into position in the mold, and patch any areas where there are gaps. Using a thumb, or wooden tool if preferred, blend the clay surfaces together thoroughly, then smooth over the surface with a rib, removing any excess clay in the process.

BEFORE YOU BEGIN

This pitcher can be made very quickly if you prepare everything in advance.

> Roll out a slab of clay using roller guides to make sure the thickness is even.

> Roll several long coils in soft clay, fractionally thicker than the slab. Keep all the clay on plastic and cover until ready to use to prevent the coils from drying out too much.

> Curl a number of the coils into spirals.

> Position the mold on a sculpting wheel.

Be aware that you do not have to build the shape to the full height of the mold—the technique will work up to any level with the potential to make a range of sizes.

You have several options for construction: you can leave out the decorative element altogether if preferred; build the whole pitcher in decorative coils; or make the entire form from rolled coils blended in on both sides—some makers like to leave little decorative areas exposed like little windows in an otherwise smooth surface.

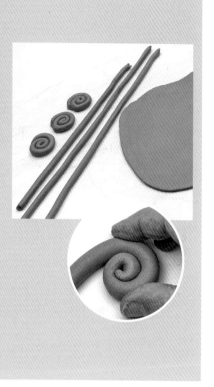

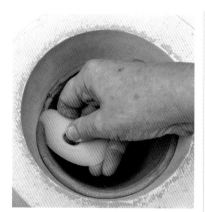

2 With the mold in place on the sculpting wheel, use a soft plastic or wooden rib to carefully level the rim of the pitcher. If you decide on a level and hold your hand very steady, the clay will cut away neatly as you rotate the mold. Do not use a knife as it will cut into the plaster and spoil your mold or, worse, contaminate the clay with plaster that could cause explosions in firing.

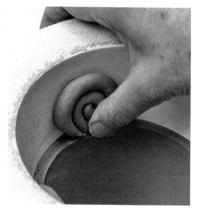

3 Still working inside the mold, carefully score the rim of the pitcher, then position three coil spirals around the edge so that they are equally spaced. Once happy with the spacing, apply a dab of slip to the underside of the spirals and fix them in place on the rim.

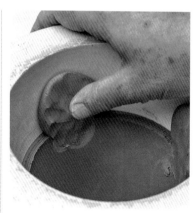

4 Very carefully blend the clay of the spirals onto the base section using a thumb.

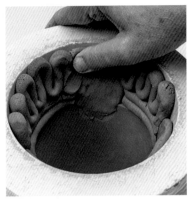

5 Using the remaining pre-rolled coils, fill in the areas between the spirals with a pattern of your choosing. The coils can be simply laid on top of one another or made into more spirals or snakes. You can use small balls of clay to fill gaps, but the key to success is to ensure there are no weak, unfilled areas.

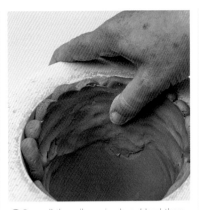

6 Once all the coils are in place, blend them together as before so that they are securely fixed onto the rim. Smooth over the blended clay with a rib or kidney to remove lumps, bumps, and any excess clay. The clay should be the same thickness as the base section when you have finished. Turn the body out onto a board.

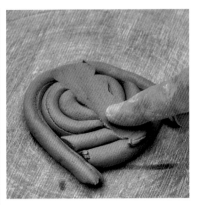

7 Make the lip for the pitcher separately using the remaining coils. Arrange the coils on a board in a decorative semicircle. Try to repeat the pattern on the body if possible, since it will look more polished when finished. Blend the coils together and smooth over the surface.

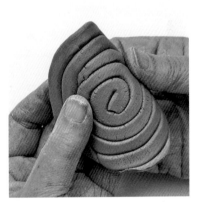

8 Lift the lip off of the board and gently curve it into the correct shape.

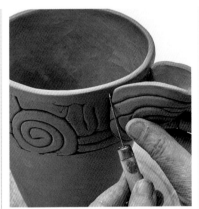

9 Allow the lip to firm up to match the clay of the body. Test the lip next to the body for the correct size: if too large, cut it down until it balances better; if too small, you may need to make another slightly larger. Holding the lip against the body, use a pin to mark the lip's outline on the body.

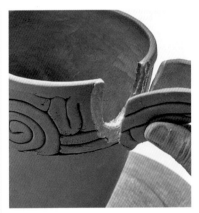

10 Draw another line within the one marked to approximately match the thickness of the clay of the lip, then carefully cut out this inner section. Score and slip the area the lip will be joined to and the edge of the lip itself, then fix in place, applying some pressure to ensure a secure join. On the inside of the lip use a soft coil of clay to seal the join, then neaten the surface with a rubber kidney.

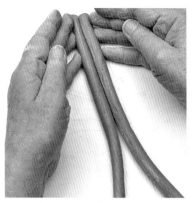

11 Make a double-coil handle using the remaining coils. Score and slip a thin line down each coil, then carefully join them together, taking care not to squeeze them too much to avoid distorting the shape.

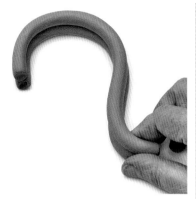

12 Turn the coils on their side so that they sit on top of one another, then form them into the shape you want them to be on the pitcher. Allow the handle to firm to a point where it is easier to lift; a blow-dryer is handy to speed up this process.

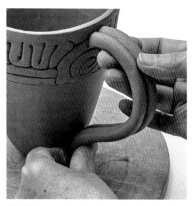

13 Measure the handle against the pitcher body and cut down to size if necessary. Mark the position for the handle on the body exactly opposite the lip. Score and slip all surfaces to be joined together and fix into place. Hold the handle for a few seconds to ensure it is secure, then carefully wipe away any excess slip.

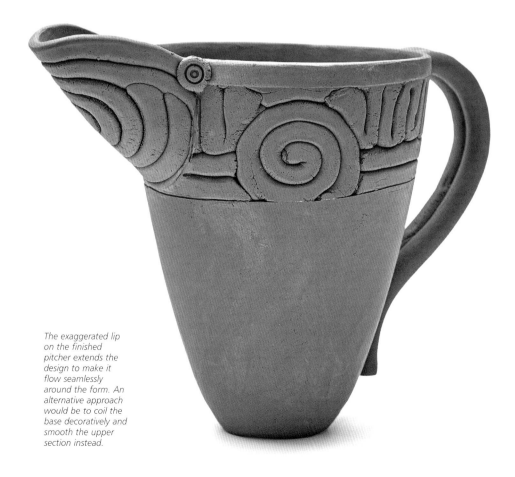

The exaggerated lip on the finished pitcher extends the design to make it flow seamlessly around the form. An alternative approach would be to coil the base decoratively and smooth the upper section instead.

1 SMALL MILK/CREAM PITCHER

Inverted cone shape. Made from a soft slab using a template, the bellied shape is developed once the edges are joined, which requires the clay to be quite soft. It has a sturdy, flat base.

Lip: The generous, beak-like lip is made from a separate slab.

Handle: A simple strap handle curves upward from the rim, giving visual lift and balance.

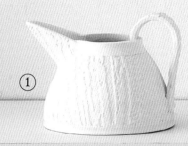

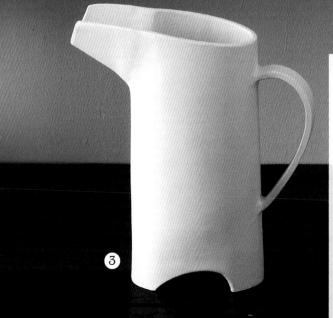

Design options
Slabbed variations

2 SEMI-ENCLOSED WATER PITCHER

Made from a soft slab formed into a cylinder. The rim detail is made by squeezing the sides together for half of the circumference, then cutting at an angle. It has a flat base for sturdiness. The shape is perfect for keeping liquids cool.

Lip: A wide and generous lip extends above the rim to align and balance with the handle.

Handle: Designed to fit the fingers when lifting.

3 TALL, OVAL WATER PITCHER

A simple-to-make shape formed around a cardboard cylinder, then reshaped to an oval. The base is recessed, allowing the sections at the base to be cut to form a decorative feature and foot.

Lip: The generous lip extends very slightly higher than the rim, and is cut off squarely at the end.

Handle: A simple but sturdy strap handle ensures ease of lifting when the pitcher is full of liquid.

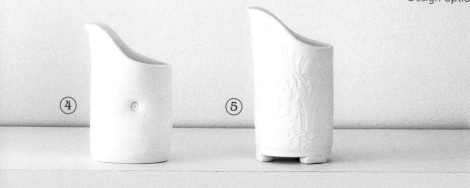

4 VERY SMALL CREAMER

This form is cut using a template shape and made from a soft slab, bellied out very slightly after the seam is secured. A flat base gives the form a pared-down aesthetic, making it suitable for any table.

Lip: This is gently manipulated at the tip to maximize good pouring action.

Handle: Two small decorative indentations on either side give a natural place to hold the pitcher.

6 SLIM OIL OR VINEGAR PITCHER

Press-molded parts in two halves, the base of this pitcher is raised at each end to give the form visual lift, but the central section is flat and quite sturdy.

Lip: The flow of liquid from this two-sided form is naturally facilitated by simply cutting the rim at a curved angle.

Handle: This narrow number "9" strap handle is comfortable to hold and perfectly fits the form.

5 SMALL CREAMER

A straight-sided form made from a soft slab using a template to cut the shape accurately. Flattened balls of clay cut level with the sides form simple feet.

Lip: The lip is integral to the shape but can be gently manipulated to give a better pouring action if the clay is soft enough.

Handle: This little creamer is small enough not to need a handle.

7 CYLINDRICAL, OIL-CAN STYLE PITCHER

Made from a soft slab formed around a cylinder, then altered to an oval shape. It has a flat base, cut slightly larger than the body to give the impression of a foot.

Lip: More a spout than a lip, and made from a small cone positioned so that the top is raised slightly above the rim.

Handle: A simple strap attached to the spout gives added stability to the form.

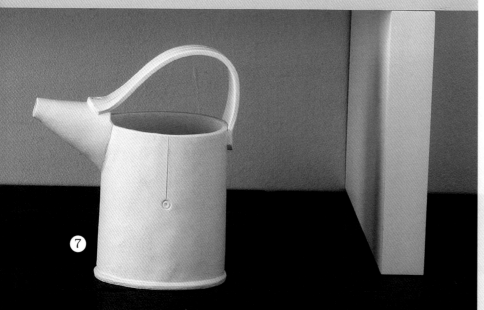

Technique
Slabbed pitcher

Slab pitchers can be made in a multitude of ways—from hard or soft slabs—in complex, multiple parts or simply from one main section. They can be made in plaster or other types of mold, formed around tubes for basic cylinder shapes, or blocks of wood.

This step-by-step sequence demonstrates just one of the above methods: how to make a pitcher from a soft slab of clay. It is a technique that is really simple once you get used to handling soft slabs, and using a template means the shape can be repeated over and over again to the exact proportions.

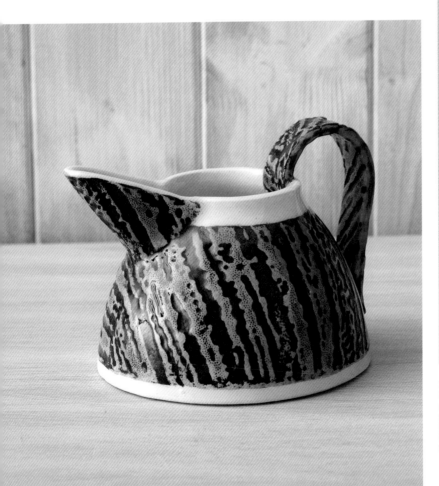

BEFORE YOU BEGIN

You first need to decide what size you want your pitcher to be, a decision dictated by what the pitcher will be used for.

> A small creamer has a height of 3–4 in. (7.5–10 cm).

> A small milk pitcher has a height of 4–6 in. (10–15 cm).

> A medium, multi-use pitcher has a height of 8 in. (20 cm) and would hold 1 pint (0.6 liters) of liquid.

> A large water pitcher has a height of 12 in. (35 cm) and would hold 2 pints (1.2 liters) or more.

Clay weight is difficult to gauge for each size, because it depends on the thickness of the slab an individual prefers to work with.

Make a paper template by drawing a large circle on a sheet of paper or cardstock—textured paper is used in this example, but it does not need to be. Draw an inner circle to the approximate height you require the pitcher to be. Cut the ring of paper out and cut one line from the outer edge to the center. Overlap the edges of the paper ring to form a cone shape the size you would like the pitcher to be. Mark the position, then cut out this shape: it should be roughly one-third of the size of the entire ring, but can be larger.

Slabbed pitcher by Jacqui Atkin
Formed from a textured soft slab of white earthenware clay, this small pitcher is the perfect size for serving milk with tea. The texture has been inlaid with multiple layers of underglaze color, before covering with transparent glaze. It was fired to 2,048°F (1,120°C) in an electric kiln.

Soft slab pitcher

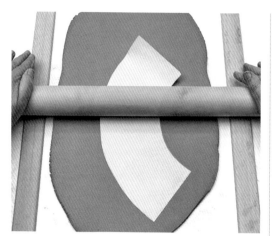

1 On a sheet of plastic, roll out a slab of clay large enough to fit the paper template you have made. If using a textured paper template, now roll this into the clay surface, with the textured side facing down. If not using texture, the template will be used simply as a cutting guide.

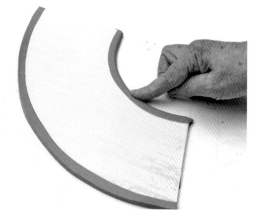

2 With the slab still in place on the plastic sheet, cut around the template, allowing about ¼ in. (6 mm) extra at both the top and bottom of the slab. If not using textured paper, simply cut the slab to the size of the template. Leave the template in place and use a finger to smooth the edge of the clay at what will be the rim. It is easier to do this now than later as the slab is in a position where it can't move easily and you can apply a little pressure without distorting the shape. Remove the paper template.

3 Miter the upper edge of one end of the slab using a thin ruler to make a straight cut, then, with the ruler still in position, carefully score the edge with a serrated kidney or similar tool. Turn the slab over by lifting the plastic sheet and repeat the mitering and scoring process on the underside at the opposite end.

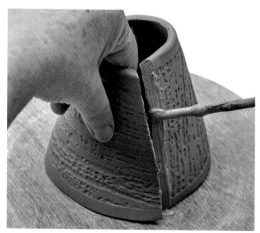

4 Lift the slab off the plastic and carefully form into a cone shape on a wooden bat. Holding the shape with one hand, slip the mitered edges and join them together carefully, taking care not to squash the textured surface if possible.

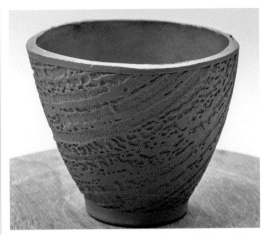

5 Turn the pitcher upside down into an inverted cone shape and smooth the joined edges on the inside using a rib or wooden modeling tool. When you are sure the join is secure, support the side of the pitcher with one hand, then use a rib to start to belly out the shape from just below the rim to the base.

6 Work around the side evenly, repeating the bellying action until you are happy with the shape.

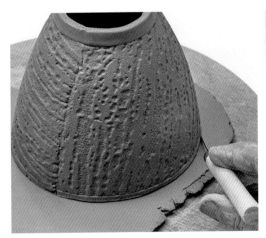

7 Roll out another slab of clay for the base and transfer it to a wooden bat. Turn the pitcher up the right way and sit it on top of the slab. Mark the circumference of the base on the slab with a pin, which is easier to do if the bat is on a sculpting wheel. Cut the slab to the marked size, then score and slip the outer edge of the slab where the body will sit, and the base rim of the pitcher, then fit them together. Wipe away any excess slip and neaten the join with a rib or similar tool.

8 Roll out another small section of slab exactly as you did for the body: if using textured clay, leave a smooth section at the rim. Cut a semicircular shape to the size you want the lip to be, then carefully bend the section into a curve. Fit the lip to the body to check it is the correct size and mark the position on the body with a pin.

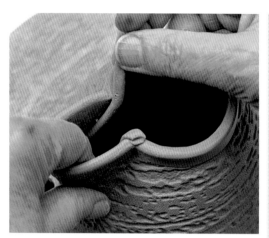

9 Cut the section for the lip out carefully from the body of the pitcher, then score and slip all surfaces to be joined and fix the lip in place. Reinforce the inner join of the lip to the body with a coil of soft clay. Blend the coil in to create a seamless finish.

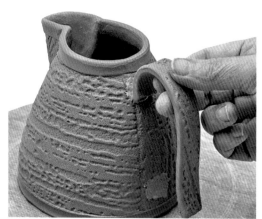

10 Cut a simple strap handle from a slab of clay—a ruler or wooden roller guide is a good width to cut the strip to. Mark a position for the handle on the body exactly opposite the lip. Score and slip all surfaces and fix the handle in place. Carefully remove any excess slip around the joins, taking care to avoid spoiling textured surfaces. A wooden modeling tool will do the job well.

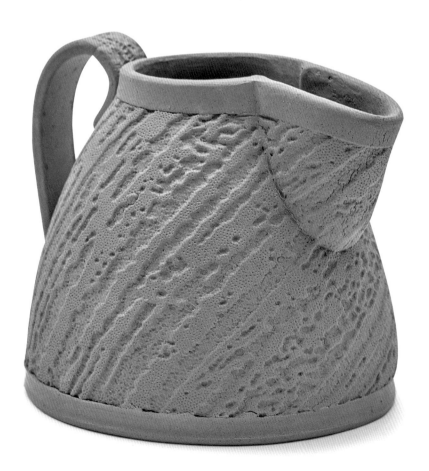

This little pitcher is the perfect size for any number of uses, but could easily be made in several sizes using the same technique to form a range for every possible use.

Technique
Slabbed creamer

Slabbed creamers are relatively easy to make, providing you have confidence in handling soft slabs. However, even if you are inexperienced in this technique, the smallness of the vessel makes the manipulation of the clay reasonably easy.

The basic technique demonstrated here can be adapted to many forms, such as larger pitchers, bowls, teapots, and any number of useful kitchen or household items.

Slabbed creamer by Jacqui Atkin
This creamer was made from a single slab of textured clay, then colored by masking off areas carefully to form a patchwork effect using velvet underglazes. White earthenware clay provides a good base for colors to show true. Fired to 2,048°F (1,120°C) in an electric kiln.

BEFORE YOU BEGIN

Make a paper template: the one used here measures 4¾ in. (12 cm) high at the central point; 3⅛ in. (8 cm) high at each end/shoulder; and 8¼ in. (21 cm) wide.

Soft slab creamer

Adapting the shape

You can adapt the basic shape of this creamer in several ways at various stages of the making process. Here are some ideas:

> The rim can undulate to add character to the overall form: just make sure when you are cutting the template that the ends where the edges will join are the same height.

> The shape can be made to belly more, which would make it slightly wider.

> A handle could be attached.

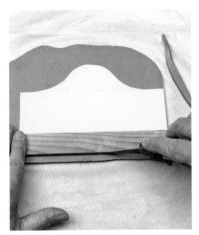

1 On a sheet of plastic, roll out a slab of clay large enough to accommodate your template. The creamer will look better if the slab is relatively thin, but this does make handling more difficult, so roll to a thickness you are confident with. Place the template on the clay and cut around the edges using a roller guide to cut straight lines where the shape will allow. Reserve the spare slab for making the base later.

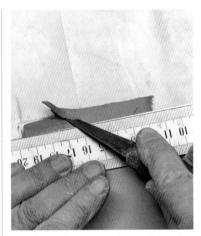

2 Using a ruler as opposed to a roller guide, positioned about ⅜ in. (1 cm) in from the edge of one short end of the clay shape, cut an obtuse miter. With the ruler still in place, score the mitered edge using a serrated kidney or similar tool. Now flip the shape over onto the opposite side, which will be easy because the clay will stick to the plastic until turned over. Repeat the mitering and scoring at the opposite end.

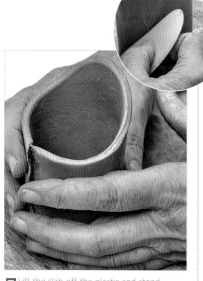

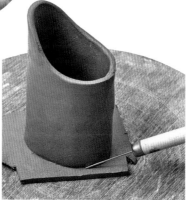

3 Lift the slab off the plastic and stand upright as shown. You will find that the clay will hold its shape once formed into a round. Carefully slip the scored edges, then overlap them and seal together, making sure no air is trapped in the join. Wipe away excess slip and smooth over the join both inside and out using a kidney or rib.

4 At this point the creamer's shape can be left round, or formed gently into an oval as here. To make the base, place the shaped creamer on the slab reserved in Step 1. Using a pin, gently score around the body to mark the base. Remove the creamer body and cut out the base shape.

5 Score around the edge of the base section and the base rim of the creamer. Slip both surfaces and join the two together. Lift the creamer and tap it down on the surface of the board a few times to make sure the join is secure. If you can, reinforce the join on the inside with a coil of soft clay. Use a round-ended tool to make sure the coil blends in well.

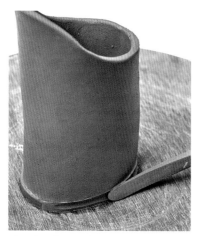

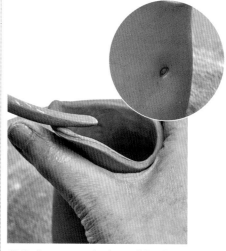

6 Make a feature of the base join on the outside by running a round-ended, wooden modeling tool around the edge to give a slightly concave line. Keep the tool resting on the board as you do this to ensure the line is straight and even. You could make a different base edge feature if preferred by impressing the tool at regular intervals around the edge.

7 Using your hand, or a rib, or kidney if your hand won't fit inside the creamer, gently belly out the clay walls to a shape that pleases you. This will give the shape a more fluid, softer look, but is not strictly necessary if you like the shape as it is. If the clay is soft enough, the shape can be manipulated quite considerably. Work around the walls in regular movements to achieve an even distortion.

8 Finally, neaten up the rim carefully using a rib or kidney to gently round off the edges. Now, with your hand holding the creamer and your thumb underneath the lip, gently ease it into a pleasing pouring shape. The clay should still be soft enough to manipulate easily, but if it has firmed up, use a wet finger to do the shaping instead of the wooden tool shown here. Use the end of a pen to make two small impressions on either side of the creamer to mark a convenient point for lifting.

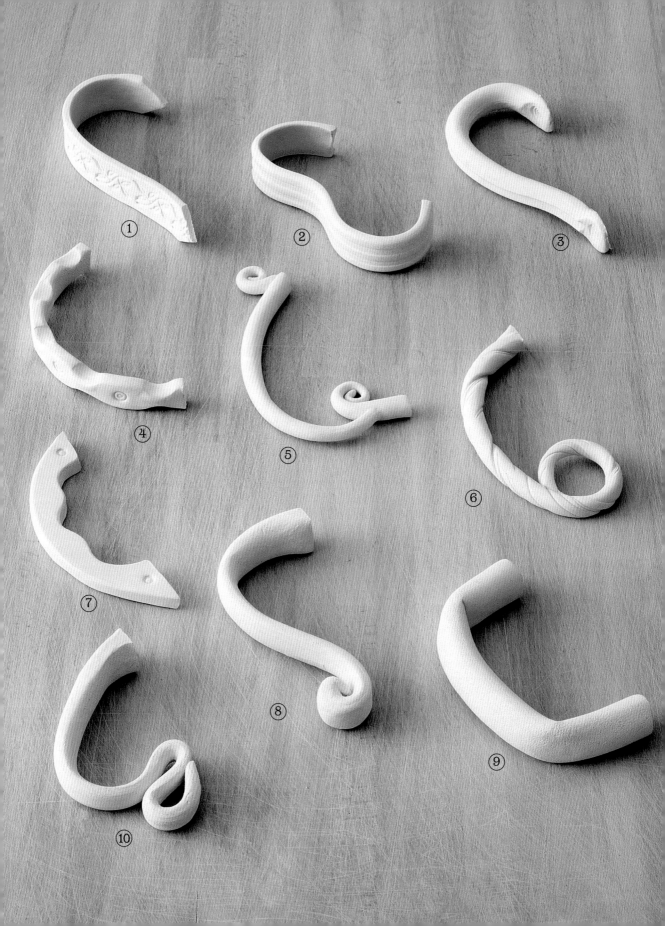

Design options
Coiled, slabbed, and pulled handles

1 SLABBED STRAP

Cut from a rolled slab to the width of a wooden batten, this handle is quick and easy to make. The edges should be smoothed to take away any sharpness that may result from cutting, and the surface can be textured if required. Each end is cut to a half diamond shape as an alternative finishing detail.

Suitability: Pitchers made by any of the making methods. Cut according to the size of the pitcher.

2 FLATTENED COIL STRAP

This handle is quickly made from a flattened coil. Use a wooden batten or ruler to cut an even strap once the coil is flattened. Smooth the edges with the fingers to remove any sharpness. Form the strap into the required shape and allow to dry to leather-hard before attaching.

Suitability: Pitchers made by any of the making methods. Suits curvy forms particularly, but can be attached to any shape to add character.

3 PULLED

This is a generic pulled handle of the type typically made for thrown wares. The shape is practical and sturdy, and could be pulled from the pitcher or made separately and attached at the leather-hard stage.

Suitability: Most suitable for thrown wares but could be attached to pitchers made by other methods. Would look best on a simple, country-style pitcher.

4 SLABBED AND PINCHED

Cut from a thicker-than-average slab, the handle is pinched in along its length at regular intervals to give a wavy edge. This is a very comfortable handle because the notches provide extra grip when lifting.

Suitability: Sturdy and practical handle for larger slabbed pitchers, but would work on those made by other methods, if the style is appropriate.

5 COILED IN PARTS

This ornate handle is made in three parts. Each section of round coil is rolled to a thinner taper at one end. The handle is assembled on a board and the sections joined meticulously to avoid cracking in firing.

Suitability: Tall, elegant, curvy shapes best suit this type of handle. The pitcher can be made by any method.

6 COILED AND ROLLED

Made from a coil, rolled to thin toward one end. The coil is textured with the edge of a wooden batten as it is rolled to give a barley-twist appearance. The shape is formed on a board and allowed to firm to leather-hard before attaching.

Suitability: Pitchers made by any of the making methods, but looks best on a curvy form.

7 TEMPLATE SLABBED

This handle is quickly made using a template as a guide to cut the shape out. The outer curve of the handle is smooth and even, but extra grip is achieved by the wavy inner edge that perfectly fits the fingers.

Suitability: Particularly suited to angular slabbed pitchers, but in varying proportions could work with many shapes made by any method.

8 PULLED AND CURLED

Made in the standard way by pulling from a thick coil of clay, this handle can be made in advance, then attached to the pot, or pulled directly from the pot itself. The clay is thinned toward the lower end as it is pulled, then a small section curled back to form a disproportionate "S" shape. The curl can be more exaggerated if required.

Suitability: Sturdy handle suitable for tall thrown pitchers, but could be applied, in different proportions, to pitchers made by other methods.

9 HOLLOW SLABBED

Made from a very thin slab formed into a tube around a piece of wooden doweling. When the tube is complete the shape is formed by bending it over a sharp-edged item—such as a ruler—at each end to the required size. You get no second chances with this type of handle, since the shape cannot be changed once formed.

Suitability: Looks particularly good on simple, solid, slabbed forms, but would work on coiled or thrown forms if in correct proportion.

10 PULLED AND SHAPED

The clay in this handle has been pulled and flattened in the traditional way before being manipulated into a decorative shape at the base. The length is thicker at the top, then tapers to a thinner end to give a delicate quality. It can be pulled directly from the pot or made separately and joined when leather-hard.

Suitability: Mainly thrown pitchers, but would work on curvy coiled forms.

Technique
Handles for pitchers

The most common method of making handles for thrown items is to pull them from the pot, but it is perfectly acceptable to attach coiled, slabbed, extruded, or rolled versions. What is important is that the handle is in good proportion to the body of the pitcher, and that it is securely attached and strong enough to hold the weight of the pitcher when full of liquid.

This is a particularly important detail when designing any form of functional ware because so often a really good body shape is spoiled by an inadequate handle, which may look good but is not fit for purpose. Another important detail is that the handle is comfortable to lift—difficult shapes could be a serious health risk, especially if the contents of the pitcher are hot.

Planning

The most important things to consider when planning your handle design are:

Proportion: The handle must be the correct size for the pitcher.

Shape and balance: Relating the shape of the handle to the body will give balance to the form.

Suitability for size, shape, and purpose: Consideration of the primary function of the pitcher in advance of making will determine how sturdy the handle will need to be: the larger the pitcher, the more robust a handle will be required. Think about the weight of the pitcher when full of liquid.

Making method: Handles made by any method can be attached to items made by any method providing the rules above apply.

BEFORE YOU BEGIN

> Refer to the section on pulling handles for cups and mugs (see pages 52–53) to see how to start the process of pulling clay for handles on thrown items.

> The pitcher should be leather-hard before attaching the handle because you will need to lift it and it should be able to hold its shape.

> Roughly mark an area opposite the lip where the top of the handle will be attached. Laying a ruler across the rim from the lip to the opposite side will help you measure the correct spot accurately. This is helpful for positioning any type of handle.

Pulled handle for thrown pitcher

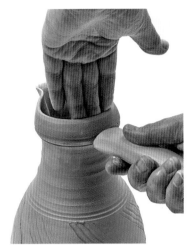 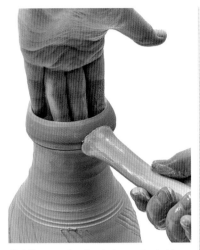 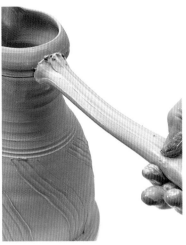

1 Snip off a section of handle about 6 in. (15 cm) long from the pulled length of clay. Score and slip the position it is to be attached to, then gently push the end of the handle onto the pitcher. Support the rim from the inside with the other hand as you press the clay into place.

2 Still supporting the pitcher on the inside with one hand, pull the clay gently but firmly away from the body between your fingers and thumb. Use enough water to ensure the clay slides easily because if it drags the handle may pull off.

3 Continue to pull the handle until you have enough length to curve it around to create a pleasing shape, then, using the thumbnail or a wooden tool, score several lines along the length.

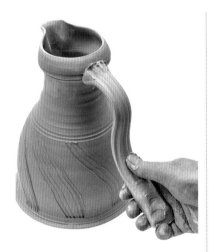 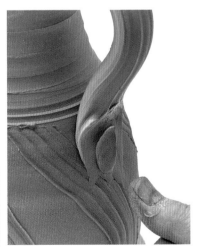 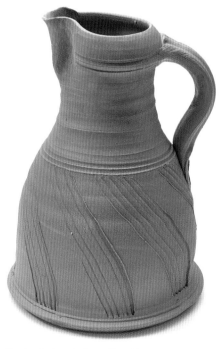

4 Sit the pitcher on the work surface with the lip pointing away from you, then curve the handle around and, making sure it is in line, press the lower end onto the pitcher wall. You can score and slip beforehand, if required, but the handle will be quite moist from the pulling action so should not require it. Snip off excess length between your fingers.

5 Smooth the clay at the base of the handle onto the wall of the pitcher, making sure it is fixed to the surface properly, then make two thumb or finger prints in the clay as a final detail. Finally, neaten up the join at the top of the handle with a damp sponge.

The handle is perfectly positioned to give maximum control when lifting and pouring. It has a sturdy thickness for good grip and to accommodate the weight when the pitcher is full.

Chapter 4

PLATES & PLATTERS

Plates and platters
Design decisions

How important is a plate? Surely, it is just a surface to serve food on? Or is it? Whether for dining or serving, a well-designed plate can really enhance the dining experience.

The plate close up

A good plate will show off food to perfection. It should be the staging for the work of art that is the food. It should look beautiful on the table and be practical in all aspects of its use.

The plates are finely thrown in quite a thin section but, fired to stoneware temperatures, they have the contradictory appearance of being both delicate and robust.

The rim of the plate is raised sufficiently to allow liquid foods to be contained. It is neither too wide nor too narrow, and the surface decoration is subtle and understated to avoid detracting from the food to be served.

The surface area for food on each plate is wide and generous. Unembellished by decoration, it is the perfect backdrop for food.

The surface treatment on these plates is aesthetically very pleasing and cleverly minimal, further adding to the sense of robustness. From base to neck, they are simply bellied out from a basic cylinder.

Thrown to a traditional round shape, these plates are made very contemporary by a subtle texturing technique and simple glaze treatment.

The platter close up

The difference between a plate and a platter lies not only in size but in usage. You would not use a platter to dine from, for instance, but you would use it in the center of the table to present or serve food from. You might also use a platter as a tray to carry things on, so its functionality extends beyond the serving of food, making it a very useful item to have in the kitchen.

The minimal rim has been cleverly designed to maximize the surface area on which to serve food.

To ease lifting, the rim is extended at each end to form handles. Making handles integral to the form is a good way of speeding up the making process because it saves having to add parts on later.

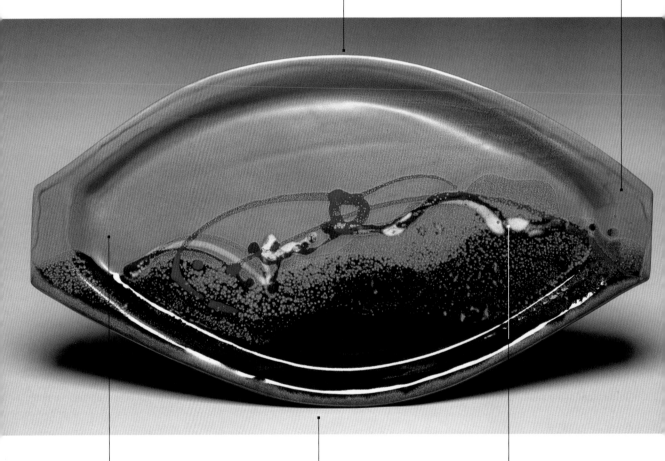

The oval shape of the platter really lends itself to serving a whole fish because it cleverly reflects a fish shape, but the design is not so specific that other foods could not be elegantly served on it.

Made in a slump mold, platters like this can be quickly and easily produced in multiples to exact measurements.

The lovely glaze decoration is rich yet subtle enough not to detract from the food it will serve.

Measuring 18 x 10 in. (45.5 x 25 cm), this platter is designed to serve a whole fish but is large enough to use as a tray for items other than food.

A good plate or platter should be pleasurable to look at in itself and when containing food. It should never compete with the food, but simply provide a perfect backdrop. Added to all these things, plates have to be functional, hard-wearing, and practical, which is a lot to ask of an item that most of us don't really give much thought to.

When making your own, the first thing to determine is how many sizes of plate you require. Most homes will have dinner plates and tea plates, but a good addition is an in-between size often referred to as a dessert plate that doubles as

a small dining plate—a good size for children or simply a small meal.

Serving plates or platters should be added to the list. It can be useful to design them to fit the center of the table, so measure the available space left on a table when the dining plates are in place and design the servingware accordingly.

The following pages will show you how to both throw and hand build plates of different sizes and proportions to accommodate all levels of ability.

Square platter by Nigel Lambert
This large platter has been thrown and altered to create the square shape. The painterly surface decoration is achieved using cobalt and iron oxides. The process of wood firing to 1,980°F (1,080°C) adds a certain charm.

Incised plate
by Marcy Neiditz
We should not confuse functionality with utilitarianism. This wonderful plate is proof that a perfectly serviceable item can also be fantastic to look at. Hand built utilizing a custom-made drape mold, the surface decoration incorporates hand painting with incised sgraffito drawings. The process includes layering of slips, underglaze, and glaze at the green-ware stage before biscuit firing to cone 6. Clear glaze applied to the biscuit plate is fired to cone 5½ oxidation in an electric kiln.

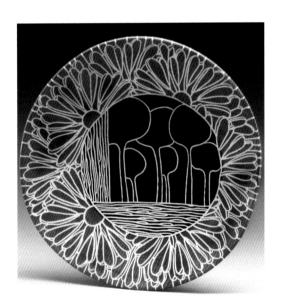

Questions to ask yourself

What makes a good plate?
The answer to this question is entirely dependent on what function the plate is going to perform: what type of food it will serve; what quantity of food; how well does it need to contain liquids, etc. Making considerations might include:
- **Size:** A range might include tea/side plate, medium dessert plate, and dinner plate, plus serving plates in various sizes.
- **Shape:** Round, square, rectangular, or irregular?
- **Making method:** Round plates are quickly made by the throwing method, providing the maker is skilled in the process. They can be altered to change

the shape at the leather-hard/turning stage, although this takes extra time and effort. Mold-made/slabbed plates are also very quick to make with the advantage that molds can be made to specific sizes and shapes, thus requiring very little additional modification after making. Simple materials can be used to make molds other than plaster, which reduces outlay on equipment and materials, but still allows the maker to repeat shapes.

Commercial ceramic suppliers usually have a wide range of plaster molds available as an alternative to making your own.

Where will I store the plates?
Consideration should be given to the practical aspects of home life, so plates should fit in the available cupboard space; they should stack well and safely; and, for everyday family use, they probably need to be robust and dishwasher proof. These considerations should inform shape and size, but also the type of clay you use—earthenware or stoneware—because generally, for durability, the higher fired the clay, the more robust it will be.

Design options
Thrown variations

1 LARGE PLATTER WITH FEATURE RIM

This large platter is designed for center-of-table use. It has a wide rim on which to sit serving implements, while being generous enough to display food well in its center.

Foot: Standard single foot ring, but a larger version may need a second or even third foot turning into the base.

Uses: Multipurpose serving platter.

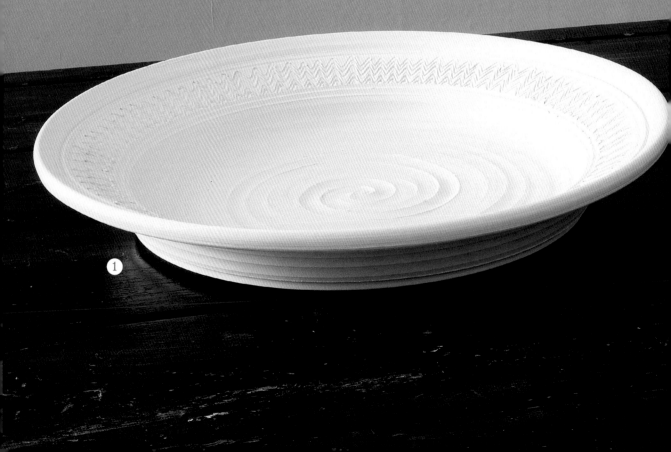

2 ROUND PLATTER

This softly thrown platter has a wide, carefully distorted, undulating rim that is achieved by running a finger under the edge without the aid of the other hand to steady it. Clearly defined throwing lines will be enhanced by glaze at a later stage.

Foot: Standard single, turned foot ring.

Uses: A stylish serving platter or dinner plate for someone with a large appetite.

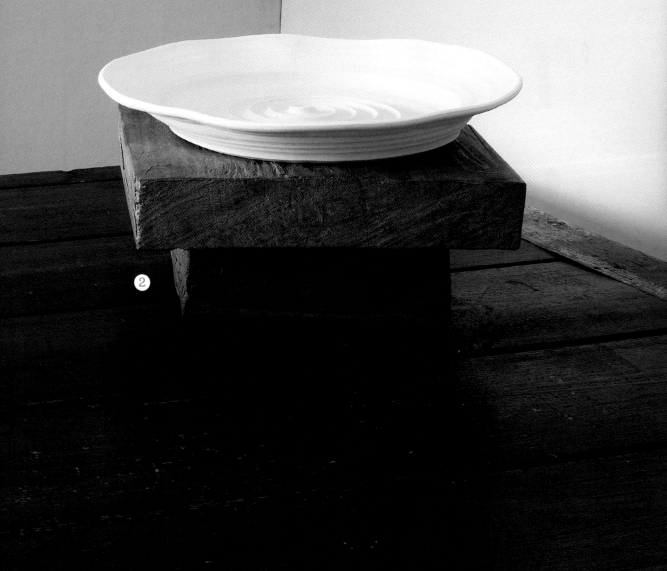

1 DOUBLE-USE PLATE/CAKE STAND

This plate is first thrown with a deep rim to form the walls, which raise the surface when the other way up. When the clay is leather-hard the dish is wired off, then turned upside down and the flat surface turned to a smooth finish. Decorative details are incised into the surface to denote the correct way up of the plate. However, the form also perfectly functions as a deep plate or shallow dish, as shown.

Foot: The walls of the dish form the foot ring and give extra lift.

Uses: Designed for cakes, this plate is also great for serving cheese or fruit when the other way up.

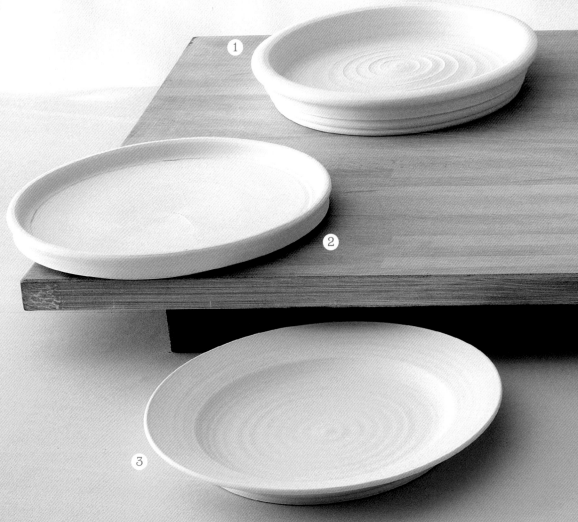

2 WIDE, FLAT-BASED PLATE WITH SHALLOW RIM

Made for serving rather than dining, this plate has a wide, flat base to maximize the surface area for food. The rim has a slight inward lean, giving a strong visual sense of containment.

Foot: None. The shell-wired base is enhanced by simple incised lines at the outer edge that give a very considered and professional finish to the plate and a little delight when turned over.

Uses: Serving plate, useful for foods with some liquid content.

3 STANDARD ROUND DINING PLATE

This is a traditionally shaped dining plate with standard-sized rim for placing cutlery. The making process is accentuated by obvious throwing rings that give a stylized, individual look to the plate. This is a practical shape for stacking and storage.

Foot: Standard turned outer ring.

Uses: Dining or serving.

4 DEEP, WIDE-RIMMED, ROUND PLATE

This plate has a smaller inner surface area for food, but is deeper than a traditional dining plate. The overall size is standardized for dining by a wide, upward-flaring rim to contain the content.

Foot: Standard turned foot ring.

Uses: Most suited for pasta dishes, risotto, paella, etc.

5 WIDE, ROUND PLATE

This wide plate has a shallow rim to maximize the surface area for foods, and is great for meals with a liquid content, such as gravy or sauce. The surface is minimally decorated with incised lines and a small curl formed by a rib when smoothing the inner surface.

Foot: The base is flat and shell wired off the bat for speed of making: not having to turn a foot ring seriously cuts down on making time.

Uses: Dining or serving plate.

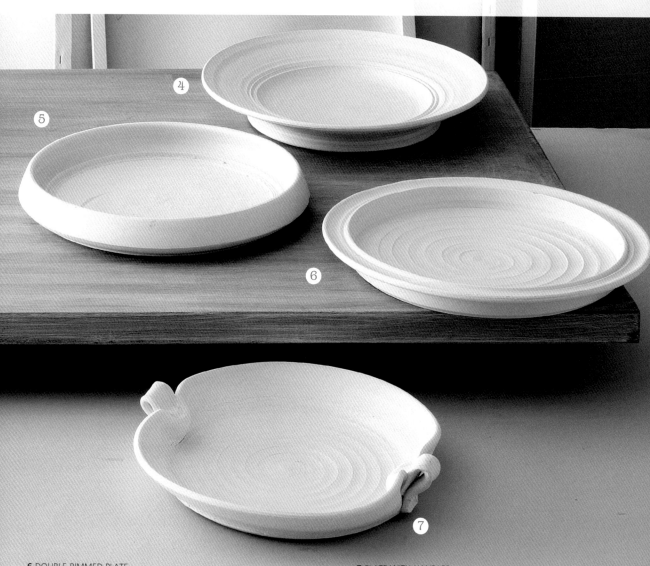

6 DOUBLE-RIMMED PLATE

This wide, open plate is slightly deeper than average with the added feature of a double rim for visual variety and clear demarcation of useful surface area. The obvious throwing lines add further character to this stylized plate.

Foot: None. Flat, unturned base.

Uses: Serving. A center-of-table plate also suitable for oven-to-table use.

7 PLATE WITH HANDLES

This plate has been thrown to a standard round format, then altered at the sides simply by lifting and pulling in the rim.

Handles: Handles have been added as a feature and to make the plate suitable for lifting from oven to table.

Foot: Simple, flat, shell-wired base: sturdy for oven use.

Uses: Perfect for foods that need to be cooked in situ and served directly.

Technique
Thrown plates and saucers

While most pottery can be thrown directly onto the wheel head, it is always better to throw plates and other large flatware on a removable bat to avoid pieces distorting when moving off. Bats allow the items to firm up to a suitable point to handle later for turning foot rings, etc.

Some wheels have fittings on the wheel head to accommodate bats, allowing them to be removed and replaced to always be in center. If your wheel does not have this feature, a bat can be temporarily secured on a pad of soft clay.

Thrown plate by Cressida Borrett
The allium design on this thrown plate has been applied using the sgraffito technique at the green stage. Underglaze and oxides are used for the color detail before transparent glazing and firing to stoneware in oxidation.

Approximate weights and measures for flatware

Item	Width	Weight of clay
Saucer	6¾ in. (17 cm)	Approx. 1.4 lbs. (650 g)
Side plate	6¾ in. (17 cm)	Approx. 1.2 lbs. (570 g)
Dinner plate	10 in. (25 cm)	Approx. 2.4 lbs. (1.1 kg)

The information given represents raw clay weight for throwing and approximate minimum fired dimensions.

Thrown dinner plate

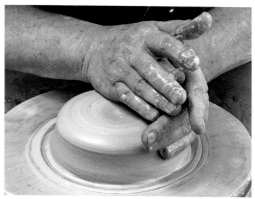

1 Center your clay on the wheel (see page 188), then, with one hand supporting the side, press down with the side of the other hand so that the clay surface flattens and splays across the bat a little.

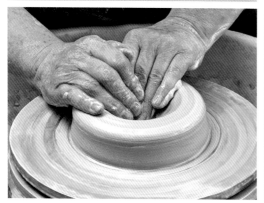

2 Working directly in front of your body, with the fingers of one hand press down into the center of the clay to create a thick wall, while at the same time using your thumb to keep the clay centered. Use your other hand to apply extra pressure and stability. Make sure you leave enough clay at the base to later create a foot ring.

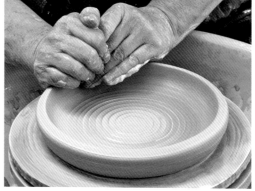

3 Maintaining the position of both hands, with the clay gently held between finger and thumb, draw the clay outward to form a wide, flat base but relatively thick wall at the side. If in doubt about the base thickness, use a pin to measure the depth.

Thrown plate continued

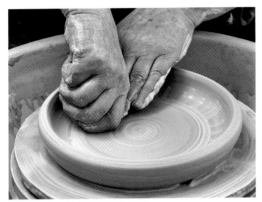

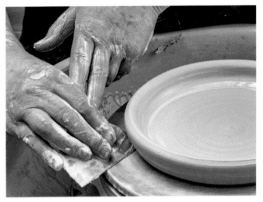

4 Knuckle your forefinger, then run it over the base of the plate several times to compact the clay. This is an important detail when making plates and failure to do it can result in major cracks in either drying or, later, in firing.

5 Remove excess clay from the bat around the outer edge of the plate using a rib or similar tool, then run the rib around the edge of the plate to neaten it up.

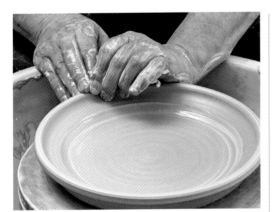

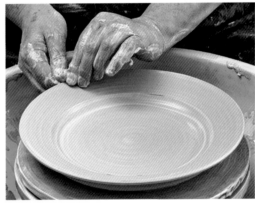

6 Throw the rim using the excess clay at the edge of the plate. Refine the change from the base of the plate to the rim by gently pressing a fingertip inside the clay at this point. Holding the rim between the thumb and fingers of one hand and using the other to keep the edge neat, draw the clay outward and slightly upward to begin with.

7 Carefully repeat Step 6 until the rim is the desired width with a slightly upward turn. Pinch the thumb and forefinger together and run around the outer edge of the rim to remove excess slurry and compact the clay: you can use a thin strip of chamois leather to do this if preferred.

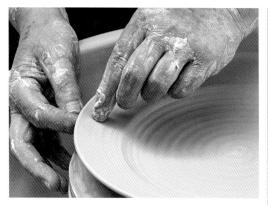

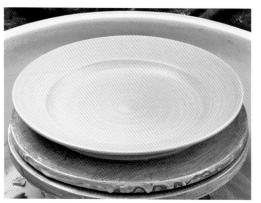

8 You can now use a rib to refine the surface and remove any slurry, or put some surface detail back in by creating obvious throwing lines by gently using a finger. If you choose to do this, be sure to support the rim on the underside with one hand as you work. The next stage is to turn the foot ring (see pages 104–105).

The finished plate should be wired off at the base after throwing, but left in position on the bat until it has firmed up enough to be handled without distorting the shape.

Thrown saucer

To accommodate the different features in a saucer—like the locating ring for the cup at the center—you will need slightly more clay than you would for a plate of the same width.

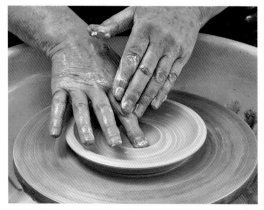

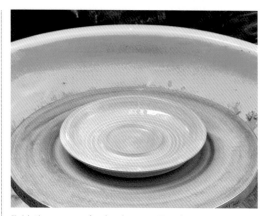

1 Using the suggested weight in the chart, center and throw the clay as for the plate to Step 4, but compact the clay at the base using the forefinger, as shown, to create an inner rim to locate the cup. Measure the cup base using calipers to ensure the locating ring is the correct size (or if making the saucer first, measure the locating ring with calipers, then make the cup to fit).

Finish the saucer as for the plate, or adjust the design for a more defined rim as shown.

Technique
Thrown platters

It is always useful to have larger plates or platters on which to present and serve food. You can make them in many styles, the simplest solution being larger versions of your dinner plates, but to maximize surface area it is better to throw them without a wide rim.

If making platters for personal use it is helpful to plan the size in advance, thinking about the space on your table, for example. When all settings are in place the space in the middle may be at a premium, but you can accommodate this by measuring the area available and making accordingly. It is useful to remember that even thrown forms can be altered to different shapes, so space that is limited for a round platter may better accommodate a square or oval, and even if you are making for other people, it makes good design sense to determine an individual's particular requirements.

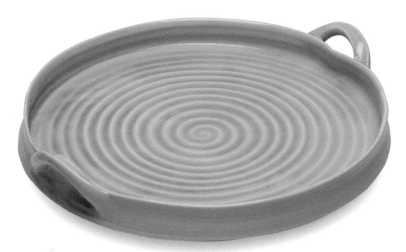

Platter by Gemma Wightman
Hand thrown in porcelain and fired to a high temperature, this lovely, simple platter is covered in a copper turquoise glaze that has pooled in the throwing rings to luscious effect.

BEFORE YOU BEGIN

> Fix a bat to the wheel head as described on page 99.

> This platter does not have a turned foot ring—it looks lovely with a shell-wired underside that can be achieved with a twisted wire drawn from side to side in a wavelike motion when wiring the underside to remove from the bat. An alternative way of creating this effect is to use a serrated kidney—wire the plate off the bat in the normal way, then simply draw across the surface in a wavelike fashion.

> The fact that there is no foot ring means that the base does not need to be as thick as for a dinner plate, and some practice may be required to achieve an adequate clay section that is even. Use a pin to measure from time to time in order to get it right.

> Feet, pulled off the bowl and added on or handmade, can be attached later if preferred as an added feature (see pages 114–115).

> Prepare your clay according to the weights recommended in the chart below.

Approximate weights and measures for platters

Item	Width	Weight of clay
Wide-rimmed platter	12 in. (30 cm)	Approx. 5.5 lbs. (2.5 kg)
Large, wide-rimmed platter	16 in. (40 cm)	Approx. 10.4 lbs. (4.75 kg)

Country-style platter with wavy rim

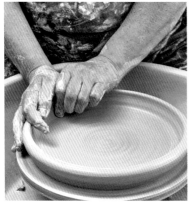

1 Follow Steps 1–4 on pages 99–100. Continue to open the base of the clay to almost the full width of the bat, keeping a thicker section at the edge for the rim as before, but not marking the point where the rim begins. Keep the side true by supporting with one hand as you gently pinch the side wall between the finger and thumb of the other hand.

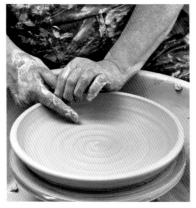

2 Keeping the gentle pinching action with one hand, pull up the wall to form a small curve upward and slightly outward. Place the other hand next to the first with the fingers in a scissor shape, as shown, so that the evenness of the rim is maintained as the wall is lifted. This has the added advantage of compacting the clay for greater strength, as well as keeping the shape.

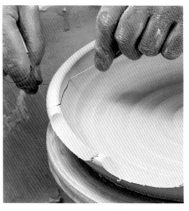

3 Once you are happy with the shape of the platter, clean away excess slurry from the inside with a sponge or rib, from the outside around the outer edge, and from the wheel head. Using a wire held taut between both hands, evenly cut away a series of semicircles around the rim of the platter, leaving a small space between each one. If you are not confident enough to do this by eye, measure out and mark the gaps in advance of cutting.

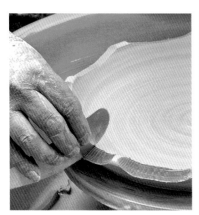

4 When all the sections have been cut away around the rim, create a shell-like texture on the curve of each section with a serrated kidney or other suitable tool. This will reflect the shell-like pattern on the underside later.

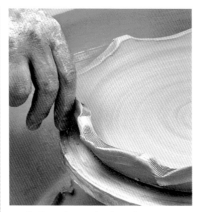

5 Finally, with the side of the finger, gently curve the clay in the cut sections upward and slightly inward to create a wavy, shell-like edge. Remove the bat from the wheel head and leave the platter to dry a little before wiring off as suggested in Before You Begin.

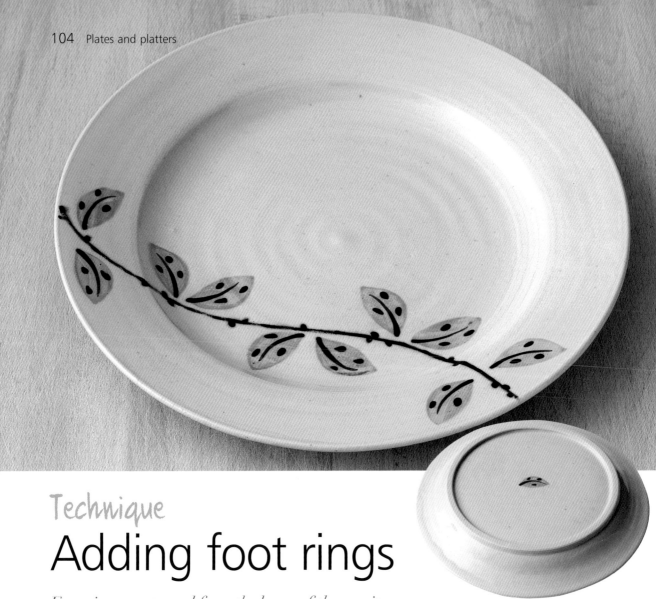

Technique
Adding foot rings

Foot rings are turned from the bases of thrown items, or fitted to the underside of handbuilt forms, for several reasons, but primarily to allow the underside to be glazed – the unglazed foot ring raises the glazed surface from the kiln shelf to prevent sticking. Additionally, a foot ring reduces the contact area of a hot item on a surface, but fundamentally it is a finishing detail that gives a form lift and style.

Foot ring on a plate by Jacqui Atkin
The underside of this stoneware plate shows a simple, classic foot ring that has been turned from the base at the green stage. A larger plate might need a second inner ring to prevent slumping in firing. The small underglaze design makes a lovely feature.

Small items like saucers only need one ring, but larger plates and platters often have two or more rings to support the center in firing, because clay can often slump at high temperatures. For thrown items the basic method of turning is the same whatever scale you are working on, be it a saucer or a large platter.

BEFORE YOU BEGIN

> Form a flat pad of soft clay on the wheel head to hold the saucer.

> Position the saucer upside down on the clay as centrally as possible, then tap or knock it to center as described on page 38.

> The wheel should be turning at a brisk rate—not slowly.

Turning a foot ring in a saucer

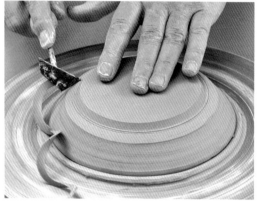

1 With the fingers of one hand holding the saucer in place at the center, and the thumb resting on the hand holding the turning tool, decide how wide you want your foot ring to be and cut a groove to mark the position. With the turning tool held at a right angle, cut away the clay vertically from the marked point to the depth you want the foot ring to be.

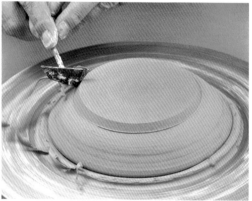

2 Having established the width and depth of the foot ring, now trim the clay below that point, following the shape of the saucer as it would be on the inside surface, to form a soft curve. Use both hands to stabilize the action.

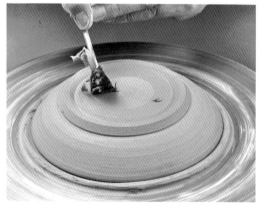

3 Turn another groove slightly in from the edge of the base to establish the width of the actual foot ring. Now trim the hollow inside the foot ring, taking care to follow the curve of the shape. Finally, make a shallow bevel on the inside and outside edge of the foot ring and smooth a finger over firmly as a finishing refinement.

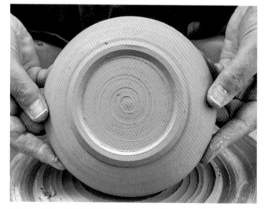

4 The foot ring is substantial enough to ensure the saucer cannot be easily overturned and deep enough to keep the base elevated from a surface when a hot cup is sitting on it. Both the inner and outer edge of the foot ring should be mitered to soften the shape.

1–3 SQUARES AND RECTANGLES

Simple, quick-to-make, multipurpose plates suitable for serving or dining and stackable for neat storage.

Forming method: Soft slabs draped over angled blocks of wood.

Foot: Three options are: slab triangles positioned at each corner and centrally on the long sides of the dish; slab circles positioned at each corner; and slab straps cut in a wave shape, or straight if preferred.

4 PLATTER/SERVING TRAY SHOWPIECE

A multipurpose serving plate with handles, suitable for serving cold cuts, breads, cheese, fruit, or cakes!

Forming method: Firm slab construction using a premade paper template.

Handles: The simple strap handles allow for ease of carrying.

Foot: None: flat base. Note: large, flat-based wares need special care when glost firing.

Design options
Slabbed variations

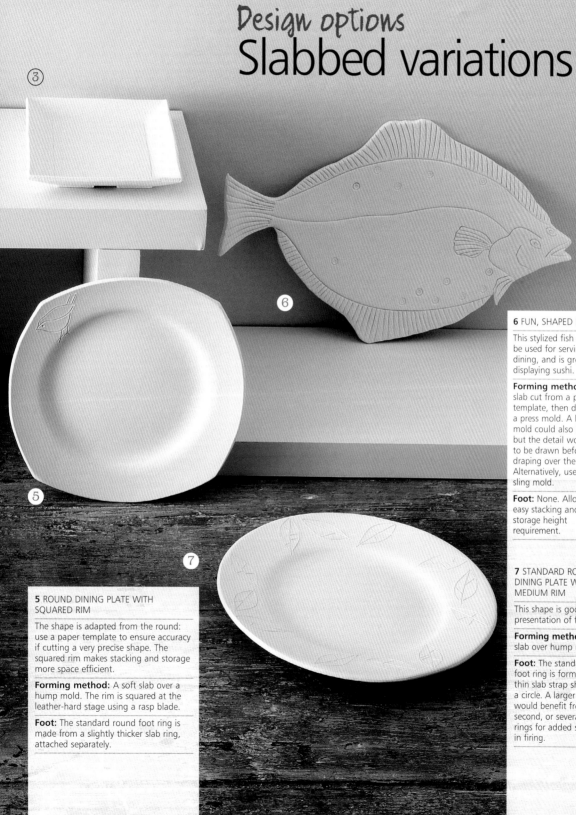

③

⑤

⑥

⑦

6 FUN, SHAPED PLATE

This stylized fish design can be used for serving or dining, and is great for displaying sushi.

Forming method: Soft slab cut from a paper template, then draped into a press mold. A hump mold could also be used, but the detail would need to be drawn before draping over the mold. Alternatively, use a simple sling mold.

Foot: None. Allows for easy stacking and reduces storage height requirement.

7 STANDARD ROUND DINING PLATE WITH MEDIUM RIM

This shape is good for the presentation of food.

Forming method: Soft slab over hump mold.

Foot: The standard round foot ring is formed from a thin slab strap shaped into a circle. A larger plate would benefit from a second, or several, inner rings for added support in firing.

5 ROUND DINING PLATE WITH SQUARED RIM

The shape is adapted from the round: use a paper template to ensure accuracy if cutting a very precise shape. The squared rim makes stacking and storage more space efficient.

Forming method: A soft slab over a hump mold. The rim is squared at the leather-hard stage using a rasp blade.

Foot: The standard round foot ring is made from a slightly thicker slab ring, attached separately.

8 & 9 SIMPLE ROUND DINING AND DESSERT/TEA PLATES

The lack of rim maximizes the surface area and allows for creative serving ideas. Lack of a foot ring allows for neat, space-saving stacking in the cupboard.

Forming method: Soft slabs pressed into a generic plaster mold. The simple, easy-release design allows for a quick repeat of the shape for batch production.

Foot: None in this example, but could be added if preferred.

11 & 12 SAUCERS

A simple round saucer and a version with a cut rim.

Forming method: Soft slab over a domed hump mold using a disk of thick cardboard rolled into the clay to form the central holding section. Unusual or irregular outlines can be cut prior to molding or at the leather-hard stage.

Foot: A slab ring cut to the same size as the cardboard disk used to form the holding section for the cup.

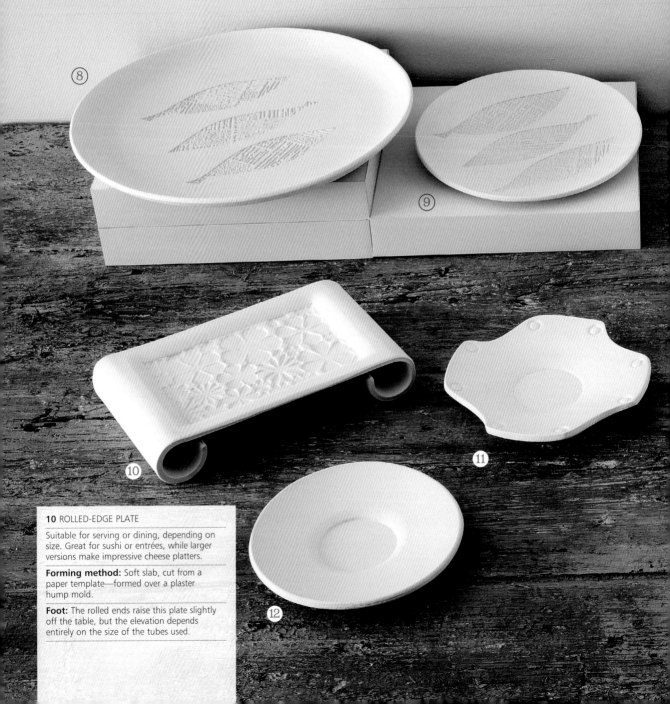

10 ROLLED-EDGE PLATE

Suitable for serving or dining, depending on size. Great for sushi or entrées, while larger versions make impressive cheese platters.

Forming method: Soft slab, cut from a paper template—formed over a plaster hump mold.

Foot: The rolled ends raise this plate slightly off the table, but the elevation depends entirely on the size of the tubes used.

14 LARGE CIRCULAR PLATTER WITH WIDE RIM AND HANDLES

A good-sized serving plate with many uses.

Forming method: A soft slab draped over a circular wooden bat. The rim is formed by allowing the clay to extend beyond the bat and sit flat on the surrounding work surface.

Handles: Handles are cut at the leather-hard stage.

Foot: Formed from a precut slab ring, cut in a wavy design for added visual interest, and attached while the platter is still in place on the bat.

15 FUN, STYLIZED FISH

Shape is suitable for serving or dining.

Forming method: Soft slab cut from a paper template.

Foot: Attached while the plate is still over the mold and made from deep slab strips positioned to complement the shape of the plate. A flat level is achieved after attaching the foot ring using a rasp blade to remove excess clay, which better accommodates the curve of the plate.

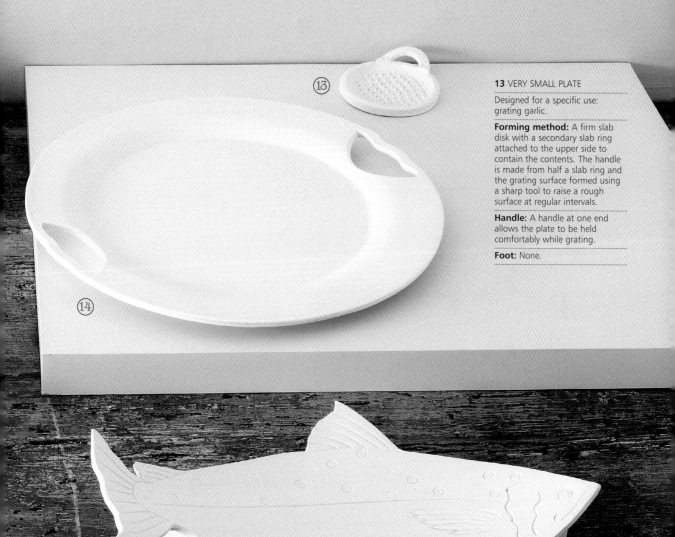

13 VERY SMALL PLATE

Designed for a specific use: grating garlic.

Forming method: A firm slab disk with a secondary slab ring attached to the upper side to contain the contents. The handle is made from half a slab ring and the grating surface formed using a sharp tool to raise a rough surface at regular intervals.

Handle: A handle at one end allows the plate to be held comfortably while grating.

Foot: None.

Technique
Slabbed flatware

One of the great advantages of making plates by the slabbing method is that very little equipment is required, and what is used (apart from standard pottery tools) is either easy to make yourself or is something generally used for another purpose. Even plaster molds are relatively easy to make.

Most simply, slab plates can be made by cutting "V"-shaped sections from the corners or edges of a slab cut to a chosen shape. When joined back together the walls pull up naturally to create a rim. The depth of the plate directly relates to the size of the sections cut away, thus giving great flexibility for adaptation.

Slabbed plates by Crystal Van Wyk
Slab plates always have a liveliness about them: they distort a little in the process of making and firing, but therein lies their appeal, because this makes them unique. These high-fired, vitreous slabbed plates are simply colored in a single turquoise glaze for maximum impact.

Molds and formers for flatware

Listed here are some of the items you can use to make plates.

Plaster, hump, or press molds.

Wooden blocks, used as hump molds. These can be mitered around the edges for added definition of shape. Cover blocks with a sheet of cotton fabric to prevent the clay sticking to the wood.

Round wooden bats, used as hump molds for round plates.

Small wooden disks, used for making saucers.

Picture frames, preferably wooden, can be used as press or slump molds.

Homemade frames, made from triangular-shaped sections of wood. A timber supplier will usually cut the sections to size for you but, if not, a simple miter angle block will ensure you cut the correct angles for the shape you require. Glue and pin the wood at the corners and you will have the perfect press mold.

Biscuit-fired plates make great molds.

Soft slab plate formed over a round bat

BEFORE YOU BEGIN

> You will need three wooden bats: two large and the other smaller to form the center of the plate. The difference in size between the clay slab and the smaller bat will dictate the width of the rim.

> Make a paper template of the plate with inner lines drawn to mark the central position for the smaller bat, and also the position for feet if they are to be added later (see pages 114–115).

1 Roll out a large slab of clay and, using the paper template, carefully cut out a circle to the required size and mark the position for the smaller bat using a wooden tool by redrawing the line through the paper.

2 With the clay still in position on the plastic sheet, transfer the circle to one of the larger bats, then place the smaller bat on top to fit within the scored line.

3 Position the third bat over the top of the second, then carefully turn everything over so that the plate is now upside down. Remove the bat that is now on top and the plastic sheet from the circle.

Slabbed plate continued

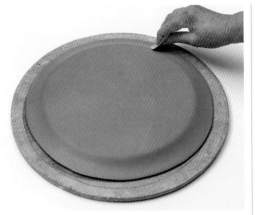

4 Using a flexible rubber kidney, gently ease the clay into a smooth and even shape around the inner wooden bat to form the rim. An alternative method for making the clay slump into place for the rim is to drop the bat from a height, but this can be a tricky maneuver if you are inexperienced, so only try this if you feel confident. At this point, add the foot design of your choice (see pages 114–115).

5 Allow the plate to dry to leather-hard. Place the first bat over the base and again turn over so that the plate is the correct way up. Carefully remove the small bat.

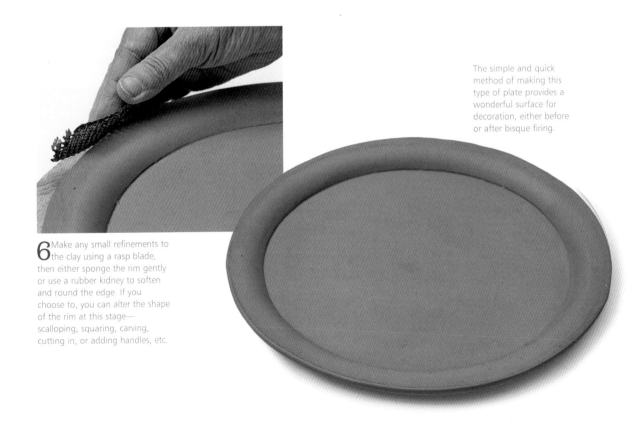

The simple and quick method of making this type of plate provides a wonderful surface for decoration, either before or after bisque firing.

6 Make any small refinements to the clay using a rasp blade, then either sponge the rim gently or use a rubber kidney to soften and round the edge. If you choose to, you can alter the shape of the rim at this stage—scalloping, squaring, carving, cutting in, or adding handles, etc.

BEFORE YOU BEGIN

> Cut a wooden block to form shallow mitered edges. You will need a miter saw to do this, but many wood suppliers or a joiner can cut these miters if you give them specific measurements. The depth of the miter will determine the depth of the plate, but if you find it is too deep, you can shave the clay rim after making to reduce the size. Wood that is about 1 in. (2.5 cm) thick before mitering is about the right depth for a good plate.

> Cover the block with a sheet of cotton fabric and tape to the underside.

Rectangular soft slab plate formed over a wooden hump mold

1 Roll out your clay to the required thickness and cut to size using a paper frame template measured to fit the shape of your mold exactly. Lightly score an inner line to mark the position of the frame—this will delineate the rim and base.

2 With the clay still in place on a plastic sheet, position the block centrally, then, drawing the plastic sheet up to keep the clay in place, carefully turn the mold over. Elevate the mold on something like a wooden block that allows you to work easily around the edge of the plate. Remove the plastic sheet.

3 Using a rubber kidney, gently smooth over the surface of the clay, taking particular care at the corners to avoid distorting the shape. Add the foot design of your choice (see pages 114–115). Allow the plate to firm up to leather-hard before removing from the mold, then, if required, tidy up the edges by shaving with a rasp blade and smoothing over with a damp sponge.

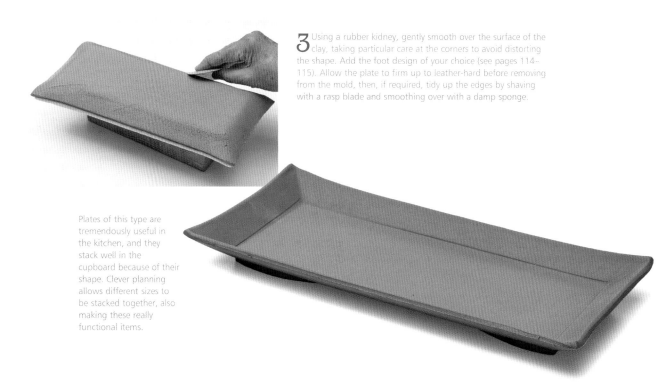

Plates of this type are tremendously useful in the kitchen, and they stack well in the cupboard because of their shape. Clever planning allows different sizes to be stacked together, also making these really functional items.

Technique
Slabbed feet

Primarily, feet are added to the bases of slabbed flatware pieces, as opposed to being cut away as they are in thrown forms. This does not rule this out as an option for thrown wares, but usually turning is faster, especially for larger production. An alternative for some makers, though, is to attach thrown and altered, or pulled, feet at the leather-hard stage.

BEFORE YOU BEGIN

> Make a paper template of two rings that will form the double-ring foot. This is usually done at the same time as templating the plate or platter (see page 111).

> Pastry cutters in gradual sizes are useful tools for cutting small rings and shapes accurately. They are usually available in sets of about six cutters, giving plenty of scope for varied sizes, but are particularly useful for cutting feet for saucers.

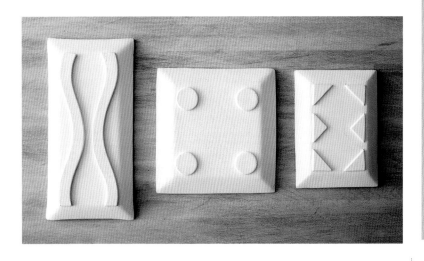

There is the potential to be very creative when making feet for slabbed items. From a basic round to the positively abstract and quirky, the choice is endless in terms of shape and style, and it can be so pleasing to turn a plate over and be surprised by the underside. Whatever design you choose, the most important thing to ensure is that the join is good, so always score and slip all surfaces to be fixed together for success.

Simple slab circles
Simple circles are cut from the slab left over after cutting the body of the plate. Use a pastry cutter to ensure all the circles are identical and also to mark the position on the underside of the plate. Score and slip all surfaces before fixing the circles in place.

Wavy lines
Not all lines have to be straight—make a paper template of a wavy line and use it to cut two or more strips from the spare slab. The waves can be made to fit lengthwise, across the width, or even formed into a frame. Fix in place after scoring and slipping all joining surfaces.

Traditional slabbed double-ring foot for large platter

1 Roll out a large slab of clay on a sheet of plastic to the thickness you want the foot to be, then, using a precut paper template, mark the outline of two rings on the clay and carefully cut the surrounding clay away, leaving the rings in position on the sheet.

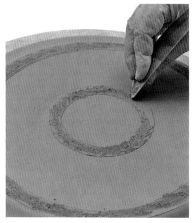

2 Using the same template, mark the position for the rings on the underside of your plate, then score the marked areas with a serrated tool and apply some slip. Do the same to the upper surface of the rings.

3 Turn over the sheet of plastic, with the rings still on it, and place in position on the base of the plate. The rings should stay in position on the plastic quite easily to perform this maneuver. Remove the sheet when you are sure the placing is correct. Place a wooden bat over the rings and apply a little pressure to ensure they attach to the base, then clean away any excess slip with a rib.

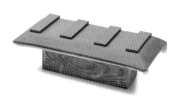

Finished rolled ends
Cut a long strip of slab to an even width then cut into four and fix in place at even intervals across the width of the underside as opposed to the length.

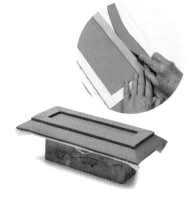

Box shape
Make a frame to fit the base of the plate. Use something like a roller guide or ruler to cut strips of even width. The corners can be mitered or butted together. Fix in place after scoring and slipping relevant areas.

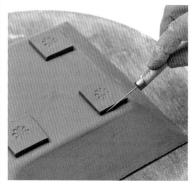

Squares
Matching the shape of the feet to the shape of the plate is a good design feature, but extra delight can be created when the underside is inspected by impressing a small detail into each section before joining to the underside.

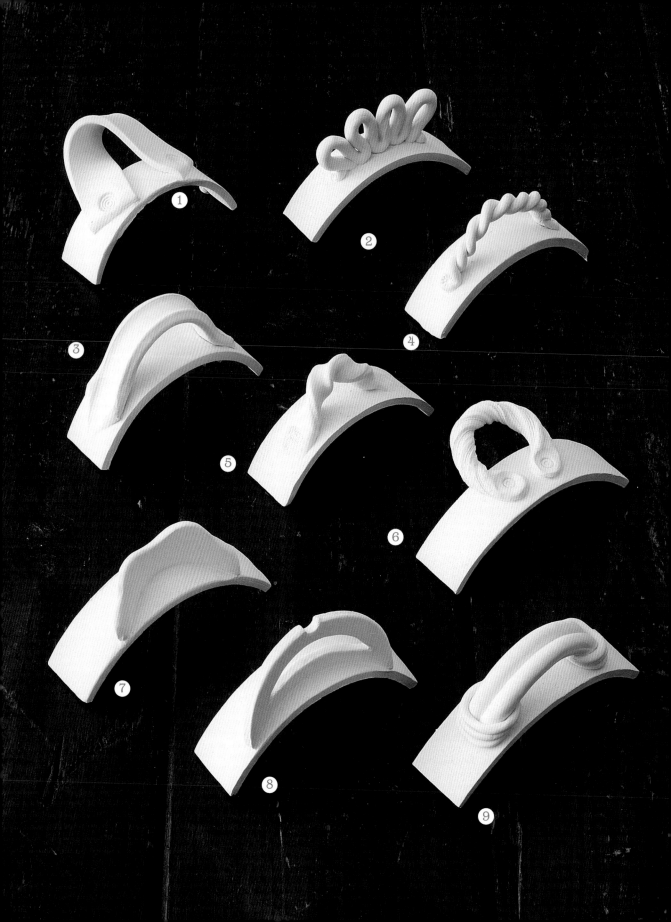

Design options
Coiled, slabbed, and pulled handles

1 SLABBED STRAP

A simple slab strap can be manipulated into any number of shapes to make handles. In this example, the strap is attached by the outer surface of one end and the inner surface of the opposite end to form a loop. A small stamp detail where the strap has been attached adds decorative detail and helps secure the two surfaces together.

Suitability: Can be fitted to the upper surface or underside of the rim of the platter to extend outward for extra purchase when lifting.

2 COILED AND LOOPED

This handle is made from a relatively thin, round coil looped several times in a snake-like fashion. The loops could decrease in size at each end for variation if preferred. Can be applied as shown, standing up, or sideways on to extend from the rim outward.

Suitability: Platters with wide rims suit this style if applied flat to extend outward. Alternatively, shallow platters with very little rim look good with this type of handle attached to the outer edge standing upright.

3 PULLED

A simple pulled strap provides a sturdy handle for larger, deeper platters. Apply to the outer edge of the platter wall or on the upper surface of wide-rimmed versions.

Suitability: Good for large, thrown, rustic platters, but suitable for platters that are made by any method.

4 DOUBLE COILED

Two thin coils twisted together give a handle extra strength. The coils can be thin or thick to suit the style of platter. Another option for this style of handle is to flatten the twisted coils slightly after making using a wooden roller guide for even pressure.

Suitability: Country-style platters. Can be attached to be raised above the rim of a platter or sideways, extending outward from either the upper or underside of a rim, depending on the style of the platter.

5 PULLED TWIST

This is a variation of a twisted handle made especially easy by the technique of pulling, since the clay is so much more pliable with this method, owing to the fact that more-than-average water is used in the process. The twist is formed freestyle from a thin pulled strap and attached to the platter by each end.

Suitability: Can be attached in an upright position on the outer wall of a shallow platter or sideways, extending outward from the upper or underside of a wider rim. Suits rustic, country-style platters.

6 PULLED BARLEY TWIST

Pulled to form a thin, round coil, the handle is incised along its length before twisting to give the characteristic surface. Can be pulled thickly or thinly, as appropriate for the form.

Suitability: Country-style platters with wavy, shell-shaped edges look especially great with this type of handle fitted to loop over a wave on opposite sides of the platter. The style can otherwise be attached to any suitable shape made by any method.

7 STYLIZED SLAB

This stylized handle is cut from a slab of clay using a template. As an alternative, the same shape could be cut out of the rim itself if wide enough. In this example, the handle has been curved to apply to the outside wall of a shallow platter, but a flat version could be applied to the upper or underside of a rim to extend outward.

Suitability: Slabbed platters of irregular size and shape and tray-like platters.

8 SLABBED CURVE

A simple handle can be quickly made from a rolled slab of clay. Cut a basic circle using a pastry cutter—use a fluted version if preferred. Then cut another inner circle using a smaller cutter to make the shape as wide or narrow as required. Extra details can be cut from the handle to give character if required. This handle has been attached to form a curve, but could be applied flat.

Suitability: Any suitable style of platter but particularly good on abstract shapes. Attach in the best way to suit the form, either extending outward or upright.

9 DOUBLE COIL

This handle is made from two round coils joined together along their length. The handle is bound with very thin coils of clay at each end once the main part is fixed to the platter. This gives a basket-like finish to the handle.

Suitability: Great handle for woven, coiled platters since it completes the basket-like look. Otherwise the handle can be applied to any suitable platter made by any method.

Technique
Handles for slabbed platters

A platter is really a ceramic tray: a large surface on which to present and serve food. For this reason the platter should be easy to lift, which is why handles are usually included in the design, although they also add to the aesthetic of the finished form.

The most straightforward method of creating handles for slabbed platters is to cut them out of the body so that they are integral to the form. However, this feature must be built into the design in advance and requires either a wider-than-average rim or a deep rim similar to a shallow dish, to give enough clay to cut the handle from.

Of course, a slabbed platter does not necessarily need a slabbed handle; you can coil or even pull a handle if preferred because all methods are interchangeable but, whichever method you choose, be conscious that the handles need to be serviceable and able to lift what is being presented.

Slabbed platter with handles by Jacqui Atkin Made from textured white earthenware slabs, the color detail has been applied by a combination of painting, sanding, sponging, and filling in with fine detail using velvet underglaze, before covering with transparent glaze. Fired to 2,048°F (1,120°C) in an electric kiln.

Simple and quick slab handles

The possibilities for creating stylish and unique slab handles are endless, but here are just a few very simple ones to get you started. Always score and slip all surfaces to be joined for a secure finish.

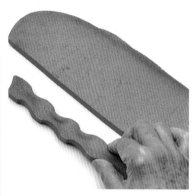

Using pastry cutters

Using pastry cutters in two sizes, cut out a semicircle from a slab of clay that has been rolled to the same thickness as that for the platter. You will have two possible handles immediately: one loop, the other a solid half-moon shape. Loops can be applied to the platter so that they extend outward from the rim horizontally, or stand up vertically. Alternatively, you can cut the half-moon shape to make a crescent to better fit the shape of the platter and apply in a similar way as a solid handle.

Pinched strap

Roll a slab of clay that is slightly thicker than that of the platter, and cut a strip to the width of a ruler or something similar. Run your forefinger and thumb along the upper edges of the strap to smooth and round them off, then turn the strap over and repeat. Now pinch the strap at regular intervals along its length. Once completed the strap can be curved into various shapes to fit the side of the platter as best suits the shape.

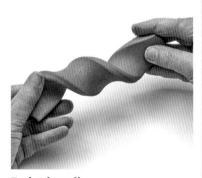

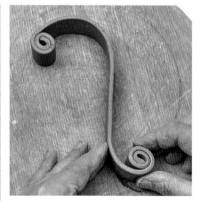

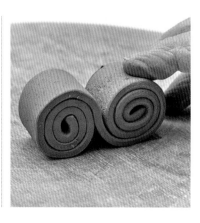

Twist handle

To make a very sturdy handle, follow the advice for the Pinched Strap to roll out a slab and cut a strip. Smooth the edges in the same way as before, then hold one end firmly in one hand and twist the shape with the other. The handle should have one full loop in the middle but could have more. Attach to the platter at each end so that the middle of the spiral stands slightly raised above the surface.

Spiral handle

Yet another adaptation of the Pinched Strap handle is to cut and smooth the clay as before, but then roll the ends to make a more whimsical handle. This type can be attached to an upper surface of the platter to stand vertically, or to the side to extend outward. The rolls at the ends can be in the same direction or in opposite directions, as shown here, and can be curled up as much or as little as will be practical for the platter. One option is to curl the strap completely, a style that is best applied to the side of a platter like a knob. It should be fixed to the side extending outward as it appears on the bat, so that the coils can be seen, or however it best suits the platter.

Chapter 5

BOWLS, DISHES & CASSEROLES

Bowls, dishes, and casseroles

Design decisions

" Bowls are an essential item of tableware, used in various shapes and sizes, and for many purposes. They are vessels that provide endless design possibilities to make and tailor to your own needs."

The bowl close up

Bowls are the most functional vessels of all, and can be such pleasurable items to make in clay. They are an enduring, ancient form, yet still present the opportunity for new interpretations of shape, functionality, and surface.

Porcelain Turquoise bowl
by Annie Greenwood
The quiet glazed surface treatment of this bowl is timeless and sophisticated. It is calm and understated, yet so much can be seen in it, proving that impact can be achieved through simple detail without compromising on functionality.

The bowl closes in ever so slightly toward the rim, giving a lovely sense of containment without detracting from its generous proportions.

The simple transparent glaze at the rim shows off the properties of the porcelain clay, the thinness of the clay wall, and also the finesse of the throwing technique.

The perfectly rounded shape is the most practical for use with utensils such as spoons. The lack of any angles makes this bowl supremely functional.

The foot ring is perfectly balanced to fit the shape of the bowl, being neither too large nor small, high nor low; it gives just the right amount of lift to the form without compromising stability.

The contrast of unadorned, white interior to colored exterior not only reflects the maker's source of inspiration, but allows the food being served in the bowl to be shown off for its own merits without the distraction of decoration.

The bowl and dish set close up

Sometimes the most stunning ceramics are the simplest, and this crudité set is a great example of this. Designed for a very specific function, each item could, nonetheless, be used separately. The simple and minimal surface decoration is not so dominant that it distracts from the food being served, but looks stunning against the white porcelain background, and is understated enough to fit into any dining scheme.

The standard-shaped dish is large and wide to accommodate a range of foods with the smaller bowl sitting inside it.

The painterly brushstrokes forming the surface decoration are cleverly aligned in both bowl and dish to visually blend the two together. They look like they are part of a set, but work just as well individually.

The small bowl has been thrown and altered to a unique shape that adds visual appeal to the set, but does not alter its functionality.

White backgrounds are always good for showing food off to its best. All colors work well on white and porcelain is a wonderful clay for this reason, needing only a clear glaze to cover the surface if wanting to work in production.

The crudité set by Elaine Tian has been wheel thrown in English porcelain and fired to cone 10 in a gas reduction kiln.

Before making bowls for your own use it is worthwhile considering and planning your exact requirements. If, for instance, you want one size of bowl to fit all your dining-table needs, such a bowl would need to be of medium size to serve both sweet and savory foods successfully. To contain hot foods safely, the form must be sturdy with a wider foot ring to keep it stable on a surface. These small considerations are important design decisions that can affect the practicality and functionality of the bowl. With careful analysis, considering why things work successfully, and looking at various options of shape and size, you can design and make wonderfully practical but beautiful bowls, personalized for your own requirements and even measured to fit precisely if required.

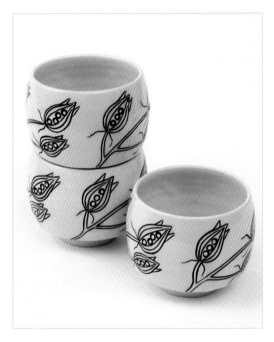

Stacking bowls
by Jacqui Atkin
Designed to stack neatly for storage, these bowls have a simple, botanical line-drawn surface that would fit into many dining schemes. The shape is suitable for a number of uses, from cereal to soup or dessert.

Pouring bowl
by Sally-Jo Bond
This lovely bowl is wide and shallow with a pouring lip. Wheel thrown in terracotta, the surface is decorated with white slip and honey glaze. The color of the glaze contrasts beautifully with that of the clay.

Questions to ask yourself

How will the bowl be used?
Think about what you currently use bowls for, since this will allow you to plan your making for specific use.

What shape do I want?
Do you want to make a one-style, all-purpose bowl for everyday use, or make a selection for different purposes—cereal, soup, pasta, dessert, etc.? Your decision will inform both the shape and size of your designs.

Do I want to expand the range?
How many serving dishes might I use? Would it be helpful if they were lidded? Do they need to match the rest of the dinnerware or can they be different in style?

How much storage space is available?
Be aware that the more disproportionate the shapes you make, the more difficult they become to store. Do you have the room to store such items?

How sturdy do my bowls need to be?
In family life, a single bowl can get a lot of use, so it needs to be hard-wearing. In addition to bowls for serving food, you may want to make items suitable for oven-to-table use, and to be dishwasher proof. Your choices will determine the best clay type and firing temperature, since the higher the firing, the more sturdy the vessel will be.

Design options
Thrown variations

1 ROUND BOWL WITH POURING LIP

Thrown to a standard round shape, this bowl has an extra usage thanks to the addition of a pouring lip. The slight flare of the rim gives the bowl an open, generous form.

Foot: A standard, round foot ring has been turned into the base to give the form stability.

Uses: A perfect bowl for batter, mixing, or for instances when liquid might need to be poured away to separate it from the rest of the content.

2 OVAL DISH

The side and base of this dish are thrown separately, then reassembled at the leather-hard stage, at which point the shape is changed from round to oval. The base must be thrown larger than required to accommodate the change of shape.

Handles: The handles are attached, then pulled out and pushed back and up to loop above the rim and down to the base.

Foot: Flat, shell-wired base.

Uses: Oven to table and serving.

3 ROUND-BELLIED BOWL

This traditionally shaped bowl has generous, open proportions. Smooth on the inside, with throwing lines in evidence on the outside and a deep smooth rim closing in ever so slightly to give a sense of containment.

Foot: The small standard turned foot gives visual lift to the body.

Uses: All-purpose bowl for dining or serving.

4 FLARED AND LIDDED BOWL

A small dish, thrown with straight sides flaring slightly at the rim. An internal flange forms the shoulder for a simple drop-in lid.

Lid: Thrown and turned with a modeled feature knob in the shape of a bird.

Foot: Flat-based for ease of use.

Uses: A perfect little oven-to-table dish, suitable for individual use or serving.

5 FLARED BOWL

This bowl is thrown to a standard round shape with the adaptation of a flattened rim, which gives the form open and generous proportions and grip for easy lifting. Varying the width of this type of rim will suggest different uses—wider versions would make good pasta dishes, for example.

Foot: A standard turned foot gives the bowl visual lift.

Uses: Multipurpose bowl for dining or serving.

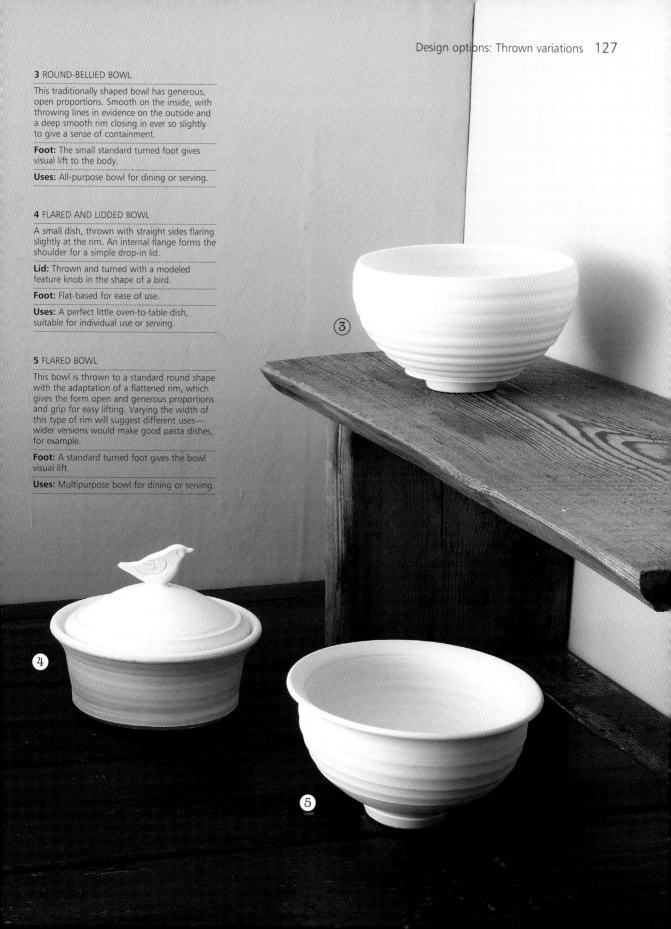

6 COUNTRY-STYLE BOWL

This large platter is thrown with a fat edge, then cut using a wire to give the wavy finish. Once the clay has firmed up a little, the shape is further developed to accentuate the waviness.

Handles: Handles are attached in the French country style to loop out from a wave on each side.

Foot: Four pulled candy-twist feet are attached to the underside.

Uses: Serving.

7 WIDE, OPEN DISH

The wide, flattened rim on this dish gives a visually strong sense of containment.

Handles: The dish is pinched in on two sides to alter the shape and provide a place at which to position the handles, which are pulled and candy twisted before looping into place.

Foot: The base is flat and shell wired off the wheel.

Uses: A lovely serving dish to decorate the center of the table.

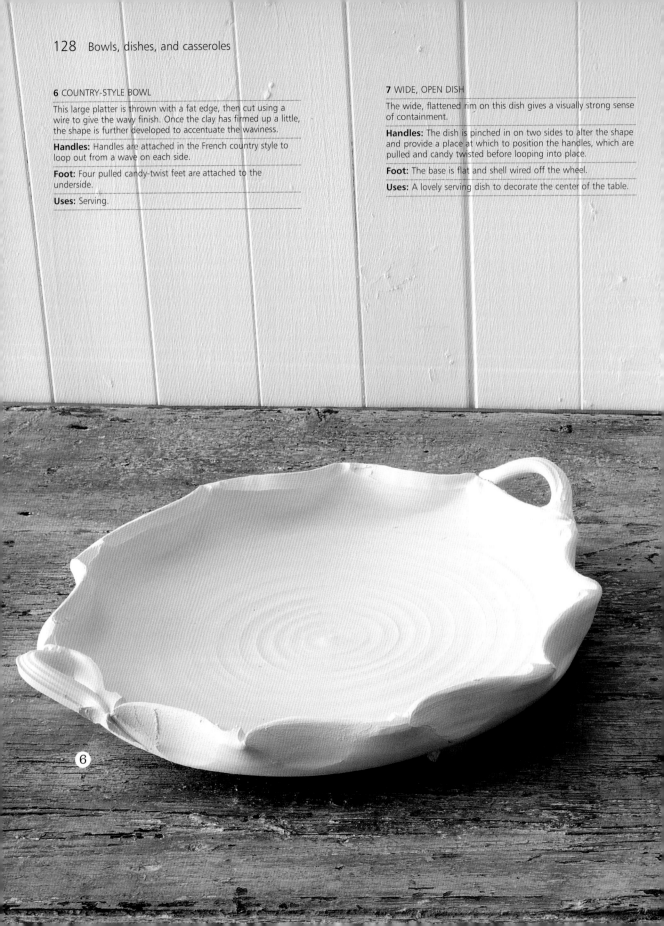

6

8 STYLIZED ROUND BOWL

This bowl is thrown to a standard round shape, then altered by drawing a finger up the side from midpoint to just below the rim, in equidistant places, to give the bowl a three-sided appearance. The shape could be further adapted by drawing more lines.

Foot: Standard turned foot.

Uses: Multipurpose bowl good for breakfast, soup, or dessert.

9 OPEN ROUND BOWL

Thrown to a standard formula shape, this open and generous bowl has deliberate throwing lines on the outside of the form to create a feature for glazing at a later stage. All decorating ideas should be planned in advance of making so that they can be incorporated into throwing if relevant.

Foot: Standard turned foot.

Uses: Multipurpose bowl for serving or dining.

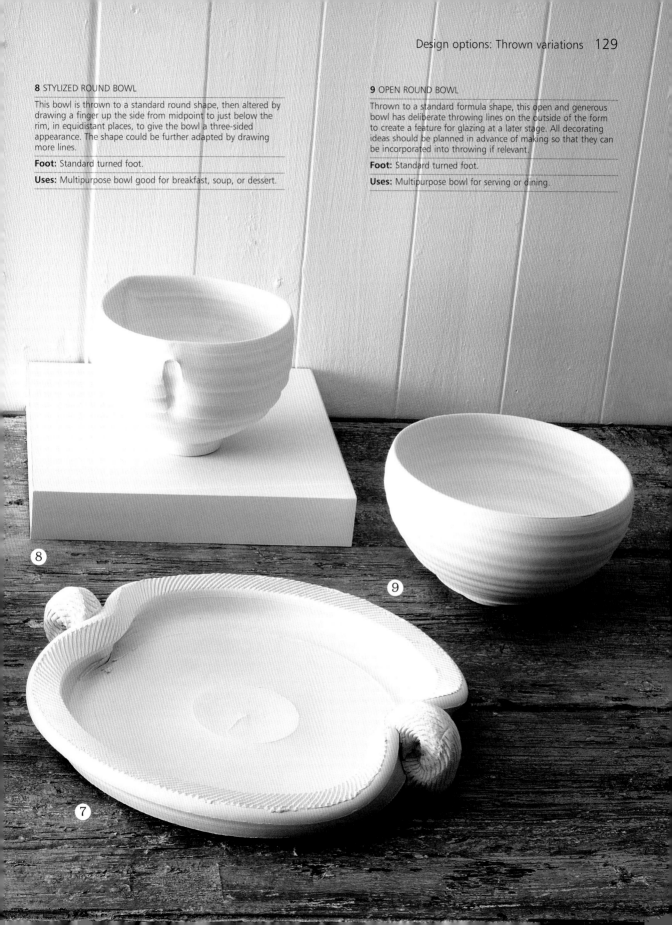

Technique
Thrown bowl

Of all the items of functional ware that can be made, bowls have the most potential for creativity because we use them for so many things. Fundamentally, we eat, serve, cook, mix, and store things in them, and these are just a few of their uses.

This makes it very difficult to make a one-size-fits-all bowl, and is the reason why most of us tend to have quite a lot of them. It makes sense then, if you are starting from scratch, to design your bowls to be practical for both use and storage, which requires planning.

Firstly, if storage space is at a premium, consider one range of dishes for multipurpose use, to serve breakfast, dinner, or dessert, for example.

Secondly, design details like stackability into your bowls. It is very space saving if items nest inside one another, especially cooking or mixing bowls, and also useful to have a particular shape of bowl or dish in a range of sizes.

BEFORE YOU BEGIN

> Bowls can be thrown directly on the wheel head or on bats to minimize handling—the choice is down to the skill level of the maker.

> The key to throwing a successful bowl is to allow enough weight at the base to support the wall as it is thrown outward, and also to form the foot ring later, when the bowl is turned.

> The focus when throwing bowls as opposed to cylinders is on the interior space rather than the outer, which is developed later when turning.

Throwing a wide bowl

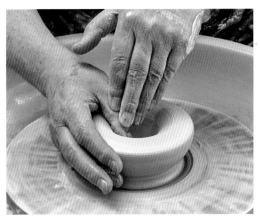

1 Center the clay (see page 188) to a doorknob shape: this allows your fingers underneath to lift the wall so that there is enough clay to support it without being excessive. Using the fingers of one hand to steady and support the other hand, open the center of the clay to the required depth, but keep the base rounded (as opposed to flat for a cylinder).

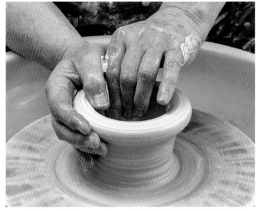

2 Pinch and lift the wall of the bowl, working from the center upward and slightly outward to create a funnel shape. Keep the shape centered with the fingers of one hand around the side and the thumb over the rim as you pinch and lift with the other in close proximity.

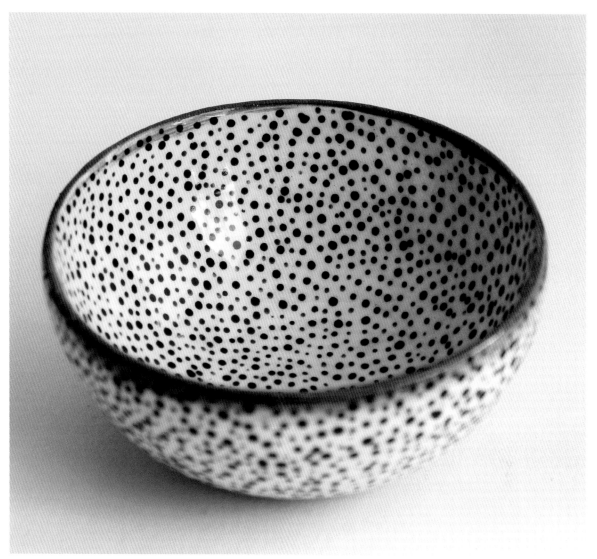

Thrown "constellation" bowl by Paige Jarman
Measuring 2 in. (5 cm) high and 4½ in. (11 cm) across, this bowl has been thrown on the wheel with a white slip applied to the surface. The surface decoration is created using cobalt underglaze before applying a transparent glaze. The rim has been left undecorated to form a lovely contrast.

Approximate weights and measures for bowls

Item	Width	Weight of clay
Small bowl suitable for serving cereals and desserts	6 in. (15 cm)	Approx. 1.2 lb (550 g)
Medium bowl suitable for serving soup and pasta	10 in. (25 cm)	Approx. 3.3 lb (1500 g)
Large bowl suitable for mixing and serving salad	12 in. (30 cm)	Approx. 5.5 lb (2500 g)

The information given represents raw clay weight for throwing and approximate minimum fired dimensions.

Thrown bowl continued

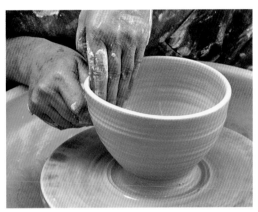

3 Establish the width at the top of the bowl quickly using the knuckling-up technique (see page 191). Keep the shape rounded and do not allow it to flare too wide. Remember to consolidate the rim regularly by pinching gently between the finger and thumb of one hand, while the finger of the other hand compresses the edge.

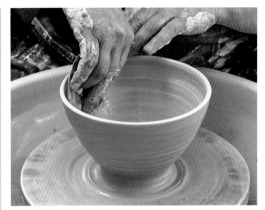

4 Taking great care, sponge out excess water from the interior of the bowl, then repeat using a rib or kidney to smooth the wall and remove any remaining slurry. You can also refine the shape further using a rib if required, but do not overwork it.

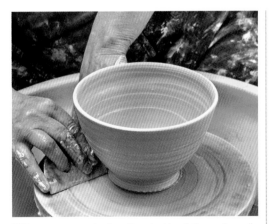

5 Sponge excess water from the wheel head, then, using a rib again, remove the excess clay around the base on the outside of the bowl, making sure to leave enough width to turn a foot ring when it is leather-hard. Wire the underside of the bowl, then carefully lift it off the wheel by holding it at the base, and transfer to a bat.

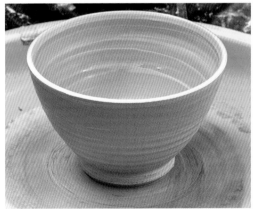

The finished bowl shows a good balance of height to width, and is practical for any number of uses, from mixing food to serving salad and much, much more—a bowl for every home.

Modifying the bowl shape

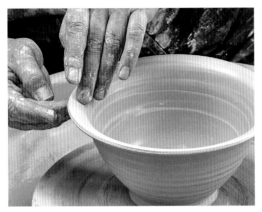

1 Modifications can easily be made to the basic bowl form if required. To change the shape at the top, simply curve the wall outward between the fingers of both hands to the required width for a flattened rim. Keep the curve upward slightly rather than completely flat.

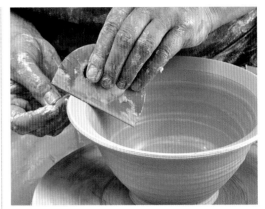

2 With fingers supporting the underside of the rim, gently run the flat edge of a rib around the upper surface to clearly define the shape and remove any surface slurry that may remain.

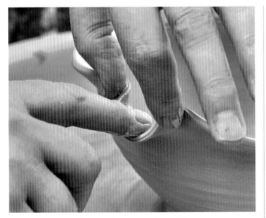

3 To form a pouring bowl, support the wall between the finger and thumb of one hand as shown, then, with a wet finger, gently belly the clay between to create a lip. Different modifications could include holes or notches for chopsticks, handles cut out or added on, or holes to make a colander or berry bowl.

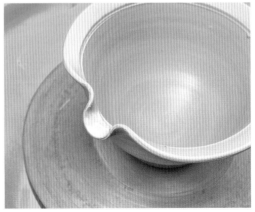

The lip of this dish is perfect for pouring and provides a place to rest possible utensils such as a small salad-dressing whisk or soup spoon.

Design options
Coiled variations

1 RIMMED BOWL

The body of this bowl is formed in a press mold from rounded coils. The rim is made from a flattened coil formed into a ring before placing on a domed hump mold. The body is then attached to the rim.

Foot: A rounded coil forms a standard foot ring, carefully blended to straighten the edges.

Uses: Traditional soup or pasta bowl.

2 ROUND SERVING BOWL WITH HANDLES

The round, wide base of this bowl is made in a press mold. The wall is built up using a flattened coil, positioned to make an obvious feature on the outside, but smoothed seamlessly internally. A slightly thicker, textured coil forms a sturdy rim.

Foot: The wide, flat nature of the bowl does not require a foot.

Uses: Suitable for serving many foodstuffs and as a center-of-table bowl for fruit, etc.

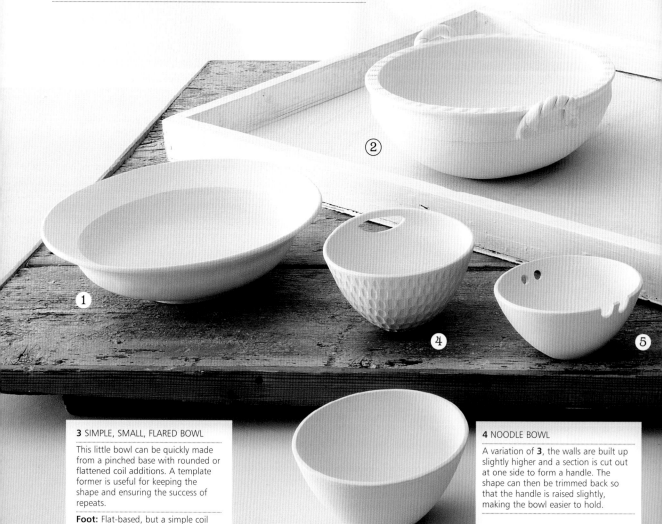

3 SIMPLE, SMALL, FLARED BOWL

This little bowl can be quickly made from a pinched base with rounded or flattened coil additions. A template former is useful for keeping the shape and ensuring the success of repeats.

Foot: Flat-based, but a simple coil could be added to form a rounded foot.

Uses: A good bowl for breakfast or dessert, its design means it stacks well.

4 NOODLE BOWL

A variation of **3**, the walls are built up slightly higher and a section is cut out at one side to form a handle. The shape can then be trimmed back so that the handle is raised slightly, making the bowl easier to hold.

5 CHOPSTICKS BOWL

Another variation of **3**, two notches on the side with corresponding holes on the opposite side give the bowl another function and dedicated purpose.

6 LARGE SERVING BOWL

The base for this shape is started in a press mold and the walls built up with flattened coils. Formed as a standard round shape first, the rim is then trimmed to a stylized, slightly off-key shape with notches cut on two sides.

Foot: A flattened coil strip is used to make the foot.

Uses: Suitable for serving any food in larger quantities.

7 SQUARED SERVING BOWL WITH FEATURE RIM

The base of this bowl is made from a slabbed section cut out using a template to form the square shape. Flattened coils are used to build up the walls. The feature rim is made from a round coil that has been textured by drawing a wooden tool along its length.

Foot: Flat-based.

Uses: A useful serving bowl for any foods, hot or cold.

8 MEDIUM-SIZED RIMMED BOWL

This bowl is made from a molded base section with sides built up from flattened coils. The rim is made from a flattened coil formed into a circle prior to attaching.

Foot: Flat base with no foot ring.

Uses: This multifunctional bowl is designed for making batter or mixing ingredients, but would also be suitable as a serving bowl for salad or fruit.

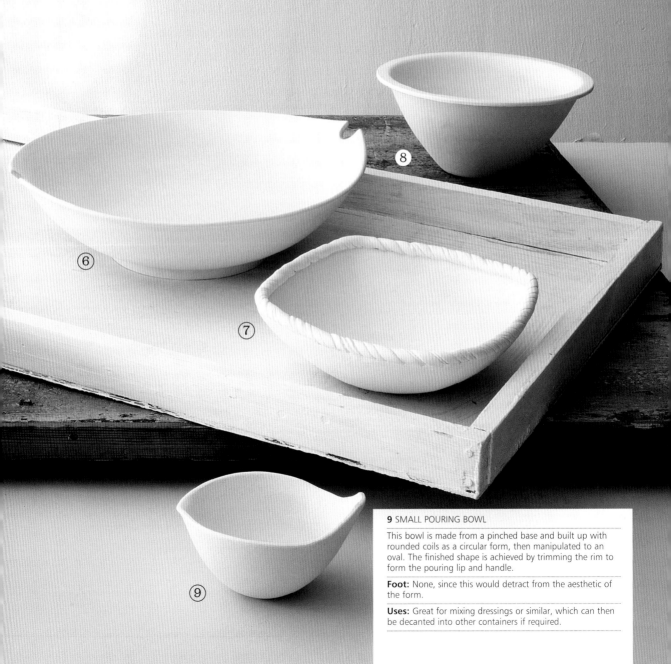

9 SMALL POURING BOWL

This bowl is made from a pinched base and built up with rounded coils as a circular form, then manipulated to an oval. The finished shape is achieved by trimming the rim to form the pouring lip and handle.

Foot: None, since this would detract from the aesthetic of the form.

Uses: Great for mixing dressings or similar, which can then be decanted into other containers if required.

Technique
Coiled dish

It is common practice to use more than one making method in the production of some ceramic items. Thrown body parts may have slabbed or coiled additions; similarly, molded bodies can be built up with slabbed or coiled parts; and pinching is often used as a starting point for small items like cups, mugs, and bowls.

When coiling an item that requires a flat base, the most sensible solution is to start from a rolled slab. Doing so will save time and speed up production, and is a more foolproof method of making a base than coiling, since a coiled base can crack if not dried carefully.

Coiled bowl
by Ann Marie Cooper
Formed from hand-rolled coils in a press mold, the outer wall of the bowl has been left unglazed to show the patterning of the coils. Oxides rubbed into the coils accentuate the design further, while a simple glaze on the interior makes the bowl food-safe. A lovely feature of this bowl is the uneven rim that has been naturally formed by the shape of the coils. Made from stoneware clay and fired in oxidation in an electric kiln.

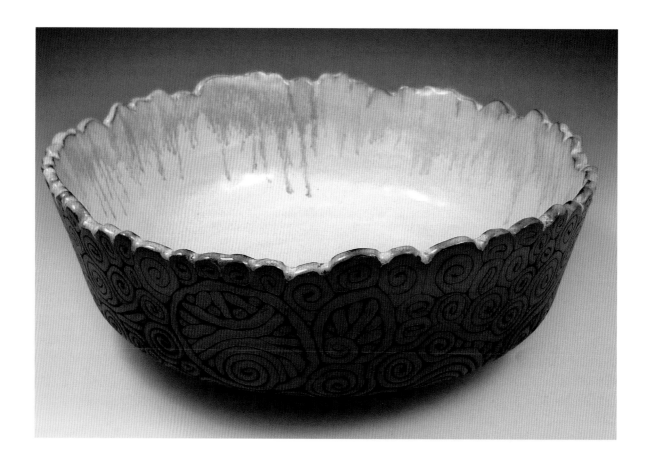

Shallow slab and coil dish

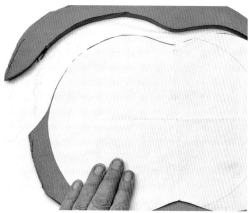

1 Roll out a slab of clay for the base. Don't roll the slab too thin since a slightly thicker section of about ¼ in. (6 mm) is best for larger dishes. Using your paper template, cut the shape out, removing the excess clay around the edge but leaving the slab in place on the plastic sheet it was rolled on.

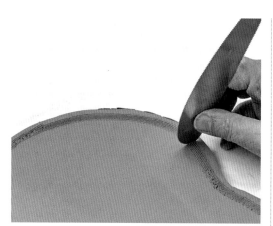

2 Turn the slab over onto a wooden bat: it should stay on the plastic sheet, allowing you to do this easily. Score the outer area of the slab, about ¼ in (6 mm) in from the edge where the first coil will be attached. Use a serrated kidney or similar tool.

3 Roll a thick but even coil of clay. The length will be dependent on the size of the base but, if possible, roll the coil so that it will go around the entire circumference. If the base is very large, you may have to attach the coils in two parts. Flatten the coil (see page 208). Sit a wooden batten along the length of the flattened coil and cut a straight edge, then, with the batten still in place, score the edge as shown.

Coiled dish continued

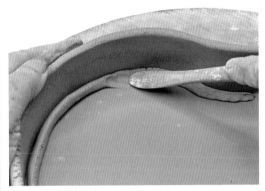

4 Slip the scored area on the slab and the coil, then fit the coil onto the slab so that it stands upright, slightly in from the edge. Overlap the ends and cut through both diagonally. Score and slip the cut ends and join them together carefully, then smooth over the join with a kidney.

5 Reinforce the inner join with a coil of soft clay. Blend the coil in using a finger or wooden modeling tool, then remove any excess clay and smooth over the surface with a rib or kidney. Support the wall with the other hand as you do this to prevent the shape being distorted.

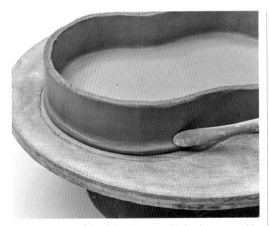

6 Level the rim of the dish using a rasp blade, then score with a serrated tool. Now neaten up the join at the base on the outside using a wooden modeling tool or a rib with a small notch cut into it for rounding off rims. If you feel it is required, you can reinforce on the outside with a very thin coil of soft clay, but, having reinforced the inside, this is not strictly necessary. Finally, smooth the edge over with a finger to soften and round it off.

7 If you would like to make a deeper dish, simply add another coil, attaching it in the same way as the first. Reinforce the join of the two coils on the inside and outside of the wall and scrape back the clay until even. To make the rim, roll and flatten another coil, making sure this one is long enough to fit all the way around the rim. Lay a wooden batten over the coil and roll from side to side so that the clay thins at the edges and the coil becomes rounded. Keeping the batten in place, cut away the surplus clay each side, then smooth the edges with a finger.

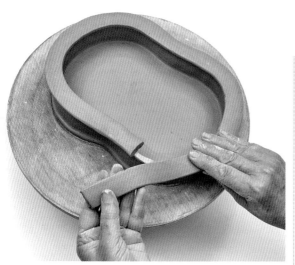

8 Turn the coil over on the plastic sheet and score the underside. Now slip the rim of the dish and the underside of the coil and fit in position, as shown. Cut the edges to be joined as before, overlapping and cutting on the diagonal, then scoring and slipping. If you can access the underside of the rim on the inside of the dish, you can reinforce with a thin coil of soft clay to neaten the join, but this is not essential.

9 Place another bat over the dish and turn it over so that you can work on the underside. Reinforce the join with a coil of soft clay, using your finger or a wooden tool to blend in and smooth the surface.

10 Neaten up the wall of the dish with a rib and smooth over the edge of the base with either a finger or rubber kidney to remove any sharpness. Turn the dish back over to dry.

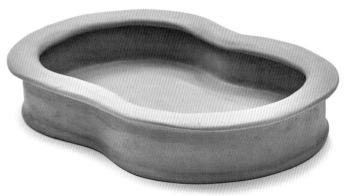

The rim of this dish serves several purposes: it acts to contain the contents, gives a surface to rest possible utensils on, and a convenient point for lifting—especially useful if the contents are hot.

①

Design options
Slabbed variations

1 OPEN RECTANGULAR SERVING DISH

This simple slab dish is completely made in a generic plaster press mold, making it quick and easy to repeat for production.

Handles: The handles are made from wide slab straps attached on opposite sides, level with the rim and curving round to fix to the underside.

Foot: None. For speed of production purposes; however, one could be added if required.

Uses: All-purpose serving dish for hot or cold foods.

2 MEDIUM STRAIGHT-SIDED BOWL

Made from soft slabs, this bowl is simple and quick to make. It is a useful shape to make in different sizes and proportions, and is very practical for storage.

Foot: None. The minimal aesthetic would be lost by any further additions.

Uses: A great salad bowl but suitable for serving any type of food.

②

3 & 4 LEAF-SHAPED SERVING DISHES

This is a quick and simple dish to make in multiple. Cut from a soft slab using a template and formed over a domed hump mold, the feet can be attached while it is in situ.

Handle: The stem of the leaf makes a perfect handle to lift the dish.

Foot: Made from four equally sized coils.

Uses: Serving any type of food that does not need to be contained.

③

④

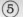

⑤

⑥

5 TRADITIONAL BOWL

This soft slab bowl is manipulated to develop the shape once the edges have been joined. The outline shape is cut using a template, which makes it easily repeatable.

Foot: A soft slab, reinforced on the inside to give a round and smooth finish. The outside edge of the base is turned to give the appearance of a foot.

Uses: Multipurpose domestic use, or for serving.

6 LIDDED SERVING DISH/CASSEROLE

Both body and lid for this dish are made in molds from soft slabs. The dish is press molded and a small gallery made by attaching a narrow strip of clay just below the inner rim. The lid is made over a hump mold.

Handles: Simple slab strap handles cut in a tapering shape to narrow toward one end.

Foot: None. The shape is pleasing without a foot ring.

Uses: A lidded serving dish for hot or cold foods.

7 FLAT SERVING DISH

This simple dish is quickly made from a slab of clay cut from a block with a wire slab cutter: this is a good technique for multiple production. The slab is shaped in a sling mold until the clay firms.

Foot: Four traditionally shaped feet are cut from a similar thickness of clay to the body.

Uses: Designed to serve two whole trout with garnish, but great for any food.

Technique
Slabbed dish

A plaster mold is the perfect example of a tool that can be used to speed up the process of making. The amazing thing is that one mold can often be used to produce many more items than it is designed for. A simple bowl press mold, for example, can be adapted to make pitchers or teapots, vases, or any number of other things. Once the basic shape has been made, it can be cut, adapted, and reconstructed to create another shape entirely, or the basic shape can be extended using techniques such as coiling or slabbing.

You do not even need to make a plaster mold yourself, because most pottery suppliers have a good range of shapes that can be adapted to your personal requirements. This project is one example of this, with a commercially bought plate press mold adapted to make a lidded serving dish. The mold is used to make both the dish and lid, ensuring a good fit and perfectly balanced shape.

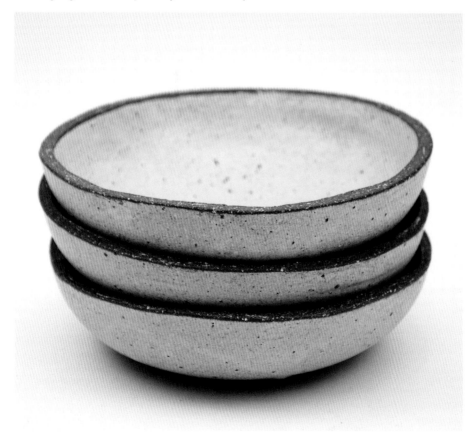

Slabbed bowls
by Susan Simonini
These rustic speckle bowls form part of a larger tableware range. They have been made by slabbing and pinching the clay, and high fired in oxidation to cone 10. They are a great example of what can be made using a basic technique with very little equipment and few tools.

Slabbed lidded dish

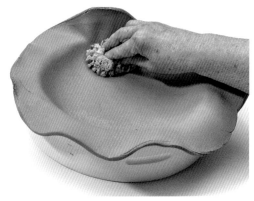

1 Roll a slab of clay large enough to fit into the mold in one piece. If you roll the slab on a sheet of plastic, you will find it much easier to position in the mold because it will stick to the plastic until it is in the correct position, but then easily peel away. Use a barely damp sponge to ease the clay gently into place, then smooth over the surface with a rubber kidney.

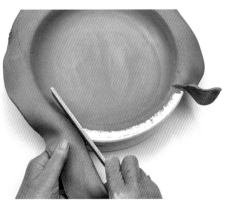

2 Place the mold on a sculpting wheel, then use a wooden batten to remove the surplus clay around the edge of the pressed shape. If you sit the narrow, flat edge of the batten on the plaster and hold it level as you rotate the sculpting wheel, the clay will come away to leave a perfect flat rim. Put the pieces of spare slab carefully to one side under plastic to prevent the clay drying out too much. It can be used later to make the handles.

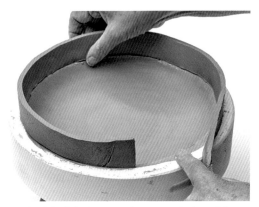

3 Roll a slab of clay long enough to cut a strip that will fit around the circumference of the dish. Use a wide batten to cut the strip and, while it is still in position after cutting, score the edge of the strip to be joined to the base with a serrated tool. Score the rim of the base carefully while still in the mold, taking care not to come into contact with the plaster. Slip both surfaces to be joined and position the slab strip in place, making sure the join is secure.

Slabbed dish continued

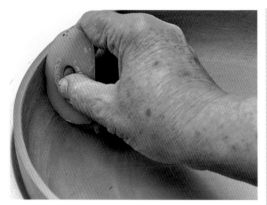

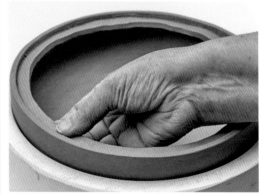

4 Reinforce the join on the inside of the dish with a coil of soft clay. Blend the coil in well using a finger or wooden tool, then remove the surplus clay with a rib: a rib like the one shown here is perfect for correcting the shape at the same time as smoothing the surface. The rim should be quite level because of the way the slab strip was cut, but if it is slightly uneven, correct by shaving with a rasp blade.

5 At this stage you can, if you choose, build the dish wall up another level by following Steps 3–4. Then, from the same slab used to cut the extension strip, cut another thin strip to form the flange on the inside of the bowl, ¼–½ in. (6–13 mm) maximum. Score the position for the flange on the inside of the dish, about ¼ in. (6 mm) down from the rim, and score one edge of the thin strip. Slip both surfaces and fit the flange into position. Neaten the join by removing any surplus slip and, if you can, reinforce the underside of the flange with a coil of soft clay.

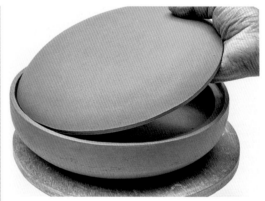

6 With the dish still in the mold and on a sculpting wheel, neaten the edge of the flange with a rasp blade. If you feel the flange is too wide, reduce the size in the same way: it is the ledge that the lid will sit on and needs to be able to hold it securely but not protrude so far that it dominates the dish. Once satisfied with the finish, turn the dish out of the mold onto a board. Neaten the join on the outside with a coil of soft clay if required and smooth over with a rib.

7 Roll another slab and press it into the mold as before to make the lid. Firm up the clay in the mold using a blow-dryer until it is the same as the body, then turn it out onto a board. Measure the fit of the lid on the dish. It will be too large, but this will give you an idea of how much it needs to be reduced in size. Return the lid to the board and shave the rim by small degrees, checking the fit constantly until it is correct, then leave in place on the dish.

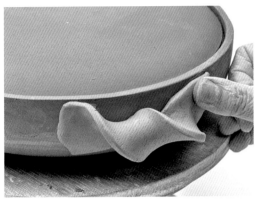

8 With the scraps of slab left over from the construction of the dish, make two handles or lugs for the side of the dish. A simple slab strap rolled into a curl makes a sturdy and practical handle for an item like this. Make sure you mark the correct position on opposite sides of the dish before attaching the handles. Score and slip all surfaces to be joined and press the ends of the curls into position. Make a small decorative impression in the clay to further encourage a good join to the side. Make another curl for the lid and attach in the same way to form the knob. Allow the dish to dry with the lid in place.

Tips when using molds

Never use sharp implements like knives when working with molds, since plaster can easily be cut, spoiling the mold, and because you don't want plaster getting into the clay, which can cause explosions during firing.

Clay will dry quite quickly in a mold because the plaster absorbs water from the surface in contact with it. You can dry the upper surface of the clay with a blow-dryer to further speed up the process, but keep the mold moving as you do this, and only dry to the point where the clay feels firm to the touch: it will quickly go beyond this point otherwise and become unworkable.

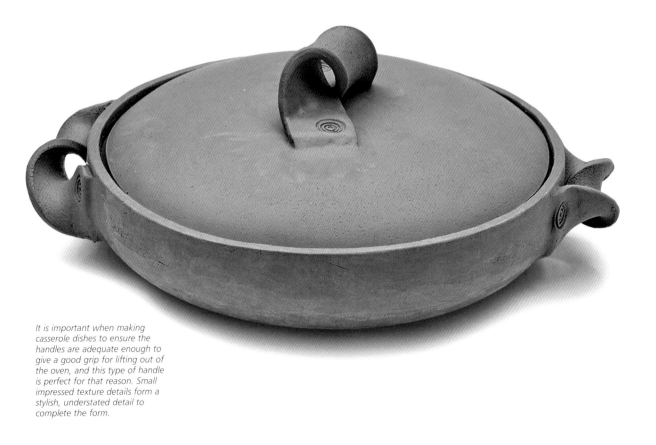

It is important when making casserole dishes to ensure the handles are adequate enough to give a good grip for lifting out of the oven, and this type of handle is perfect for that reason. Small impressed texture details form a stylish, understated detail to complete the form.

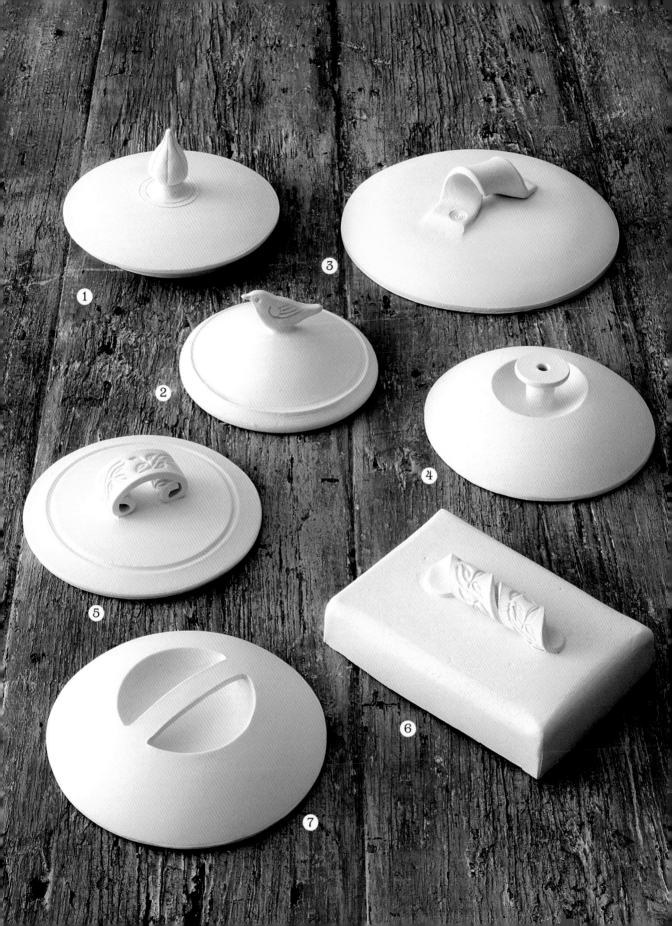

Design options
Slabbed, molded, and thrown lids

1 SLABBED AND MOLD MADE

This round lid is simply made by cutting a disk of clay from a rolled slab. The disk is formed over a hump mold to give the domed shape. The shape is designed to sit on the rim of a dish or bowl with a flange attached to the underside to locate or hold the lid in position.

Knob: The stylized knob is pinched from a small ball of clay that is later carved with a modeling tool to give the surface detail. When applying a hollow lid like this, a small hole should be made through the lid into the knob to allow for the release of air when firing.

2 THROWN DROP-IN LID

Designed for a small casserole or serving dish, this lid is a simple drop-in shape that fits on a flange in the dish itself. The lid is turned to a dome shape with a simple feature circle cut near to the rim.

Knob: Animal or bird shapes make great knobs for domestic wares. This little bird has been modeled from a small ball of clay with the line detail drawn in with a pin.

3 SLABBED AND MOLD-MADE DROP-IN LID

This lid, made specifically to fit a low, flat-based dish made in a mold, sits on a flange in the dish. Both dish and lid are made in the same press mold, designed for making plates. This is a great example of the multifunctionality of a simple plaster mold.

Knob: A simple slab strap, curled and joined to the lid at each end, provides good grip when lifting.

4 SLABBED AND MOLDED DROP-IN LID

This lid utilizes two molds made for other purposes. A slab disk with a central circle cutout forms the main part of the lid, with a second, much smaller molded bowl shape attached to the underside while still in situ in the larger mold—this forms the concave section for the knob. The lid sits on a flange in the dish.

Knob: A hollow tube formed around a piece of doweling with a flat disk attached to the top end. A hole is pierced through the lid, tube, and disk to allow for the release of steam.

5 SIMPLE SLABBED AND MOLDED DROP-IN LID

Formed over a hump mold, this simple lid is quick and easy to make from a slab circle. The addition of an incised line adds character to the lid and marks a line to glaze to or a point in which glaze will pool for decorative effect. The lid sits on a flange in the dish.

Handle: A textured slab strap, rolled at each end to form two curls, makes a good and sturdy handle with room to get the fingers under for ease of lifting.

6 SOFT SLABBED LID

Made from a single slab of clay with four small squares cut from each corner. This method produces soft, rounded edges when the corners are joined together, unlike a firm slab version made in sections, which would have hard, angled edges. Designed to either sit on a plate, inside a dish resting on a flange, or over a dish or shallow plate where the walls act as a flange, it is a very versatile design.

Handle: Rolled, textured slab strap formed around a thin tube into a long curl, which gives great purchase for lifting. Fixed to the lid at each end of the curl.

7 SLABBED AND PRESS MOLDED

This lid utilizes a bowl mold for the basic shape, and incorporates the handle into the primary form by simply cutting two semicircles out of the clay, about 4 in. (10 cm) apart, before positioning the slab in the mold. The concave part of the lid can be mold-made or pinched, but must be fixed to the underside when the lid is still in place in the larger mold.

Handle: Integral to the lid, the handle can be shaped more elaborately if required. Cut a template to ensure the shape is repeated exactly for both halves.

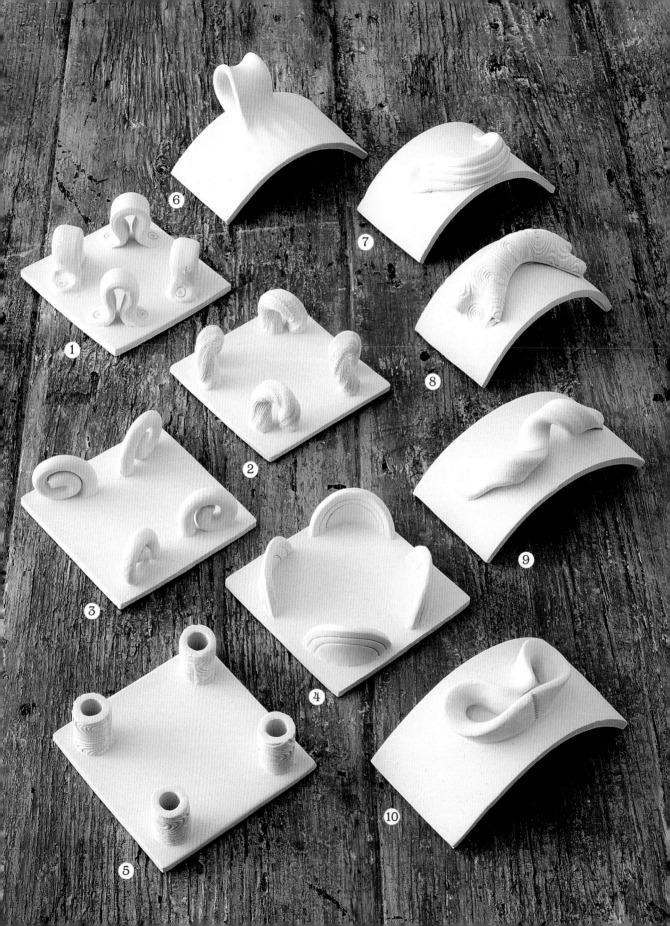

Design options
Coiled, slabbed, and pulled knobs and feet

1 PULLED FEET

This type of foot is quickly made from a pulled length of clay that is simply looped before attaching to the underside of a vessel. The loop can be as deep or shallow as required to suit the particular form.

Suitability: Particularly suits rustic dishes or deep plates, but could be applied to many forms, including teapots and bowls. Pulled feet can be applied to forms made by any method.

2 PULLED BARLEY-TWIST FEET

The barley-twist effect is achieved by scoring lines into a pulled length of clay, then twisting to give the characteristic effect. The feet are looped and attached at the butt ends. The point of attaching each end is slightly offset for variation.

Suitability: Large rustic thrown dishes and bowls, but could be attached to teapots or other forms to suit.

3 COILED FEET

Simply made by rolling round coils into tight round curls, this type of foot is surprisingly sturdy. Most suitable for earthenware forms to avoid the clay of the vessel slumping over the raised feet when firing, which can happen in higher firings.

Suitability: Smaller coils are suitable for cups, mugs, and teapots. Larger versions can be attached to plates, bowls, and dishes where appropriate.

4 SLABBED FEET

Simply made from a rolled slab of clay, circles are made using a pastry cutter, then halved before attaching to the vessel in a curved position. Incised lines give the feet added surface detail, but they could be textured or just left plain.

Suitability: Stylized slabbed bowls, dishes, and teapots. The feet shown here are exaggerated in size for clarity, so be aware that feet of this type should be modified to fit and balance with the vessel they are attached to.

5 HOLLOW, TUBULAR, SLABBED FEET

This is a very sturdy solution for vessels that need extra support. The slab is formed around a thin length of wooden doweling, then equal lengths cut before attaching to the vessel. The tubes can be cut quite short if preferred: the example here is larger than would probably be used to show the style off to best effect.

Suitability: Any suitable style of vessel made by any method, although slabbed teapots especially.

6 PULLED STRAP

Knobs should be quite substantial because they are generally attached to oven-to-table ware, and therefore need to be adequate for safe lifting. This knob is pulled as a wide flat strap before attaching to the surface in a loop to rise above the rim slightly. When in positon on the vessel the clay is manipulated slightly to give a curved appearance.

Suitability: Casserole and similar open dishes. Large bowls.

7 TRADITIONAL PULLED STRAP

This is a traditional shaped knob, simply pulled from a wide length of clay. The surface is incised with the nail of the thumb or a suitable tool before attaching to the side of the vessel in a curve to give the best grip for lifting.

Suitability: Generally and widely applied to thrown dishes and casseroles, but could be attached to some plates or vessels made by other methods.

8 HOLLOW SLABBED KNOB

This knob is made for a thin slab of textured clay formed around a thin tube. When removed from the tube the clay is manipulated into a curve and pinched at each end between finger and thumb, but not sealed off completely to allow for the escape of air when firing.

Suitability: Bowls, casseroles, dishes, and plates made by any method, including thrown wares.

9 COILED KNOB

Made from a slightly flattened coil, this knob is curled around a section of thin wooden doweling to give the twisted appearance, before attaching at each end to the vessel. The outward curl of the coil gives great grip for the fingers.

Suitability: Quick and easy option for all styles of vessel, made by any method, that require knobs.

10 PULLED AND CURLED KNOB

This knob is pulled as a wide strap, then each end curled around to join at the center to look rather like wings. The ends must be secured to the center before the whole thing is attached to the form. Extra detail, such as incised lines, can be applied if required. The knob is attached sideways to give a substantial handle for lifting.

Suitability: Especially good for thrown casseroles and other oven-to-table ware, but could be attached to vessels made by other methods.

Chapter 6
TEAPOTS

Teapots
Design decisions

In this fast-paced age, many might think the teapot is redundant, but really tea tastes so much better made properly in a pot, and to make a good one is such a great achievement.

The thrown teapot close up

For many, serving tea is almost ritualistic, and the beverage itself is elevated to medicinal levels as a salve for all kinds of problems. Such status should demand that this wonderful liquid is served from a wonderful vessel.

The lovely oriental-style lid is unembellished by knobs or handles, but has a raised edge that makes it easy to lift. It is wide and generous in proportion, a feature that will make the cleaning of this vessel much easier.

The teapot is decorated in an unsophisticated yet highly dramatic way with simple glaze treatments that make it look luscious.

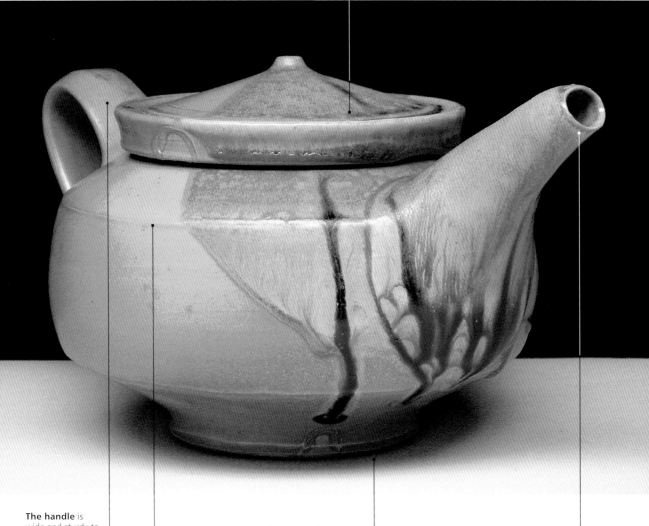

The handle is wide and sturdy to lift the pot safely, but is perfectly balanced in proportion to the rest of the pot.

The crisp way the body closes in at the shoulder gives a great sense of containment to the form.

The proportions of this teapot are perfect. It is not as tall as usual teapots, but is wider to accommodate several cups of tea.

The foot ring is directly in proportion to the lid in terms of size. It gives the squat form both lift and balance.

The spout is exactly positioned to rise above the lid of the pot, which is important to avoid spillages when filled.

The family teapot close up

A teapot for family use needs to be sturdy and generous in proportion, with the capacity to serve four to six cups of tea. A sturdy shape is most suitable in a home where the pot will be used regularly.

The lid locates securely on a deep flange on the body of the pot. The opening is wide enough to allow easy access for cleaning.

The strap handle is sturdy and comfortable, with a wide enough loop to ensure the fingers don't come into contact with the body of the pot when full of hot fluid—which is an important feature when the pot may be used by family members of varying ages.

The tip of the spout is angled to make sure it won't dribble after pouring. The tip also rises above the level of the water line to ensure hot fluids cannot escape accidentally before pouring.

The earthenware clay is simply glazed to produce a creamware-type surface, with the addition of a simple motif painted in underglazes to give a clean and fresh look that visually completes the form.

Four simple slab feet lift the base of the pot to prevent heat from the contents coming into contact with the surface beneath the pot. This is vital for a pot with a wide base like this one.

The body of the pot has been coiled to an inverted cone shape—wide at the base and narrow at the neck—which is a good shape to keep liquids hot.

The pot has a wide base, making it particularly sturdy. Pots with bases like this are less easily knocked over than those with narrower bases.

A good teapot is really something to possess, and to make a good working teapot is a great achievement. So often we can be delighted by a lovely designer teapot in a restaurant or café, but find its functionality does not match its looks: for example, it may not pour well; the tea spills when lifting; the spout dribbles after pouring; often the handle is impractical, making the pot difficult to lift; or the lid may fit badly.

To avoid these problems, there are some basic rules to making a good teapot that should always be followed. They can be applied to any design, be it thrown or hand built, and if adhered to will ensure a properly functioning pot that will be the envy of all who see and use it. In the following pages you will be guided through the process of making both a thrown and handbuilt teapot using these basic rules.

Incised teapot
by Mayumi Yamashita
Sometimes, a ceramic item almost sings because it is so pleasing to the eye, and this teapot is just one of those items. Made in white stoneware clay, the pot has a simple, incised surface that is complemented by a white matt glaze. The lovely roundness of the pot is beautifully balanced by the spout and handle, and the lid perfectly suits the form without the need for a knob.

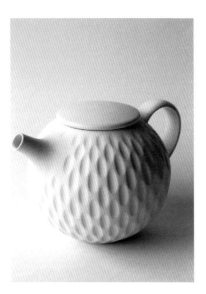

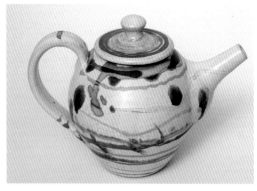

Teapot by Chris Barnes
This traditionally shaped teapot is wheel thrown in stoneware clay and fired in reduction in a gas kiln. A white feldspathic glaze forms the background for trailed colored glazes that perfectly suit the shape of the pot and add a visual sense of fun.

Questions to ask yourself

How big do I need the teapot to be?
The answer depends on how many cups you need to serve at any one time. A single person might like a pot that serves two cups, but a family pot might need to hold up to six cups, perhaps more.

What is the best making method?
Throwing a teapot requires a certain level of technical ability, so if you have not quite reached this yet, then opt for a hand-building method. If you have the skill to throw a pot, then here are some weights and measures for guidance:

Four-cup teapot
Clay weight: 1½ lb (0.7 kg)
Height when thrown: 4½ in. (11 cm)
Opening width: Approx. 2¾ in. (7 cm)
Standard round lid: 5 oz (0.14 kg) of clay

Six-cup teapot
Clay weight: 2½ lb (1.1 kg)
Height when thrown: 5½ in. (14 cm)
Opening width: Approx. 3½ in. (9 cm)
Standard round lid: 8 oz (0.2 kg) of clay

For both sizes, extra clay will be required for the spout and handle.

The same guidance cannot be given for hand building pots because so much depends on individual design.

Which clay should I use?
This is a preference and it doesn't really matter, providing the pot is glazed properly with a glaze that doesn't craze.
Firing temperature may also be a factor in making this decision. If you are using an electric kiln, the higher the firing, the more expensive it will be.

Design options
Thrown variations

1 CONICAL TEAPOT

This pot is thrown from a wide base to a narrower neck with an upright flange. The lid is thrown as an upturned bowl to locate precisely over the body.

Spout: The cutaway feature of this spout adds extra visual detail.

Handle and foot: The pot has a pulled strap handle, looped to align with the spout, and a flat, shell-wired base.

2 WAISTED CYLINDER

The waisted detail on this basic cylinder shape is created with a wooden rib while the pot is on the wheel. It has a jar-style cap lid that fits over a flange on the pot.

Spout: Standard shape and fit.

Handle and foot: Twisted coil lugs are positioned to accommodate a nonceramic handle (metal, wooden, etc.), and the base is flat and shell-wired off the wheel.

3 SMALL GLOBE TEAPOT

A lovely round pot with concave gallery and sunk-in lid that has been thrown at one time.

Spout: This is cut away at the tip to expose the pouring lip, a small design detail that adds character.

Handle and foot: The handle is pulled from the pot, is rounded at the top, and flattens slightly where it joins the side. The pot has a standard turned foot ring.

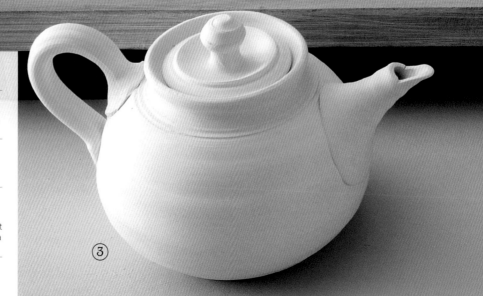

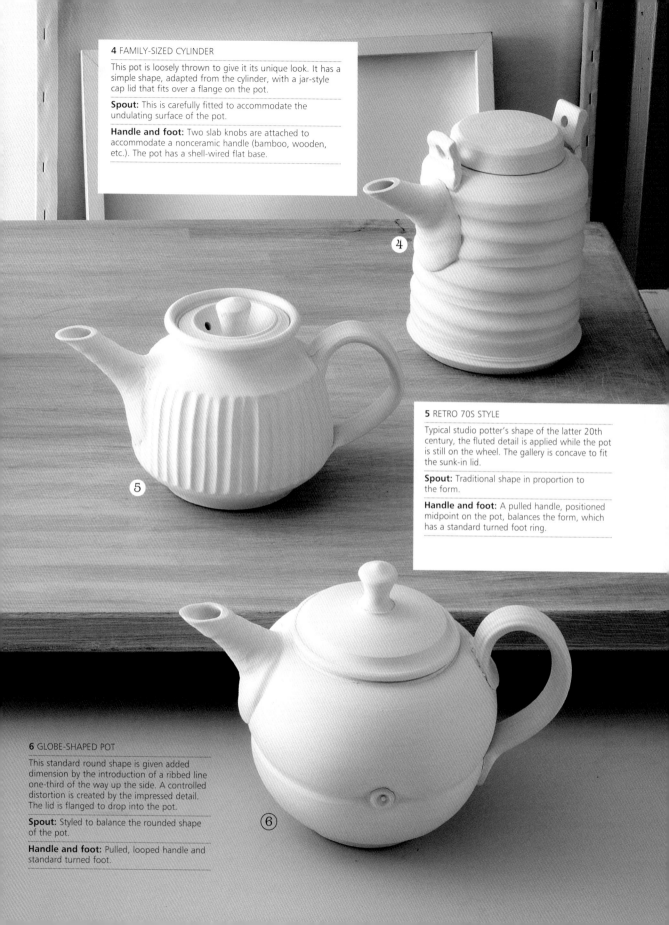

4 FAMILY-SIZED CYLINDER

This pot is loosely thrown to give it its unique look. It has a simple shape, adapted from the cylinder, with a jar-style cap lid that fits over a flange on the pot.

Spout: This is carefully fitted to accommodate the undulating surface of the pot.

Handle and foot: Two slab knobs are attached to accommodate a nonceramic handle (bamboo, wooden, etc.). The pot has a shell-wired flat base.

5 RETRO 70S STYLE

Typical studio potter's shape of the latter 20th century, the fluted detail is applied while the pot is still on the wheel. The gallery is concave to fit the sunk-in lid.

Spout: Traditional shape in proportion to the form.

Handle and foot: A pulled handle, positioned midpoint on the pot, balances the form, which has a standard turned foot ring.

6 GLOBE-SHAPED POT

This standard round shape is given added dimension by the introduction of a ribbed line one-third of the way up the side. A controlled distortion is created by the impressed detail. The lid is flanged to drop into the pot.

Spout: Styled to balance the rounded shape of the pot.

Handle and foot: Pulled, looped handle and standard turned foot.

Technique
Thrown teapot

The teapot is perhaps the most challenging item to make in clay because many different techniques are involved to make the various parts—body, spout, lid, handle, flanges, and foot ring. The key to success is to make all component parts in the same session so that they dry at the same time, to reduce the problem of cracking at joints. These parts must be in correct proportion to one another; therefore careful planning is vital.

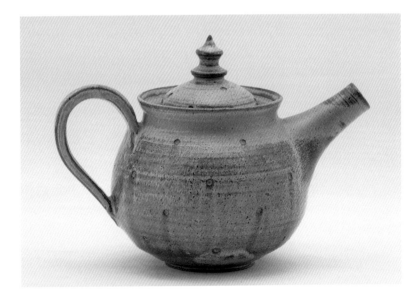

Remember when throwing the pot that the clay wall must be thick enough to retain the heat of water and to sustain sudden changes in temperature. Other things to consider are that the handle should be comfortable to use, and the height at the tip of the spout should be above the top of the pot or internal water line when full.

Thrown teapot by Michelle Daniels
The body of this pot has a simple impressed surface decoration that causes the blue-gray glaze to catch and run slightly, thus accentuating the detail. The lid has a lovely feature knob, which looks very pagoda-like in style. The teapot was fired to stoneware temperature.

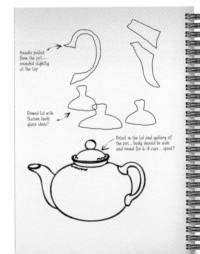

Handle pulled from the pot... rounded slightly at the top

Domed lid with feature knob, glaze ideas?

Detail in the lid and gallery of the pot... body should be wide and round for 6–8 cups... spout?

Sketching your ideas

• Decide on a size and shape for the body—round, cylindrical, conical, etc.—and draw several.

• Now decide on the shape of the spout, and try each of the drawings with a spout in different proportions. If the shape does not look good, alter accordingly.

• Do the same exercise with the lid, handle, and remaining features until you arrive at a shape that you are completely happy with.

Thrown teapot body

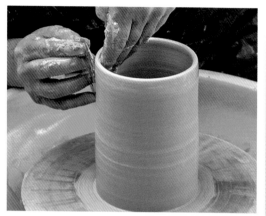

1 Center the clay on the wheel (see page 188) and throw a straight-sided cylinder with a base width approximate to the size you want it to be when finished (allowing for the clay that will be removed when turning the foot).

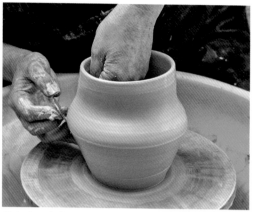

2 Begin to belly out the body with one hand inside the pot applying pressure and the other on the outside, using either the knuckle of the other forefinger or a rib (as shown) to lift the clay.

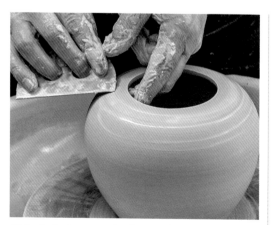

3 Continuing to support the shape on the inside with the fingers and using a rib in the other hand, carefully close the belly inward at the rim. When closed to the required size, carefully cut a raised flange around the opening using the tip of the rib—the lid will sit on this. You can also use the rib to form a waist at the midpoint of the pot if required.

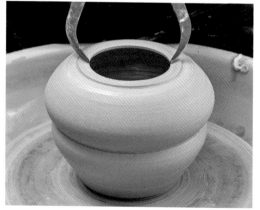

4 When you are happy with the shape, use a sponge to clean away excess clay and water from the inside of the pot and from around the base of the pot and wheel head. Using a set of calipers, measure the diameter of the rim. You will need this measurement later to make the lid accurately.

Thrown teapot lid

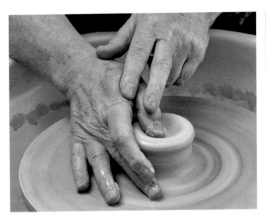

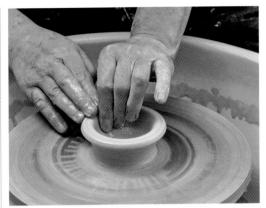

1 Center a small ball of clay directly on the wheel head. Now press the thumb of the right hand into the center of the clay to form a donut shape. Use the fingers of the other hand to steady and apply extra pressure over the thumb pressing into the clay.

2 Continue to open the shape as you would for a bowl with a rounded base (see pages 130–132). As you lift the wall, keep a thicker-than-average amount of clay at the rim. When the shape is opened to the required size, level the rim slightly with the fingers.

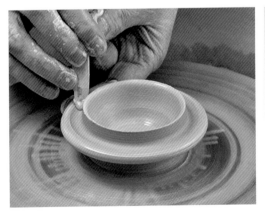

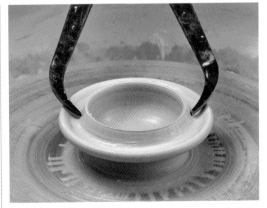

3 Using the caliper measurement taken from the body of the pot, mark the width on the rim. Now, with a finger on the underside of the clay and using a wooden tool or rib, carefully press down to split the thick rim, leaving the flange standing upright. Continue to work on the outer rim to correct the shape and neaten the edges.

4 Measure the diameter of the flange of the lid again with the calipers to ensure it will fit on the teapot. Make any small adjustments if it is either too large or too small. Remove excess clay and slurry from the base of the lid, wire it off the wheel head, and transfer to a board.

Thrown teapot spout

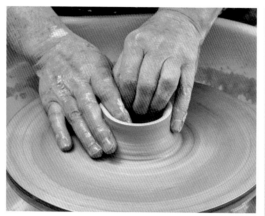

1 Center and open up a small ball of clay as a cylinder with hands in the position shown. The shape should be more conical than straight—do not allow the walls to splay outward.

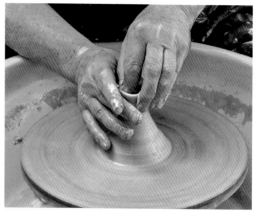

2 Start to collar the spout in using the finger and thumb of one hand to pull up the wall, while pushing the clay inward with the other hand.

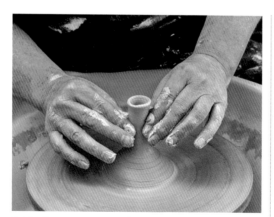

3 Continue to narrow and lift the spout to the required height using the fingers and thumbs of both hands in a pinched position, as shown.

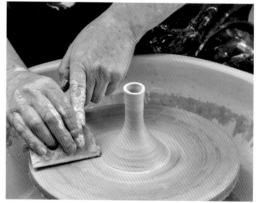

4 When you are satisfied with the shape and height of the spout, clean away excess clay and slurry from the surface using a rib, then repeat on the wheel head. Finally, cut a miter around the base of the spout, wire the underside, and transfer to a board.

Assembling the teapot

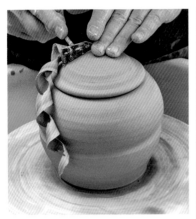

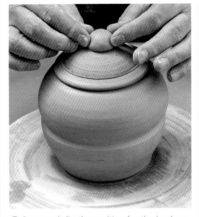

1 With the teapot still in its original place on the bat, and therefore centered, fix the bat back onto the wheel. Put the lid in place on the pot and, using a turning or loop tool, trim away the excess clay to form a domed shape to match the curve of the interior. Trim the clay down from the top of the lid to within half an inch of the rim so that it will sit flat on the pot.

2 Score and slip the position for the knob on the top of the lid, then roll a small ball of clay and drop it onto a surface to flatten it on one side. Position the ball on the lid. Using as little water as possible, now throw the knob to the required shape using the tips of the fingers. Wipe away any slurry left after throwing, then, using a hole cutting tool, make a small hole in the lid for the release of steam.

3 Wire the pot off the bat, remove the lid, and trim the base to form a foot ring (see pages 38–39).

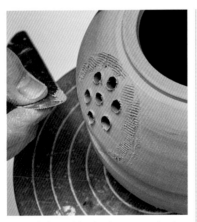

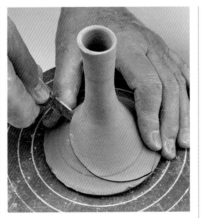

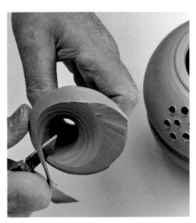

4 Mark the position for the spout and, using a hole cutter, make a series of holes to form the strainer. Neaten the holes on the inside of the pot to remove rough edges.

5 Prepare the spout by cutting at a diagonal angle so that there is more clay below it than above.

6 Thin the clay on the inside of the spout at the base so that it will fit flatter to the wall of the pot when in position.

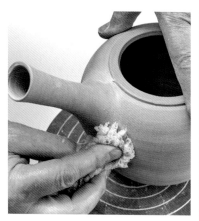

7 Score and slip the spout and corresponding position for attaching on the body, then fix into place, making sure the join is sealed. Wipe over the seam with a damp sponge to smooth the clay and remove excess slip.

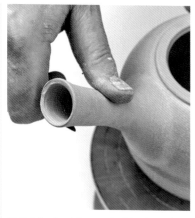

8 Cut the tip of the spout off level to a size that balances with the body of the pot, then soften the edge with a damp finger to neaten it up and ensure a good flow of liquid.

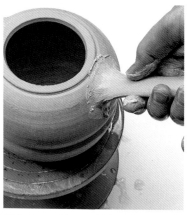

9 Score a position on the body for the upper part of the handle, exactly opposite the spout, then slip the marked area and push a fat coil of clay into place. Smooth over the join so that it blends onto the body wall. With a wet hand, pull the handle between the fingers and thumb of one hand, while supporting with the other until it is the thickness and shape you want it to be.

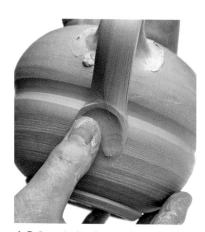

10 Curve the handle around into a shape that pleases you and also balances with the spout. Pinch off any excess between the fingers and then fix into place, making sure the handle is vertical. You can mark, score, and slip the position first if preferred to make sure it is in line. Smooth the clay into the body, sponge away any slurry or slip from the joins, and make a little ridge in the clay with the thumb as a final detail.

The completed teapot is perfectly balanced in the proportions of its component parts, making the form immensely pleasing to the eye, as well as being perfectly functional.

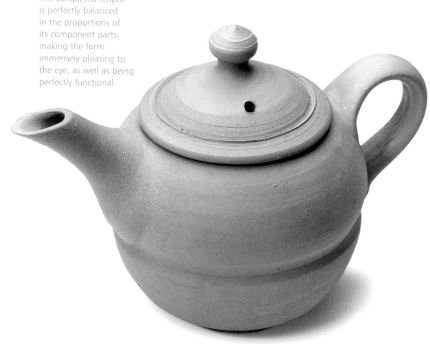

Design options
Coiled variations

1 ELEGANT SPOUTED TEA/COFFEE POT WITH AN ORNATE HANDLE

Constructed from flattened coils built onto a pinched base. The lid is pinched with a further coil added as a locating ring. A simple coil twist forms the knob.

Spout: Rising from the base, the top of the spout must be above the liquid line in order to pour well.

Handle and foot: The coiled handle is made in three parts before attaching, and a simple coil forms the foot ring.

①

2 FAMILY TEAPOT

Made in a plaster mold to give support while constructing, the decorative section is made from rolled, shaped coils blended on the inside only: the rest is blended on both sides. The lid is made in the same way, with a coil twist for the knob.

Spout: A flattened coil forms an open-style spout.

Handle and foot: A coil strap forms the handle with added decorative coils, and the pot has a flat base.

②

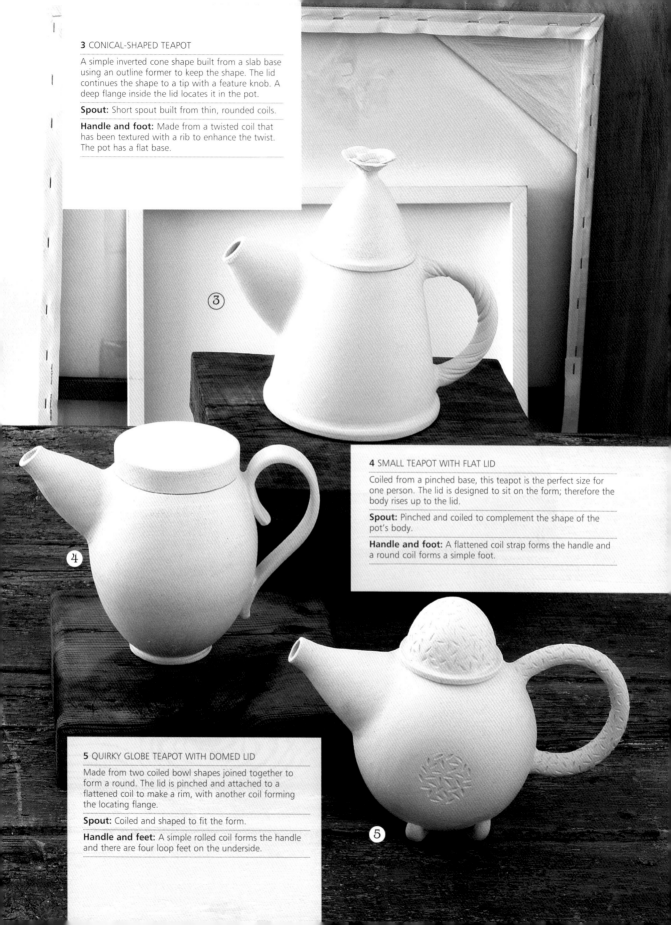

3 CONICAL-SHAPED TEAPOT

A simple inverted cone shape built from a slab base using an outline former to keep the shape. The lid continues the shape to a tip with a feature knob. A deep flange inside the lid locates it in the pot.

Spout: Short spout built from thin, rounded coils.

Handle and foot: Made from a twisted coil that has been textured with a rib to enhance the twist. The pot has a flat base.

4 SMALL TEAPOT WITH FLAT LID

Coiled from a pinched base, this teapot is the perfect size for one person. The lid is designed to sit on the form; therefore the body rises up to the lid.

Spout: Pinched and coiled to complement the shape of the pot's body.

Handle and foot: A flattened coil strap forms the handle and a round coil forms a simple foot.

5 QUIRKY GLOBE TEAPOT WITH DOMED LID

Made from two coiled bowl shapes joined together to form a round. The lid is pinched and attached to a flattened coil to make a rim, with another coil forming the locating flange.

Spout: Coiled and shaped to fit the form.

Handle and feet: A simple rolled coil forms the handle and there are four loop feet on the underside.

Technique
Coiled teapot

Coiling is a versatile method of construction that is particularly suitable for developing complex shapes, because the clay can be manipulated very specifically if required. For makers who prefer simplicity, very stylish forms can be built from round or flattened coils using an outline former to keep the shape. It is a making method that requires very little equipment and few tools, and is therefore good for people just starting to work with clay. It is also an intimate way of working that encourages a good understanding of the way clay behaves.

Teapots are the most challenging of items to make because of the many parts that form the whole, but making a good one can generate such a great sense of achievement. Just be aware that certain factors are really important for the pot to function well: it must have a sturdy handle that can lift the weight of the pot when full of hot liquid; the spout should not drip; the lid must fit well, etc. In other words, it must be fit for purpose and look good!

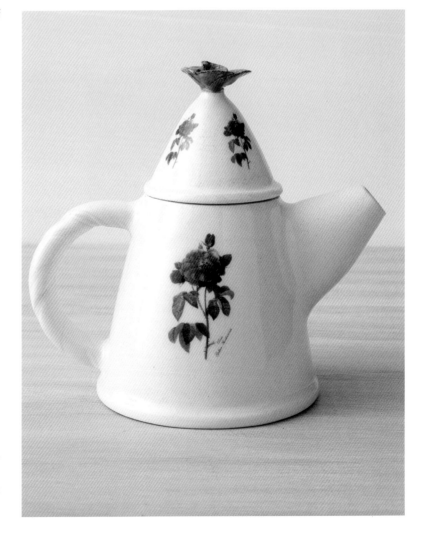

Coiled teapot by Jacqui Atkin
Made from white earthenware and simply covered with transparent glaze, the surface of this pot has been decorated with commercial rose decals to accentuate the detail of the knob. Glaze fired in an electric kiln to 2,048°F (1,120°C), the decals were later fired on at 1,346°F (730°C).

Coiled teapot

1 Score and slip the outer edge of the teapot base and one edge of the first coil, then fix in place. Where the coil ends overlap, cut through both diagonally, then score and slip the cut ends and join them together securely.

2 Reinforce the join on the inside of the pot with a coil of soft clay. Blend the coil in thoroughly and neaten up by smoothing over the surface with a rib or rubber kidney. Make your first test of the shape by positioning the former at the side of the pot and drawing it around the circumference. Make any corrections necessary: if it is too small, try pinching the clay evenly around the rim to expand the shape a little; if it is too big, cut small V-shaped sections from the wall in two or more places and rejoin the clay as you would in other places.

3 Level the rim of the pot with a rasp blade, then score, slip, and position the next coil. You can control the shape of the form by flattening the coils in a semicircle, then, if you attach the coil on the concave edge, the form will flare outward, and if on the convex edge, it will close in. Reinforce the join on both the inside and out with very thin coils of soft clay. Scrape away any excess with a rib and smooth over for a seamless finish. Test the shape with the outline former again and make corrections.

4 Continue to build the body shape in the same way to the desired height, then level the rim using a rasp blade. From a slab of clay, cut a circle to fit the top of the pot. You can measure this by sitting the pot on the clay and marking the opening with a pin. Cut a circle from the center large enough to give you sufficient access to the inside of the pot. Score and slip the edge of the disk and the rim of the pot, and join the sections together. Use a wooden paddle to tap the ring securely in place and smooth over the join to neaten it up.

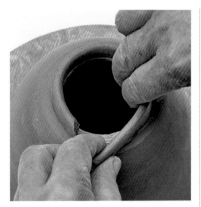

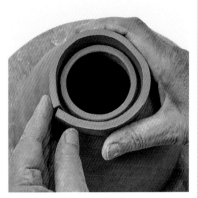

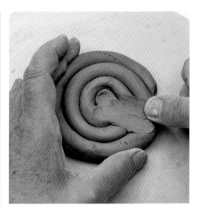

5 Make a flange for the lid from a thin flattened coil. Cut one side of the coil level using the edge of a batten to cut a straight line. Score the coil edge with the batten still in place. Score the position at the opening of the pot and slip both surfaces, then fix the flange in place, overlapping and cutting the edges as before for a neat join.

6 To begin making the lid, flatten another coil of clay slightly wider than the one made for the flange and form it into a circle to fit around the flange on the rim of the pot. Don't make the fit too snug, since there should be a little space between the two surfaces to allow for clay shrinkage. Join the ends of the coil and neaten the join.

7 Make the top of the lid by curling a round coil into a circle on a sheet of plastic. Make the circle fractionally larger than the ring made in Step 6. Blend the coils together and smooth over the surface. Transfer the circle to a hump mold if you have one, or over any surface with a domed shape—just make sure the clay can't stick to the surface by covering it with plastic wrap first. Blend the coils together, as shown, then smooth over the surface with a rib.

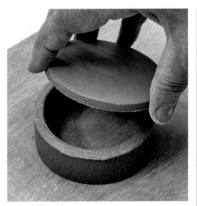

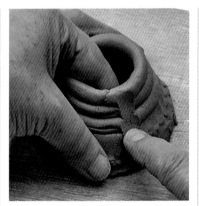

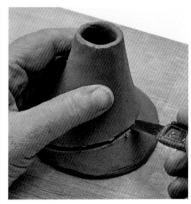

8 Fix the domed disk to the ring, making sure to score and slip all joining surfaces beforehand. Secure the join on the inside of the lid with a coil of soft clay blended in to give a seamless finish. Smooth over the join on the outside.

9 To make the spout, roll a long coil of clay on the thin side of medium thickness. Working on a board on a sculpting wheel, coil the clay upward from an open circle, closing in to form a cone shape. One coil may not be enough, but form the first one for its whole length, then blend the coils together, as shown, to establish the shape. Continue to extend the shape with as many coils as needed to complete the spout. Smooth the outer surface with a kidney or rib, then lift the spout off the board and very carefully blend the coils on the inside using a modeling tool.

10 Hold the spout to the body of the pot to estimate how the shape needs adapting to fit properly. You will have to do this by eye. Return the spout to the board and, holding it firmly in one hand, carefully cut it to the shape you require to fit the body. Most spouts require a semicircular section cutting away from midpoint either side, as shown, so that they stand more upright when fitted onto the pot. Remember that the top of the spout must be higher than the water level when the pot is full.

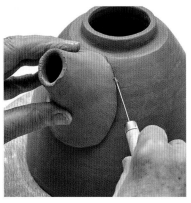

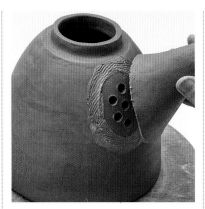

11 Fit the spout to the side of the pot and carefully mark the position with a pin. Remove the spout, then draw a second inner line about the same thickness as the clay of the spout wall. Inside the second marked line cut away a series of holes using a hole cutter—six to eight should be enough. Use a soft brush to neaten the holes on the inside of the pot, and empty away the fallen bits of clay.

12 Score and slip the marked position for the spout on the pot and the rim of the spout itself, and join the two together. If you can get your hand inside the pot, support the wall as you press the spout into place; otherwise, hold the spout for several seconds until you are sure the fit is secure. Reinforce the join around the spout with a coil of soft clay. Blend the clay into a seamless finish. Wipe over with a barely damp sponge if required.

13 Roll and flatten a coil of clay to make a strap handle. Use a wooden batten as a guide to cut the edges of the coil straight. Run your fingers down the length of the coil to soften the edges, then, if you like, use the edge of the batten to impress a line detail into the clay. Form the handle to the correct shape, measuring it against the side of the pot first to get the length right, then make a knob for the lid from the remains of the coil. Firm the handle and knob up a little with a blow-dryer to make it easier to attach and keep shape.

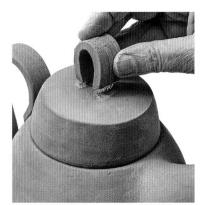

14 Mark the position for the handle exactly opposite the spout and fix it into position after scoring and slipping all relevant surfaces. Do not try to lift the pot by the handle at this point! You may need to reinforce around the handle with a tiny coil of soft clay. If so, make sure that all surplus slip and clay is blended in or removed to give a neat finish. Fix the knob onto the lid in the same way.

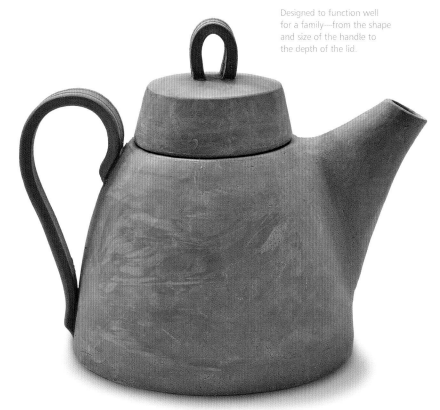

Designed to function well for a family—from the shape and size of the handle to the depth of the lid.

Design options
Slabbed variations

1 FOUR-SIDED POT MADE FROM FIRM SLABS

Made from equal-sized sections, the lid sits flat on the squared-off top of the form with an inner flange to locate. The knob visually completes the shape.

Spout: Made in a three-section triangular shape.

Handle and foot: This strap handle is shaped to mirror the body and balance with the spout. The base is made from a slab draped over a hump mold, which naturally forms four feet and elevates the body.

2 SOFT SLAB MEDIUM-SIZED POT

Constructed from two slabs joined with exposed overlapping seams. The drum-shaped lid has a deep rim that sits over a raised flange, jar-style.

Spout: Made from a soft slab shaped as a cone before fine modeling and cutting to size. Positioned in a raised style so that a small section is above the top level of the pot.

Handle and foot: A slab strap attached to the spout forms a very secure handle, and the flat base gives stability.

4 CIRCULAR, ART DECO STYLE

Made from firm slabs, two disks for the sides and a wide slab strip to complete the body. The lid sits on the surface with a flange extending into the body to locate.

Spout: Made in four sections and designed from a small circle.

Handle and foot: A wide strap handle complements the body shape, and two slab feet support and elevate the form.

3 RECTANGULAR TEAPOT

Made from two shaped side sections divided by a single slab running from front to back. The lid sits on the surface with an inner locating flange and simple slab knob.

Spout: Made in four sections.

Handle and foot: Cut from a thick slab, the handle is designed with a notch for extra support when lifting. The base is recessed to show the cut detail at the bottom of the pot.

5 TALL, STYLIZED TEAPOT

Made from two arch-shaped side sections and divided by a single slab running from base to base. The lid is recessed into the body, giving a seamless line with a stylized slab knob.

Spout: Made in four sections from a template.

Handle and foot: The strap handle sits over the top of the body, creating greater visual height, and to compensate for the pot's flat base.

Technique
Slabbed teapot

Slabbing allows the maker to work in two ways, to construct angular forms or soft organic ones, depending on the stiffness of the clay when assembling the parts. Teapots can be made from either type of slab and, accordingly, those made from stiff slabs will have sharper features because the clay has less flexibility once firmed up, while those made from soft slabs can be more rounded as the clay can be manipulated more readily.

The most important feature for a teapot is functionality; therefore the principles of making are basically the same as for the thrown example (see pages 158–165), but essentially there are a lot more joins in a slabbed pot, so it is vitally important to make sure that they are very securely fixed together because these are the points most vulnerable to cracking.

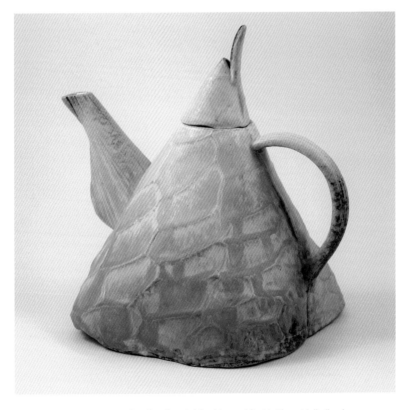

Sand series slabbed teapot by Matthew Mulholland
This unusual teapot has been made from textured and stretched stoneware clay slabs. The lid has a thrown and attached interior to locate it, and the surface has been sprayed with lithium and cobalt glazes, before firing to cone 6 in oxidation.

TIPS

• Try the same exercise as for the thrown teapot (see page 158), drawing the pot in various proportions with all additional parts to get the dimensions right and a shape that pleases.

• Softer work will need some support when constructing—scrunched-up newspaper can be used inside a form and then left in place, since it will burn away in firing.

• Sponge or foam cut to shape, wooden supports, and temporary clay stretchers will all support the clay until it is firm enough to support itself, but must be removed before completion of the form.

• Clay itself can be used as a prop for parts and has the advantage that it can be shaped specifically to support a particular shape.

BEFORE YOU BEGIN

> Construct the shape in thin cardboard template form first, then dismantle and keep the sections to use later when cutting out the clay. This will give a good indication that the proportions of the pot are correct and that it will work well.

> Roll out a slab of clay large enough to cut out all the parts of the pot if possible. If this is not possible, prepare a second slab at the same time.

> Allow the slab to firm up to just before leather-hard before cutting the parts out. The side sections need some flexibility to curve into place.

> Turn the slab over from time to time to allow it to firm up evenly.

Slabbed teapot

1 Mark the position for joining the inset base by placing it in position first, then running a pin along each side. Score both the marked position and the edge of the base slab.

2 Slip the scored edges, then fix the sections together securely (holding the slab in place for a moment and applying some downward pressure will help). Reinforce the join with a coil of soft clay and blend it in with a wooden modeling tool.

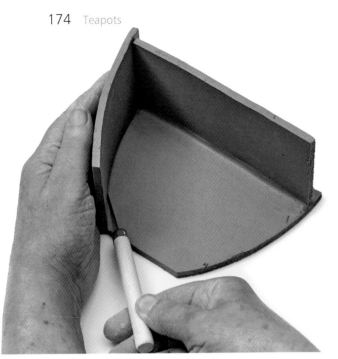

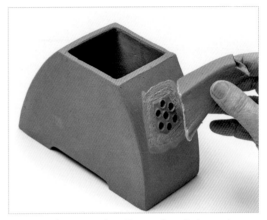

3 Position a side panel on the outer edge of the construction and gently curve it into the correct shape, as shown. Now repeat the exercise of marking the position for joins as before—score, slip, and fix the part in place, then reinforce with soft clay.

4 Repeat the process of marking, scoring, slipping, and reinforcing for all parts of the body and make the spout in the same way, joining the four sections together. Mark the place for the spout on the side wall of the pot, then cut out a series of holes within the marked area using a hole cutter. Score and slip all relevant surfaces before fixing the spout in place and reinforcing with soft clay.

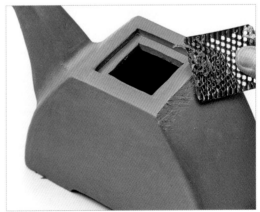

5 Join the two sections that form the top of the pot and the flange together so that the smaller section fits below the larger one. Score and slip before joining, then neaten up the joins to remove excess slip.

6 Fix the top of the pot in place as for all other joins. Refine the shape using a rasp blade to remove excess clay if necessary. Smooth over the shaved areas with a rib or kidney.

7 Fix the knob in place on the lid and make a small hole to one side for the release of steam when the pot is in use. The knob here is an inverted copy of the shape of the pot, but any shape could be attached to give the pot character.

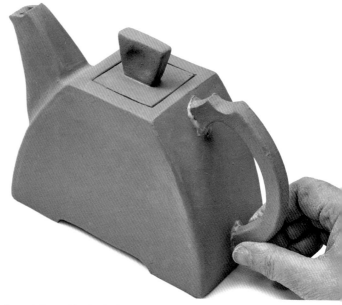

8 Finally, mark the position for the handle, making sure it aligns with the spout before fixing it in place. If you think it may need extra reinforcement, secure the joins with tiny coils of soft clay, making sure to blend them in well to the body and the handle itself.

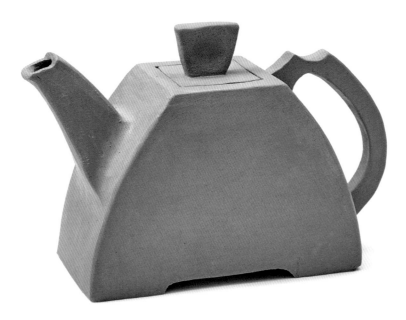

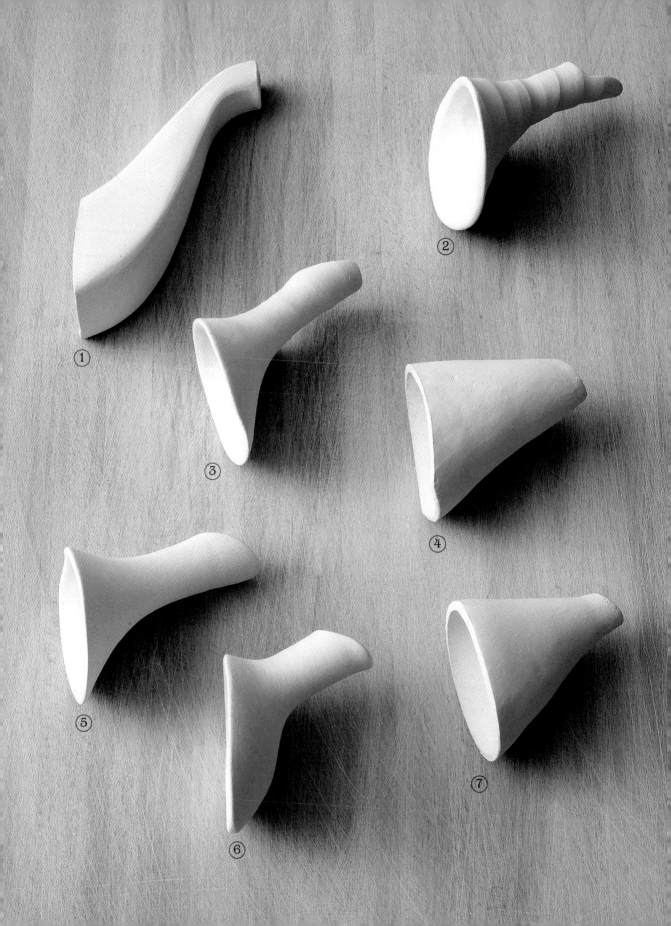

Design options
Handbuilt and thrown spouts

1 LONG HANDBUILT SPOUT

A long and slender spout with clearly defined edges. This spout is made from four semi-soft slab sections. The clay needs a little malleability to round and soften some of the sections when constructing.

Suitability: A tall and elegant slabbed or coiled tea or coffee pot with similarly defined details and proportions.

2 THROWN SPOUT WITH STYLIZED TIP

The spout is short in length with slender proportions. Loosely thrown to show the throwing rings on the outside as a design feature, the spout is first formed quite long to allow the detail of the tip to be cut and shaped, and the base is shaped to fit the pot.

Suitability: Ideally suited to any similar loosely thrown pot, but particularly simple cylindrical forms.

3 THROWN SPOUT WITH OPEN POURING TIP

Similar to the previous spout (2) in basic shape but slightly shorter and even more slender at the midpoint. Finely thrown, the surface has been smoothed so that the throwing lines are less obvious. The tip has been cut on a long diagonal to open the end, then the very end of the tip is squared off as a final detail.

Suitability: Traditional-shaped thrown pot of rounded proportions, or a cylindrical form.

4 SHORT HANDBUILT SPOUT

This spout is short, oval-shaped, and narrow at the tip, but generous at the point where it fits to the body of the pot. The base has been cut square at the lower edge as a design detail that matches the style of the pot. Shaped from thin, round coils, this spout is first made in the round, then manipulated into an oval once the surfaces have been refined. The base is cut square as a final refinement to fit to the shape of the pot.

Suitability: A similarly oval-shaped pot of medium to large proportions, made by the coiling or even slabbing method.

5 SHORT THROWN SPOUT WITH FLARED TIP

A short but robust spout, thicker in dimensions than the previous examples (2 and 3). This is a sturdy spout thrown and finished in a traditional style. The tip is simply cut at an angle to allow good pouring, and the surface has been refined to remove all traces of the making method.

Suitability: Any thrown pot of any style.

6 SQUAT THROWN SPOUT

This spout is rounded and very short. Thrown in a slightly different way with a rounded/bellied base to fit to a dedicated shape. The mid-section of the spout is really very short, and the tip cut at a traditional angle and slightly shaped in order to ensure a good pour.

Suitability: A small, round thrown pot suitable for two or three cups of tea

7 ROUNDED, SQUAT HANDBUILT SPOUT

A short, round spout with a slightly stylized tip. It is made from a single soft slab cut from a template. Making it in soft clay allows the tip of the spout to be shaped more easily once the edges have been joined and neatened.

Suitability: A small and quirky round pot made by coiling or slabbing.

Technique
Thrown spouts

The spout is an important component of the teapot form because it has the greatest function. No one likes a dripping spout. Making spouts that function properly is notoriously difficult, and the problem can be simply that the angle of tilt is incorrect or the end of the spout has been cut badly and poorly finished off.

For both aesthetic and functional reasons it is important that the spout is proportionally balanced with all the other components of the pot, but because this is pertinent to the style and size of pot these decisions can only be made at the time of making. However, certain basic rules apply to making and, if obeyed, they will greatly improve the chances of success.

Thrown spout variations

There are various spout variations that you might want to consider.

Twisted surface

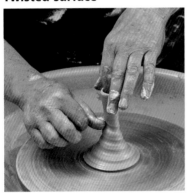

Add a little character to the spout by creating a twisted surface detail. This is not the same as throwing the spout in a twisted fashion, but rather a finishing touch. With the finger of one hand inside the spout to keep the shape, and with the wheel turning relatively slowly, gently draw the thumb up the outside of the spout. You must perform this maneuver all at once, since the clay generally will not tolerate a second attempt and the finish will be different.

Traditional curved

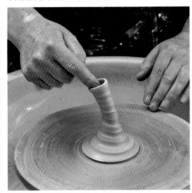

Curved spouts are usually made longer than usual to accommodate the alteration of shape in the spout itself, but also for larger and different-shaped pots. To make the curved spout, simply insert a finger into the end when you have completed throwing it, and bend it over to the desired shape. It is best to do this when the spout is still on the wheel head and the clay is still soft.

Information for thrown spouts

- Spouts are generally thrown from a relatively small amount of clay, ½ lb (225 g) or less.

- Always make spouts larger than required to allow for the shape to be cut to the correct size for the teapot.

- Throw a selection of shapes in various proportions and keep the spares for future reference—you can even biscuit fire them if required.

- Once you have decided on a spout shape, throw a couple of spares in case you make a mistake with the first one when fitting to the pot.

- Throw spouts as smoothly as possible, since excessive twisting will cause warping when firing, especially in high-firing types of clay.

- The tip of the spout must always be higher than the water level to prevent easy spillage of hot liquid.

Alternative base shape

This method changes the shape where the spout fits to the body from round to oval, and is particularly suitable for a tall teapot or coffee pot. The same principles of cutting the shape to fit the pot apply.

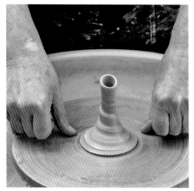

1 Once the spout has been thrown, wire it off the wheel head.

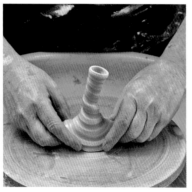

2 Squeeze the shape at the base gently while the clay is still pliable, to an oval shape.

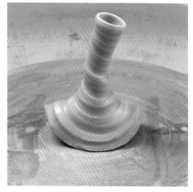

Finished spout

Contemporary spout

This spout is most suited to a sharp, angled, cylindrical-shaped pot.

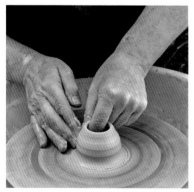

1 Throw a small cylinder that slightly closes in to a conical shape at the rim. You can close it in more than is shown here if required, to suit your own pot, but this type of spout generally has a wider opening than usual. Use a rib to remove all surface slurry and throwing rings—the wall should be smooth and unblemished. Cut a small miter at the base of the spout with the tip of a rib and clean excess clay and slurry from the wheel head.

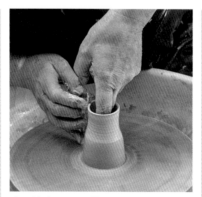

2 With the spout still in place on the wheel and using a rib or similar tool, press one side of the spout in gently as shown. Now turn the spout and make another indentation with the rib on the opposite side to create a figure eight opening where one half of the "eight" is slightly smaller than the other. Wire the spout off the wheel head and transfer to a board to firm up before cutting to fit your pot.

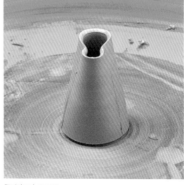

Finished spout

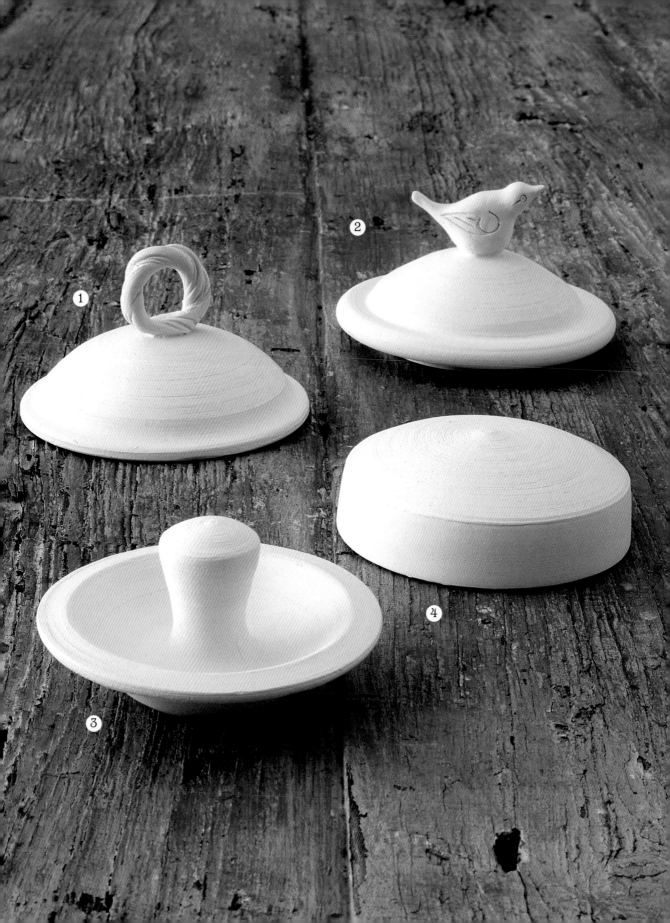

Design options
Coiled, slabbed, and thrown lids

1 THROWN AND COILED GALLERY
DROP-IN LID

Designed to sit on a gallery in the pot, this is a typical example of a simple lid suitable for a teapot or bowl where the opening is narrowed. It gives good heat retention for pots containing hot fluids. The upper surface of the lid is turned in order to produce the domed shape.

Knob: Coiled, textured, and twisted into a circle before attaching to the lid. The same knob could be made by the pulling method.

2 THROWN AND MODELED FLANGE LID

This style of lid has a flange that locates it on the pot. The lid itself rests on the wall of the pot, thus providing a good dust cover because it extends over the rim when in place. The upper surface of the lid is turned to produce the domed shape.

Knob: Modeled bird, made from a small ball of clay formed to the outline shape with detail drawn in using a potter's pin.

3 THROWN CONCAVE SUNK-IN LID

This type of lid is thrown upright and completed all together. It is generally thrown off the hump so that several lids can be produced in one throwing session. The style of pot this lid fits has a slanting or curved gallery. Generally, no turning is required to finish this lid.

Knob: The knob is thrown at the same time as the lid itself. The shape you see here is traditional, but there is scope to make the knob more stylized if required.

4 THROWN AND TURNED JAR-STYLE CAP LID

This style of lid is designed to fit over the rim of a shouldered pot. It is a simple, stylish lid that gives an oriental aesthetic to a pot and provides a good dust cover. In some instances, deeper versions of this type of lid are used as cups for the liquid content.

Knob: The style specifically does not have a knob, although one could be attached if preferred.

Technique
Teapot lids

For many makers, especially those working in batch production, it is not time efficient to weigh out lots of individual and small amounts of clay to make lids, so instead they make them using a method called throwing off the hump. This technique allows lots of small items to be made from a cone of clay, including small bowls and teapot spouts as well as lids.

Drop-in lid that sits on a gallery

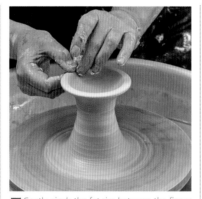

1 Begin by centering a large piece of clay into a cone. The cone should be wide at the base and not too thin. Form a waist just below the top of the cone, as shown, then flatten off the top so that it splays out to a doorknob shape. With the fingers of the right hand nestled around the waist of the cone, gently press down with the thumb to open out the lid. Use the fingers of the other hand to support the clay and keep it centered as you press down.

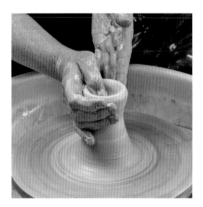

2 Open the shape of the lid to form a small bowl. Use the left hand to lift the wall, gently pinching the clay between fingers and thumb as the shape develops. The right hand keeps the shape on the outside and should operate in tandem with the left as the shape develops. Leave the lid rim slightly fatter.

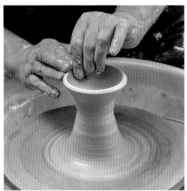

3 Gently pinch the fat rim between the finger and thumb of one hand so that it splays outward from the main form. Use the other hand to support and keep the shape as the rim is formed. Run a rib over the rim to ensure it is flat and neat. Measure the lid with calipers to check the size is correct for the pot, and make any adjustments required.

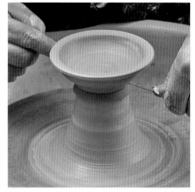

4 Using a rib or sharp implement, carefully cut a groove into the cone at the point where the lid is to be wired off the hump. Wipe excess slip from the inside and outside of the lid with a sponge. Holding a cutting wire taut between two hands, and with the wheel turning slowly, carefully draw the wire through the clay at the marked point. Lift the lid onto a board and allow to dry to leather-hard before turning and applying a knob of choice (see page 162).

All-in-one lid with integral knob

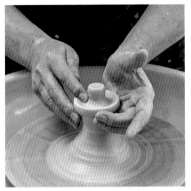

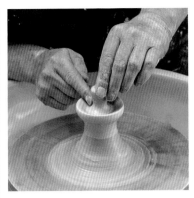

1 Start by following Step 1 for the basic drop-in lid (left). This lid is made as a saucer with a knob in the center, so begin by separating the two parts. With the left hand cupping and supporting the outer wall, gently press down with the forefinger of the right hand to divide the clay as shown, and form a well around the central knob.

2 Before developing the shape of the saucer the knob shape should be defined and refined to your required shape. It is a tricky detail and only one finger can be used to throw the outer profile, while the upper end is kept central between the finger and thumb of the other hand. Try to refine the knob quickly and with as little water as possible: it requires a delicate but confident touch.

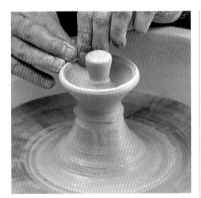

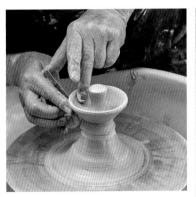

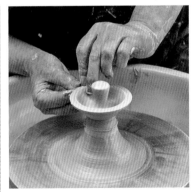

3 Now pull out the saucer part of the lid between fingers and thumb in a gentle pinching action. Use the fingers of the opposite hand to keep the rim level as the shape is opened out. Measure the lid with calipers and make any adjustments required.

4 Very carefully refine the underside of the lid using a rib to form the shape and remove any excess clay from the surface. Support the inside with a finger as you complete this stage. Using the same rib, divide the lid off from the hump by scoring a V-shape cut at the point where the lid will be wired off. Be careful where you cut, but do not take more weight than you need. You cannot turn a lid like this, so the cut has to be accurate.

5 Finally, flatten the outer rim slightly between finger and thumb to create a secure fit for the lid on the flange of the pot it is made for. Carefully sponge away any excess slip from the surface of the clay, then wire the lid off the hump with the wheel turning slowly, as for the basic drop-in lid. Transfer to a board to dry. The lid is now complete and does not need to be turned.

Chapter 7

MAKING METHODS

Formers, templates, and profiles

You can achieve great mastery of shape using formers, templates, and profiles. They allow a handmade item to be made as accurately as a thrown form by controlling the shape throughout the building process. Alternatively, the thrown form itself can be adapted by the use of profiles to create individual details of form.

Formers

These are items that clay can be formed on or around. In theory, a plaster mold is a former, but really there are many alternative items that can be used as effectively that do not need to be specially made, and the best formers are things we all have easy access to.

Two simple ideas for formers
Cardboard tubes
• All sizes are useful for different vessels.
• Use to make cups, mugs, pitchers, bowls, and dishes.
• Clay can be wrapped around these formers or cut sections of slab draped over them to give shape before joining.

Wooden blocks
• Use to make square cups, mugs, pitchers, or dishes—the clay can be wrapped around the blocks in the same way as cardboard tubes so you don't need to join lots of edges.
• A short length of 2 x 2 in. (5 x 5 cm) is a good size for cups.

Profile templates for coiling

One of the best methods of keeping shape when coiling a round form is to use an outline profile template or former. This is simply an outline shape of the item to be made and is usually cut from a rigid material like thick cardboard, thin MDF, or acrylic sheet. Profiles used for projects in earlier sections can be found on page 217.

Making an outline former will help you keep control of the shape as you build coiled vessels. Use thin MDF, thick cardboard, or hardboard.

What to consider when making a former
• The board should be large enough to allow you to hold it comfortably when in use. Take a rough measurement by gripping the side of the board before drawing and cutting out the shape.
• Draw the outline shape with a black marker pen—it is easier to see than a pencil line when cutting out.
• The board must have a level base so that it can sit on the board that the pot is made on to keep the shape true.
•To use the former, hold it flat on the board the pot is sitting on, then draw it carefully around the form to check the shape. It will help if the board is sitting on a sculpting wheel to do this. Any corrections to the shape should be made as soon as they are deleted.

Using templates and profiles when throwing

Templates and profiles are a great way to start adding details of individuality and quality of finish when throwing. They are very simple to make and use. Throwers will often have a collection of these ready-to-finish bases and rims—some may even use them for the whole profile of small forms if they throw similar forms repeatedly.

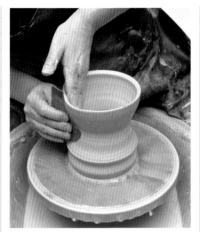

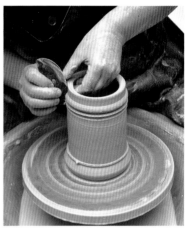

1 Templates and profiles can be used at the wet throwing stage or at the next stage of turning when the clay is leather-hard and a crisper, hard-edged profile is required. Use wood or plastic for ease of cutting, or metal. Old credit cards are ideal for this. Simply cut your desired profile into the card and sand to refine the edge and remove any burrs.

2 When using a template with throwing, press the template against the side of the form and the soft clay will take the exact profile offered to it. It is best achieved in several firm but gentle actions with the addition of water in between to achieve the perfect result. When used while turning, the clay will be easily subtracted.

3 The template is offered up to the side of the form at different angles while throwing to achieve different profiles. The inside left hand can gently press the clay into the profile of the template. You can apply small amounts of water to prevent dragging.

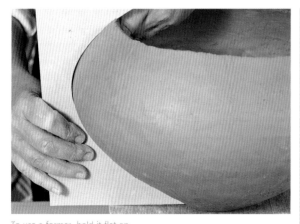

To use a former, hold it flat on the board the pot is sitting on, then draw carefully around the form to check the shape.

Templates for slabbing

Templates for slabbing are simply the outline shapes used to cut out accurate sections for slab wares like teapots, cups, mugs, bowls, and dishes. They are used throughout the book for various items, and if you want to use them repeatedly it is worth using a durable material like thick cardboard or acrylic to cut them from.

You will find it useful to label and number your templates and keep the various sections together in files. It is also useful to keep a master copy for when the templates wear out if you are intending to use them a lot. Templates for some items made earlier can be found on page 216.

Techniques: Throwing

Throwing is arguably the most difficult making technique to master. The fundamental key to success is practice, but often the most simple tip—such as being shown the correct hand position— will revolutionize your understanding of a process and make the difference for early success. This section is full of essential tips and information to start you off throwing.

Centering the clay

You can achieve nothing on a wheel until you can center the clay. From the basic hand position through to fully centered clay, this section will take you through all the key stages of this most important technique.

Positioning the clay on the wheel

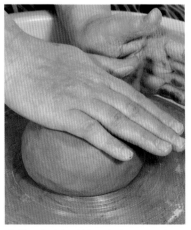

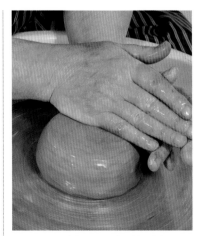

1 The wheel head must be clean, dust-free, and moist in order for the clay to adhere to it. Wipe over the surface with a damp sponge— don't use excessive water, or the clay will slide off the wheel head as it gathers speed.

2 The wheel should be spinning at speed as you center the clay, but slow it down to open out and lift the walls. Try not to spend too long centering the clay or you will overwork it, but do take the time to perfect the centering technique before moving on to the next stage.

3 Brace your left arm on the side of the pan. This hand controls the side of the clay. Your right forearm should also be braced on the pan to allow the edge of your hand to control the top of the clay. Keep your back and shoulders rigid, with your elbows tucked into your body for support.

Centering any weight of clay

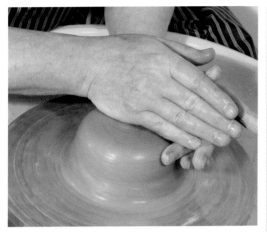

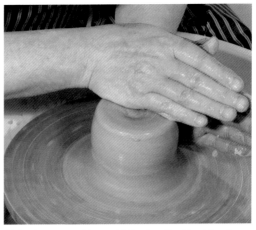

1 The following technique will allow you to center any weight of clay once it is positioned on the wheel. Set the wheel spinning and dribble a small amount of water over the clay.

2 Apply pressure with your left hand on the side of the clay so that it rises as it rotates.

Opening up

"Opening up" is not a call to confess all, but the next stage in the throwing process. This is the term used to describe the technique of making an opening in the centered ball of clay to begin to form the wall and base of a pot.

Start with the thumb

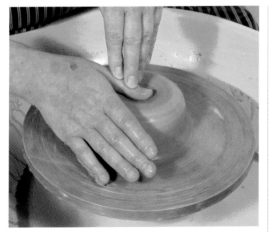

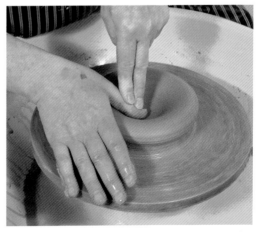

1 Place the flat of your right thumb over the center of the clay and place the fingers of your left hand on the thumb for added pressure. Push your thumb into the clay so that the ball opens up into a donut shape.

2 This will allow you to see inside and judge the depth, and will help to prevent you knocking the clay off center. Don't try to open up the clay by creating a vertical hole down through the center—keep your thumb flat! Remember to lubricate the clay from time to time.

Three essential hand positions for opening up

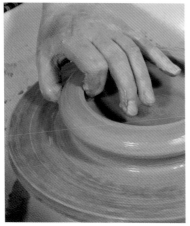

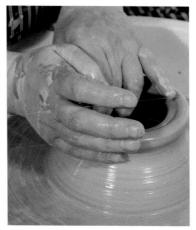

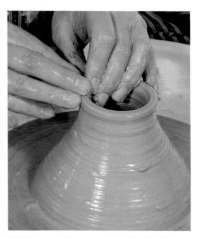

1 With the first finger of your left hand inside and your thumb on the outside of the clay wall—pinching like a crab's claw—gently squeeze and lift the wall up an inch or so.

2 Now place your right hand on the outside of the form and continue to lift the form upward and inward. Your right hand prevents the clay from naturally opening out. You should be aiming to keep the base broad and the top narrow.

3 When you have completed the first lift, check that the top is running true. You can consolidate by carefully holding the rim between the fingers of your left hand, while gently applying pressure with the fingers of your right. You should do this after each lift. If there is excessive unevenness, remove the rim with a pin or wire.

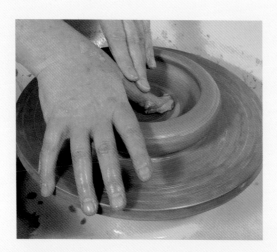

A strong base

It is important to compress the clay in the base of the pot by running your thumb over the surface from the center to the outside edge three times to prevent the base from cracking. Alternatively, you could use a knuckle, sponge, or rib to compress the base. Using the same thumb positions, open up the form by applying pressure across the base to the side, bending the thumb of your right hand from the flat position as you reach the edge, to help shape the wall.

Knuckling-up and lifting off

Knuckling-up is critical to the success of lifting the clay smoothly and efficiently into a cylinder.

Foolproof knuckling-up

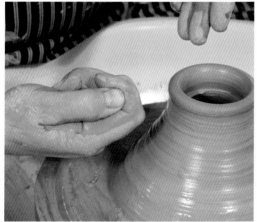

1 Narrow the cylinder slightly toward the neck by exerting inward pressure with your supporting hand. After each lift, use your fingers to compress the rim inward and downward at the same time to keep it level.

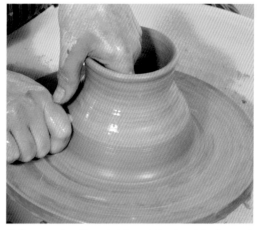

2 Place your knuckle against the outside edge of the form and the fingers of your left hand inside it, so that the clay is trapped between them. The thumb of your left hand should rest on the knuckled hand.

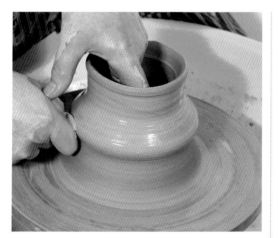

3 Keeping your hands in this position, lift the clay gently to form a basic cylinder shape. Repeat this action as many times as necessary to lift the shape to the required height.

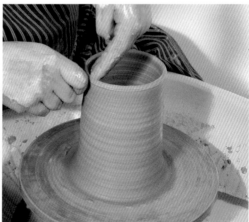

4 Once you have finished lifting the clay, and before removing your fingers and knuckle, it is important to relax and allow the shape of the top to come back to round. If you remove the knuckle too quickly, the shape will be knocked off center and the form will wobble.

Knuckling-up variations

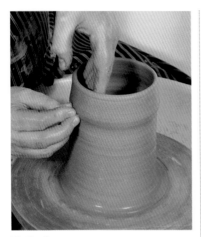

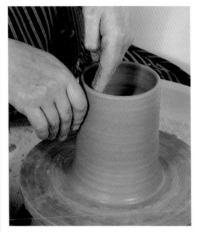

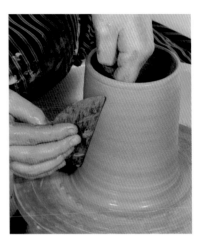

Method one
Use your fingertips on both the inside and outside to lift and shape the form.

1 Use the side of the forefinger of your right hand on the outside of the form and the fingers of your left hand on the inside.

2 Smooth off the outside of the cylinder by replacing the fingers of your right hand with either a wooden, metal, or plastic rib. You can also learn to lift the wall this way, with practice.

Stress-free lifting off

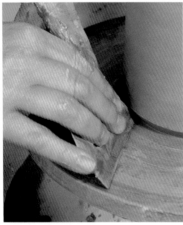

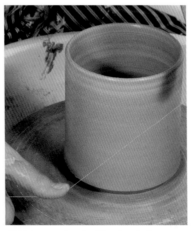

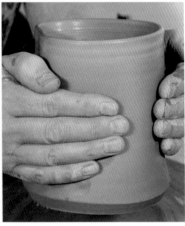

1 Remove all excess clay from the base of the pot using a rib held at an angle of 45 degrees to the pot and the wheel head. (This angle will ensure that the surplus clay travels up the back of the rib, away from the pot.) Now, with the rib still at 45 degrees, cut a bevel at the base of the pot to allow a clean transit of the wire.

2 Make sure the wheel head and wire are clean, then, holding the wire taut, pass it under the base of the pot.

3 Make sure your hands are clean and dry, and then cup them around the pot as near to the base as possible. Gently tilt the pot back toward your body as you lift. This allows air to pass underneath and releases suction as the pot is lifted, and makes the procedure much easier. Transfer the pot to a board as quickly as possible.

Making a bellied vase

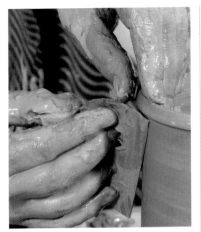

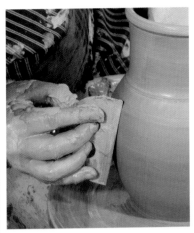

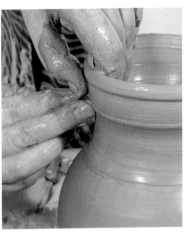

1 Throw a basic cylinder, leaving an amount of clay on the top edge of the pot as a fat rim. This weight of clay is required to give a visually bold rim or to form the lip for a pitcher if you want to adapt the form further.

2 Using a rib on the outside as support and to keep the surface smooth, apply gentle pressure to push the clay out with your fingers from the inside, beginning from the base and stopping at the two-thirds point.

3 Remember to lubricate as necessary.

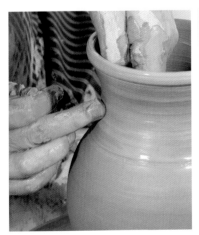

4 Throw the remaining neck third using the pinch and lift method (see page 69). To narrow the neck further, apply slightly more pressure from the outside when lifting and then finish the shape by slightly flaring the neck out at the rim. You now have a basic vase. You can also use this technique to make cups and mugs, or continue the steps to turn the vessel into a pitcher (see page 69).

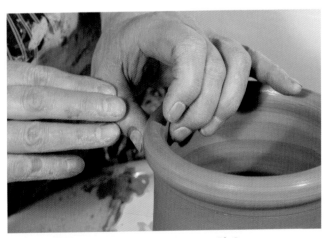

Forming a gallery for a lid

Throw a cylinder with a thick rim (as for the vase, above). You will need this weight at the top to form the gallery. Place the thumb of your left hand on the outside of the rim and the second finger of your left hand inside the rim, so that the forefinger can come down between them to spread the clay open for the gallery. The right hand is only used to steady the left hand as the clay is rotating. Remember to relax your hands when you have finished making the gallery to allow the form to settle before removing them altogether. Measure the gallery at this stage to enable you make the lid to the right size.

Throwing bowls

The principles of throwing bowls are slightly different to those for cylinders because the focus is on the interior shape and profile rather than the exterior, which is developed later. From centering the clay to developing the bowl shape, the following hints and tips will ensure success for any weight of clay.

Basic bowl success

The key to throwing a successful bowl is to allow enough weight at the base to support the wall as it is thrown outward and to form the foot ring later when the bowl is trimmed.

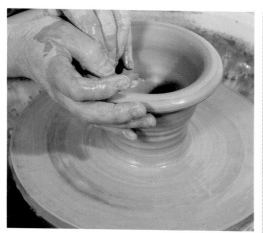

1 Center the clay to a doorknob shape. This allows your fingers underneath to lift the wall so that there is enough clay to support the wall without it being excessive.

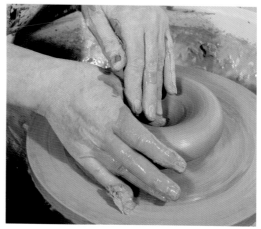

2 Open the center of the clay up to the required depth, keeping the clay in the base rounded (unlike for the cylinder where it was flattened).

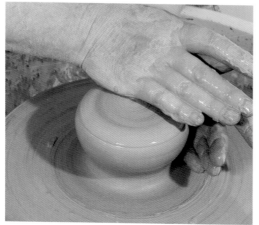

3 Pinch and lift the wall of the bowl, working from the center upward and slightly outward to create a funnel shape.

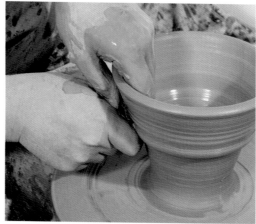

4 Establish the width of the top of the bowl as quickly as possible by gently easing the clay up using the knuckling-up technique.

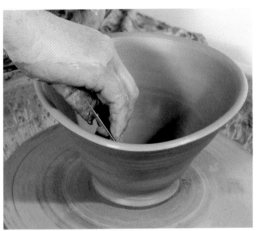

5 Using your fingers or a rib, gently press the wall of the clay on the inside to create the curve of the bowl. Warning: If this is done too soon, the bowl will have a tendency to slump down on itself.

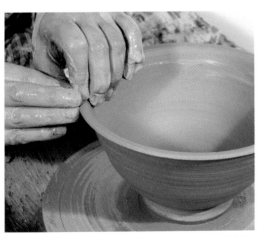

6 Neaten up the outside wall of the bowl with a rib and finish the rim. Clean the wheel head and finish the base of the bowl as for a basic cylinder, before wiring off and lifting it onto a board.

How to get the shape you want

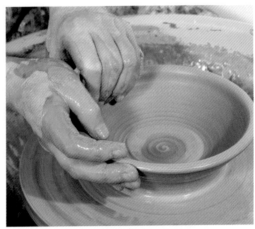

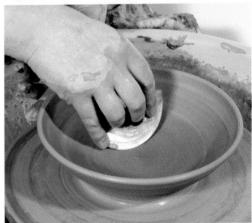

A wide, shallow bowl
The principles are the same as for the basic except that it is opened wider at the base before lifting the walls. The key to success is to leave enough clay at the base to support the flare of the bowl.

A bowl with a flattened rim

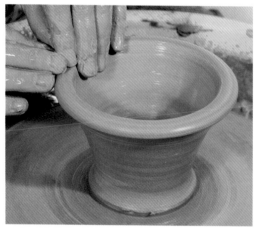

1 Center, open up, and lift the clay as for the first bowl, but leave an amount of clay at the edge as a fat rim.

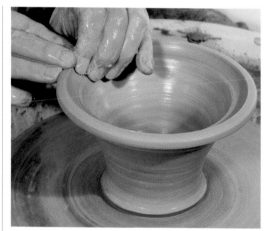

2 Pinch and lift the fat rim at a slightly more flared angle to the bowl, but keep it slightly concave. If it is opened too wide at this stage, it will flop over.

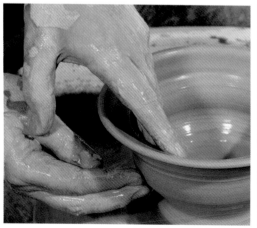

3 When the rim is finished, curve out the belly of the bowl.

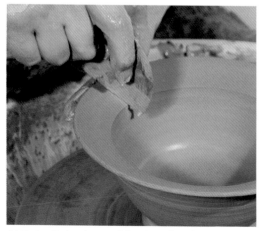

4 Neaten the bowl up carefully using a rib or kidney to give a smooth surface for decorating later. Remember to support the rim from underneath as you run the rib over the upper surface.

Throwing plates

Plates are always best thrown on wooden bats to prevent distortion from handling at the wet stage. So, unless you have a dedicated wheel head, throwing the perfect plate begins by learning how to attach a bat to the wheel head.

Attaching a bat

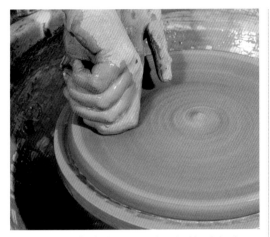

1 Throw a pad of soft clay to cover the wheel head that is ½–1 in. (2–2.5 cm) thick. Use either the side of your finger or a rib to achieve a level surface.

2 Using your finger or a tool, press gullies into the clay at approximately 1 in. (2.5 cm) intervals, from the center to the outside edge.

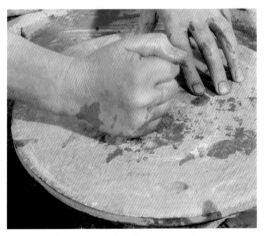

3 Neither the clay nor the bat should be wet, because excessive water will cause the bat to slide. Clean off any dust on the bat, then position it centrally on the clay pad. Thump the bat a few times to secure it onto the clay.

Easy bat removal

To remove a bat from the wheel head after throwing, push a potter's knife sideways between the bat and the wheel head, then twist it until the bat releases. The clay pad can be used as long as it remains soft enough.

The rim is flat and smooth.

The base of the plate is slighty hollow so that it doesn't touch the table.

The outer edge of the foot ring is the only part that touches the table.

Throwing a plate that won't collapse

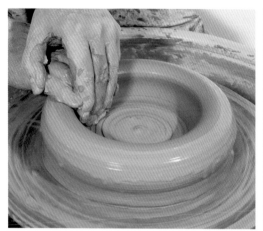

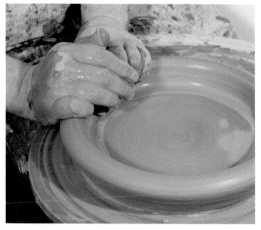

1 As for a basic cylinder, center your clay and open it out to create the base. This must be thick enough to later turn a foot ring—around ¼–½ in. (5–8 mm) thick for a dinner plate. Leave a weight of clay at the edge to form the rim of the plate. This weight, together with that of the base, will determine the final diameter of the plate.

2 Compress the clay in the base of the plate to prevent cracking, and consolidate the rim to keep it running true. Supporting the edge with your right hand on the outside and your finger and thumb in the pinch and lift position, squeeze the clay and gently pull it up to begin with.

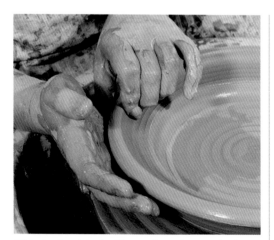

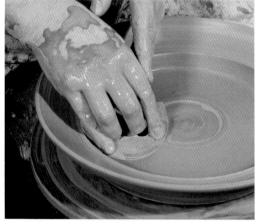

3 As the clay of the rim thins, gently ease it outward. It is very important to ensure that the face of the rim is slightly concave and the underside is convex to prevent the rim from collapsing due to gravity.

4 Use ribs and kidneys to refine the surface of the plate and reconsolidate the clay in the base.

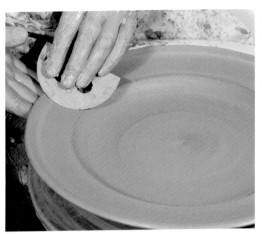

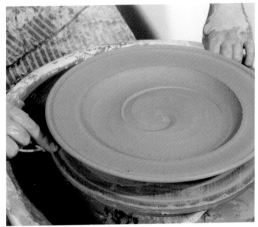

5 Only refine the rim at the very end of the throwing process, especially if the clay is very soft. Don't overwork it because excessive rotation of the wheel will cause the rim to collapse.

6 Add decorative details such as lines and swirls if required, before trimming the underside in preparation for wiring under the base. Lift the bat from the wheel head, but do not handle the plate until it has stiffened to leather-hardness.

Throwing lids

The term "throwing off the hump" is used to describe the practice of throwing a series of pots from one large lump of clay. It's ideal for making small items such as lids.

Throwing off the hump

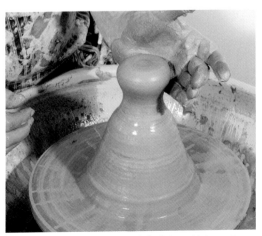

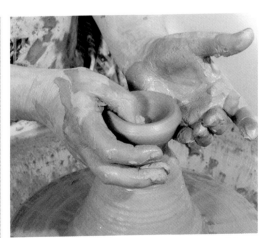

1 Center a larger-than-necessary ball of clay—this is usually referred to as the "hump"—then create a small doorknob shape at the top of the clay.

2 Press the thumb of your right hand into the center of the clay to form a small donut shape.

Throwing off the hump continued

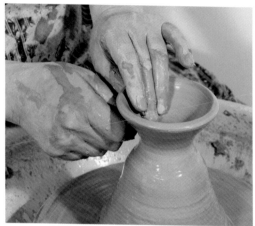

3 Open out and lift the shape by knuckling-up (see pages 191–192) to create a miniature bowl form. Flatten off the rim a little between your fingers and thumb, or use a rib. This will keep the lid from warping and gives it an edge to sit on inside the pot.

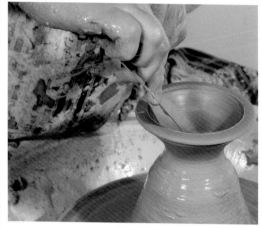

4 Sponge out the inside of the lid, then, using a pin or the point of a rib, score a line around the inside of the lid close to the rim, as a marker for waxing and glazing later.

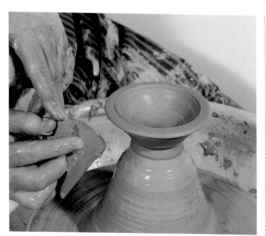

5 Using a rib, trim away excess weight from the underside of the lid. Then, using the point of the rib, cut a "V" just underneath to mark where the lid will be wired off.

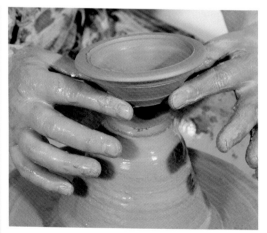

6 Wire underneath the lid and then lift it off carefully onto a board. Dry the lid to leather-hardness before trimming.

Throwing a lid with a gallery

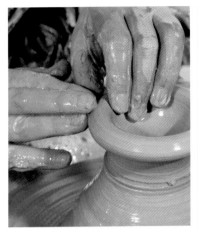

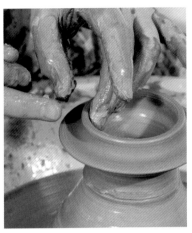

1 Throw a small bowl shape off the hump (as for the lid on pages 199–200), but leave some extra weight at the rim.

2 Split the rim using the second finger of your right hand, or a tool, while supporting the inside with the fingers of your left hand. This will create a "gallery" to sit inside the pot (as opposed to the whole lid sitting inside the pot).

3 Neaten the underside of the lid and cut a "V" shape. Then wire off and move the lid onto a board to firm up, ready for trimming later.

A perfect fit

Using a pair of calipers, set one tip against the rim's inside edge (at the widest point in the opening) and the second tip just wider than the inside edge of the gallery (the narrowest point in the opening). This will give just enough play for a comfortable fit. Set the calipers aside at this width so you can measure the lid once you have made it and achieve the perfect fit. Remember to measure the lid regularly as you make it to ensure it is the right size.

Cross section of a flanged lid sitting on a pot.

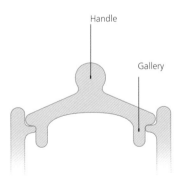

Handle

Gallery

The corresponding measurement for this type of lid is made on the inside of the rim of the pot.

The measurement for this lid is taken outside of the gallery because this is the part of the lid that will sit on the rim of the pot.

Trimming

Trimming is the term used for the process of turning away excess clay from the base of thrown forms. Pots are usually trimmed at the leather-hard stage because they are easier to handle without risk of damage, and the clay will cut most precisely.

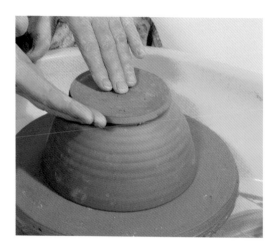

Knocking onto center

"Knocking onto center" is the term used for centering pots directly onto the wheel head for trimming. It's a traditional method, but difficult to master. You'll need plenty of practice to accomplish this technique, but it is by far the best and fastest method if you have a lot of pots to trim.

Dampen the wheel head, then position your pot using the concentric lines to center it as far as is possible. With the wheel rotating, look at the edge of the pot on the left side, then, when you see a wobble, strike the opposite side of the pot with your other hand. Repeat the process until the pot runs true to center.

The right time to trim

If a lid is to have a thrown knob attached to it, then choosing the correct time to trim is critical. The clay of the lid should not be too soft because this will make it vulnerable to collapse, but neither should it be too hard, because this will cause problems when you try to join it to softer clay. Somewhere just short of leather-hard is optimum, but you will need to experiment for best results.

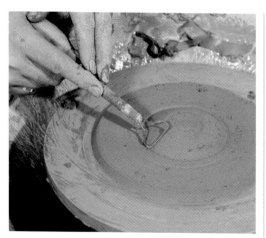

1 If the clay in your lid is soft, you can form a slight hump in the center of the pad to support the underside as you trim and then throw on the knob or apply a handle.

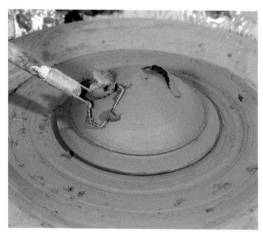

2 Center the lid on the pad of clay. Using a turning tool, create the edge of the lid first, then turn away the excess weight of clay to form a dome.

How to trim a bowl

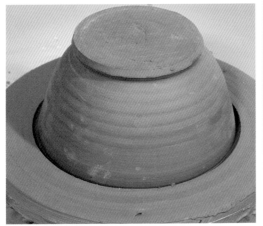

1 Position your bowl in the precut gully in the pad of clay. You can dampen the rim slightly to make it stick if you need to.

2 The first cut in the trimming process is made to check that the outer diameter of the pot is running true and the base is flat. Once you have done this, mark where the foot ring is going to be using the tip of your turning tool, then trim away the excess clay on the outside edge to the marked line.

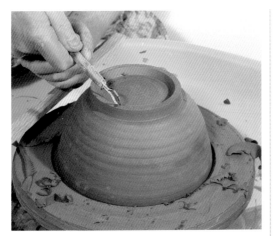

3 Working within the marked line of the foot ring, trim away the excess clay from center to edge, following the curve of the bowl. The cut will be deeper at the edge of the ring than in the center.

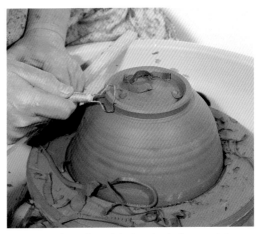

4 Once you have trimmed the foot ring to the correct shape and size, cut a little miter on the inner and outer edges to finish off.

Techniques: Slabbing

Slabbing is the term used to describe the technique of making clay objects from sheets of clay. It is a versatile and exciting way of working that allows great scope for experimentation for making anything from domestic ware to sculptural pieces. Slabs can be made in several ways and the method of making is a personal choice. It is also determined by the type of object you intend to make and the clay you want to make it from.

Cutting regular slabs

A clay harp is a good way of cutting smaller slabs of regular size and thickness. The mechanism works by adjusting the wire down a notch each time a slab is cut. Use firm pressure to keep both sides of the harp rigid and firmly on the work surface because the wire will otherwise rise as it cuts through the clay, making the slab very uneven. Draw the wire through the clay from front to back.

This method is particularly suitable for tile making where a lot of slabs need to be made quickly. Form the lump of clay into the correct size for your tiles prior to cutting, which will save having to cut them to size again later. All clays except porcelain (which is generally prepared in much thinner slabs) are suitable for this method of making. Unfortunately, the notches on harps are generally too widely spaced to make really thin slabs.

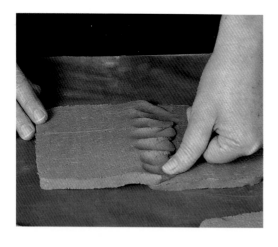

Making larger slabs

You can make larger slabs by joining smaller ones together. Simply overlap the edges of the slabs, then blend the two surfaces together using your finger or thumb. Turn the slab over and repeat the blending process on the underside. Smooth over the slab with a scraper to even out the thickness when all the sections have been joined together.

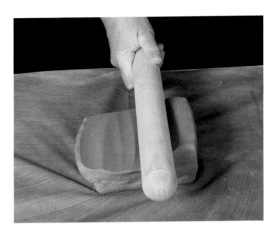

Reducing thickness

To reduce the size of a large lump of clay to a manageable thickness prior to rolling, beat the clay evenly across its surface with the side of a rolling pin. Turn the clay over and through 90 degrees and then beat it again. Continue to do this until the lump is adequately flattened. Try using the side of your fist as an alternative if you can't get the hang of using the rolling pin—the key to success is to keep the clay as even as possible as you reduce it in size—try to avoid deep impressions from the rolling pin or your hand because these can cause weaknesses in the slab.

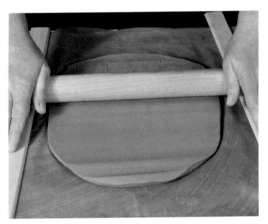

Rolling

To make slabs of even thickness place two wooden roller guides on either side of your lump of clay before rolling out with a rolling pin. Each end of the pin should eventually rest on the guides as the slab thins out.

Making thin, even slabs

1 This is a method that requires a little practice but once mastered is a great way of making thin, even slabs quickly. Cut a piece of clay from a lump, then, holding it in both hands so that it hangs down, throw it onto the work surface.

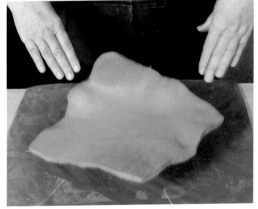

2 Lift the slab from another edge and turn it around so that, when you throw it onto the surface again, it lands on the other side. Repeat the throwing process until you are satisfied with the thickness of the slab.

Because this method is generally used to make larger slabs, the most suitable clay to use would be a grogged variety that is robust during handling.

Joining slabs

The method used for joining all edges and separate elements in clay is known as "score and slurry" or "score and slip." It provides the surface "key" or "glue" that holds pieces of clay together. This approach is used when you do not want to disturb the surface of clay as you would when joining coils or pinching.

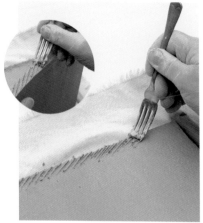

1 Provide a key to hold the slurry on both surface areas to be joined. Use a fork, needle, knife, toothbrush, or specific scoring tools to rough up the clay surface. Be careful not to score the surface too deeply, since this can create small air pockets that may cause problems when firing.

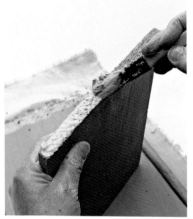

2 Once you have scored the surfaces, apply liberal amounts of slurry to one or both surfaces with a brush.

3 Push the two slabs together, moving them from side to side as you do so. This will key the bond completely. If you can see the slurry ooze out of the join this means you've applied the right amount. If you can't, then you probably haven't used enough.

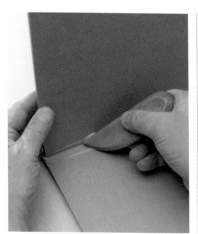

4 Clean away the excess slurry with a tool or sponge. For much smaller areas, you can use a paintbrush. Pressing the join with a tool will create a firm bond.

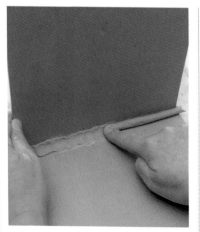

5 Large slabs can benefit from a reinforcing coil of clay run along the line of the join and blended in. If you do this, make sure the slab has not dried too much, otherwise the additional clay will crack as it dries and shrinks.

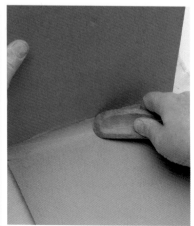

6 Finish the reinforced join by running a right-angle or curved tool over the clay.

Making a sling mold

Canvas or cloth can be hung in a simple frame or tied to the legs of an upside-down
chair to form a sling mold. This kind of work has the advantage of being able to be
manipulated from both sides to create a wide range of undulating forms.

1 Hang a piece of canvas or cloth to form a sling mold.

2 Lay the slab in the canvas or, when dealing with a large
slab, you can leave the clay on the canvas on which it was
prepared to avoid adding any stress cracks while moving.

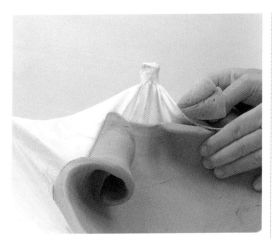

3 Alter the clay with a sponge to avoid putting any finger
marks into the surface. The sling can be altered at the
corners to support the changing shape of the slab.

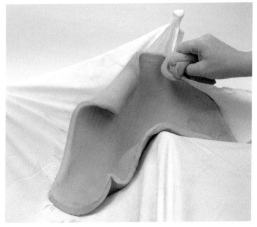

4 Manipulate the slab from underneath into the required
shape; it can be further supported by foam blocks or
newspaper and left in the canvas sling to dry out.

Techniques: Coiling

Making coils requires practice, but it is worth taking time to perfect the technique before starting to build. The beauty of clay is that it is never wasted. If it dries out, it can simply be slaked down and re-wedged to use again.

Rolling coils

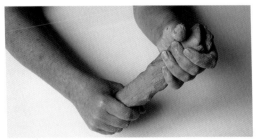 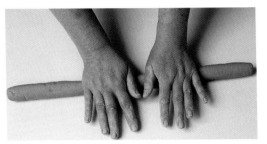

1 Roughly form the clay into a thick coil shape, using both hands and working from the middle toward each end. The more even the shape at this stage, the easier it will be to roll later. Work the coil until it is a manageable size for rolling.

2 Roll the clay on a clean, nonabsorbent surface. Rolling can dry the clay, so it is important not to use a surface that would draw even more moisture from it. Dry coils are hard to work and are more likely to separate in the firing process. Using the palms of both hands rather than the fingers, roll the coil gently but firmly back and forth from the middle outward to each end. Each coil should be about ½ in. (13 mm) in diameter.

Correcting misshapen coils and flattening coils

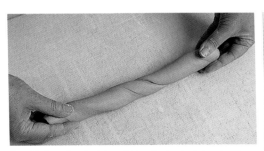 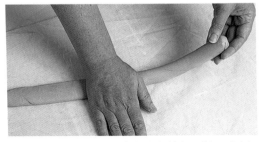

Roughly form the clay into a thick coil using both hands. When rolling the coil, use the palms of the hands in a long, smooth rolling action beginning at the middle of the coil and working outward. Try not to use the fingers because this can make the coil uneven and difficult to handle. Your aim is to produce a thick coil about 1 in. (25 mm) in diameter and 12 in. (30 cm) long. If the coil flattens in the process of rolling, it is possible to correct it by twisting at one end in an outward direction, while twisting inward at the other end and then re-rolling. The shape of the coil can be corrected as many times as necessary. In fact, this process adds some strength to the clay.

Working again on the sheet of plastic, hold the coil in a slightly raised position at one end, while flattening the other end with the heel of the other hand. Work along the length of the coil in this way using a firm and even pressure at all times, but not flattening the coil too much to begin with. Repeat the process by lifting the coil from the plastic and turning it over to flatten the other side. To help form the shape of the pot, the coil can be manipulated into a curved shape during the final part of the flattening process.

Fixing flattened coils to a flat base

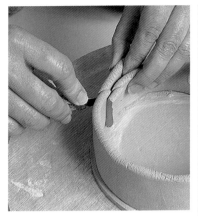 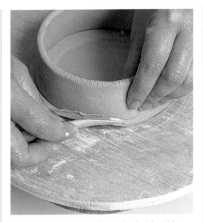 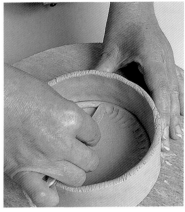

1 Position the longer edge of the curved coil slightly in from the outer edge of the base slab, overlapping the coil where the ends meet. Cut through the overlapped sections of coil at a diagonal and discard the excess clay. Using a toothbrush and water, score the cuts and join the overlapping sections of coil together securely, trying not to distort the shape too much in the process.

2 Supporting the work on the inside with one hand, use a wooden tool to blend the clay from the base section, extending out from the point where the coil was positioned, up and into the wall of the coil. Set the bat on a turntable to do this because it allows for a smooth and even action as the work turns. When all of the base clay is blended into the coil, use a metal or wooden scraper to smooth the surface and remove any excess clay.

3 Roll out a thin coil of soft clay and place it around the inside join of the base. Using a wooden tool (or a finger if you prefer), blend the reinforcing coil into the base and press it firmly onto the wall of the flattened coil. Support the outer edge at the base at all times to prevent the shape from distorting. Smooth off with a rounded tool or finger.

Building shape

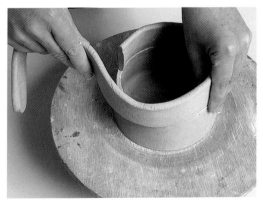 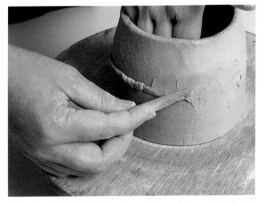

1 Roll out the shape of the next coil as before. Using a toothbrush and a little water, score the upper edge of the pot. Position the coil around the rim, gently pushing the clay into place with one hand while supporting the rest with the other. As with the first coil, overlap the ends and cut diagonally through both sections, then secure them together.

2 Having checked that the shape of the pot is correct, roll out some thin coils of soft clay. Blend one coil into the join on the outside of the pot, using your fingers to pinch it into position and then a wooden tool to smooth it out. Make sure that the inner surface is supported at all times with one hand. When the coil is thoroughly blended in, use a metal kidney to finely smooth the surface. Repeat the process on the inside join, making sure you support the outer surface at all times.

Tools glossary

Each making process uses specific tools and equipment, but there are some tools that are used across all making methods and that form the basic tool kit. These can be purchased from most ceramic suppliers, who will stock a good selection of these items.

Clay cutters
Technique: Cutting clay, cutting items off the wheel.
Uses: Clay cutters (cutting wire) are used to cut slices from a large block of clay, and for wedging, slabbing, and cutting items off the wheel head after throwing.
Range available: Available in 12–18-in. (30–45-cm) lengths and in different gauges in nylon with hardwood toggles, stainless steel, and twisted wire form to produce shell ridging on the underside of thrown forms.
Skill level: Basic.

Rubber kidneys
Technique: Smoothing.
Uses: Rubber kidneys are generally used for smoothing plastic clay surfaces and in press molding. Very soft rubber kidneys can be used to smooth decals when fixing them.
Range available: Now available in many sizes and gauges, but generally 3 x 2 x ¼ in. (100 x 55 x 6 mm), 4¾ x 2 x ¼ in. (122 x 57 x 6 mm), and 5½ x 2½ x 5⁄16 in. (138 x 64 x 8 mm). Smaller and larger, heavier, and more flexible varieties are available through different suppliers.
Skill level: Basic.

Metal kidneys and palettes
Technique: Scraping and refining the clay surface.
Uses: Smoothing and trimming leather-hard clay and plaster; burnishing. Serrated kidneys are used for rapid shaping and texturing of the clay surface and rectangular palettes for angled surfaces.
Range available: Two thicknesses—flexible and very flexible. Kidneys are available in sizes 3⁄8 x 3⁄16 in. (90 x 45 mm) and 7⁄16 x 3⁄16 in. (102 x 45 mm).

Rectangular palettes are ½ x ¼ in. (125 x 51 mm) and serrated kidneys 3⁄8 x 3⁄16 in. (95 x 45 mm).
Skill level: Basic.

Needles
Technique: Trimming pot rims, piercing, and sgraffito work.
Uses: Can be used to measure the thickness of clay to ensure evenness. They are generally used as a sgraffito and piercing tool, but fine needles are also useful for accurately trimming the rims of pots.
Range available: Generally available in two sizes—fine and thick. Needles can also be made from bodkins fixed into bottle corks.
Skill level: Basic.

Potter's and other knives
Technique: Cutting and fettling.
Uses: Potter's knives are used for cutting clay at all stages of making. They are also used when fettling the surfaces of mold-made wares, in slip casting, and so on. Craft knives are useful for many applications, including clay and paper work.
Range available: A general-purpose potter's knife has a very sturdy 2-in. (54-mm) blade shaped to a point. Craft knives are available from most stationers in multipacks.
Skill level: Basic.

Palette knife
Technique: Cutting, stirring, mixing, and scraping.
Uses: A multipurpose knife, but generally used for mixing or grinding colors for various methods of surface decoration. Also used for cutting and scraping clay and other surfaces and stirring liquids.
Range available: In many sizes, with blades ranging from 2½–10 in. (63–250 mm).
Skill level: Basic.

Sponges
Technique: Finishing, cleaning, and decorating.
Uses: Natural sponges are used for

fettling and finishing clay surfaces, soft soaping in mold making, applying coats of slip and glaze for overall or decorative coverage effects, and mopping up when throwing on the wheel. Synthetic sponges are generally used for cleaning surfaces and mopping up but can be cut into shapes for slip or glaze stamp decoration.
Range available: Small to large, fine to coarse texture. Always have a selection, including a large bench sponge, on hand.
Skill level: Basic.

Rolling pin and roller guides
Technique: Slabbing.
Uses: Rolling pins are used for rolling clay for slab building; roller guides ensure an even thickness of clay.
Range available: Generally available in 14- and 20-in. (355- and 510-mm) lengths. A child's-size rolling pin is useful for jewelry and small slabs. Rolling guides should be chosen to match the thickness of slab required; most builders' merchants will have a range of battening that can be cut to the required size.
Skill level: Basic.

Double-ended strip tool
Technique: Turning, trimming, and carving.
Uses: With sharp, ground-steel cutting edges, these tools are designed for fine and medium cutting, turning foot rings, trimming excess clay, carving, and decorating leather-hard surfaces.
Range available: A large selection of both single- and double-ended strip tools is available for specific tasks, but a simple tool that is squared at one end and rounded at the other is a good basic for all-round use.
Skill level: Basic.

Hole cutters
Technique: Cutting holes or squares.
Uses: Producing holes in lamp bases, teapots, and so on; also used to cut out decorative patterns in leather-hard surfaces. The blades are half round to prevent clogging as the clay is cut.

Range available: Round hole cutters are usually available in several sizes to make holes from 1/8–1/2 in. (3–13 mm); square cutters from 1/16–1/4 in. (2.4–6 mm).
Skill level: Basic.

Double-ended cleanup brush

Technique: Cleaning delicate surfaces.
Uses: These spiral brushes are invaluable for cleaning out small holes and delicate surfaces on handles, and so on. The long end can be used for larger and deeper openings and the small end for fine sculpture and cutout work.
Range available: One size.
Skill level: Basic.

Surform

Technique: Shaving excess clay and plaster.
Uses: Surforms (the blades are also known as rasp blades) are used for reducing the thickness of clay walls, leveling rims, and shaping sculptural forms, and can also be used to texture clay surfaces. In mold making they are used to reduce the bulk of the mold immediately after casting in plaster, and for rounding off sharp edges.
Range available: Blades are available as curved, flat, round, and half round to fit relevant-sized planes.
Skill level: Basic.

Wooden bats/boards

Technique: Supporting work in many studio processes.
Uses: Boards allow maneuverability of items at all stages of making, drying, and storing. Round bats are also used on the pottery wheel to avoid distortion of thrown items when lifting off.
Range available: Most pottery suppliers have a range of boards; building suppliers also have boards that can be cut to requirement.
Skill level: Basic.

THROWING AND TURNING TOOLS

The tool kit for throwing needs only a few items in addition to the basics. However, there are many tools listed here for specific use at the throwing, *turning, or decorating stages that the maker will find useful to have as they become more proficient.*

Dottle—sponge on a stick

Technique: Throwing, slip casting, and fettling.
Uses: A dottle is used in throwing to sponge up excess water from the insides of forms that cannot be reached by hand. In slip casting, it has a similar function but is also used to smooth over seam lines and irregularities in the cast surface and to soften rims.
Range available: Several shapes and sizes are available, with rounded, squared-off, and angled ends for specific uses.
Skill level: Basic to intermediate.

Wooden ribs

Technique: Generally used in throwing, but can also be used in other making techniques.
Uses: Ribs are generally used for smoothing and shaping pots on the wheel but can also be used in hand-building processes and as decorating tools.
Range available: Several sizes and shapes, large and small: angle curve, convex oval, flat concave, flat rectangular, flat curve.
Skill level: Basic to intermediate.

Large throwing rib with handle

Technique: Throwing and hand building.
Uses: A long-handled rib is used for smoothing and shaping the insides of pots that are difficult to reach with the hand when throwing or hand building. They can also be used for cutting and slicing.
Range available: Generally one size.
Skill level: Basic to intermediate.

Throwing sticks and stick with hook

Technique: Throwing.
Uses: This tool aids in the shaping and compressing of clay when throwing items that have a deep, narrow neck where the hand cannot reach.

Range available: Different sizes and lengths, up to 12-in. (300-mm) long.
Skill level: Basic to intermediate.

Bamboo comb tool and fluter

Technique: Throwing and hand building.
Uses: Generally used to texture and flute the surface of wheel-thrown wares when the clay is still relatively soft, but can also be used to similar purpose for handbuilt items.
Range available: Comb tools are generally double-ended, with three prongs at one end and four at the other. Fluters have the fluting device at one end and a two-pronged comb at the other.
Skill level: Basic to intermediate.

Calipers

Technique: Throwing and measuring.
Uses: Calipers are most often used for measuring the width of lids and galleries when throwing, but can also be used on handbuilt objects where good fit is important. The calipers are set to a specific width and put aside until needed later.
Range available: Wooden, metal, and plastic, in several sizes from small to large.
Skill level: Basic to intermediate.

Stem turning tools

Technique: Turning foot rings and decorating surfaces.
Uses: Stem tools are a type of turning tool with flat steel blades set on wooden handles. Each tool is multisided to allow great flexibility when turning pots of different shapes.
Range available: Pear-shaped, quadrilateral, triangular, and approximately 6½ in. (165 mm) long.
Skill level: Basic to intermediate.

Steel turning tools

Technique: Turning bases on wheel-thrown items.
Uses: An alternative choice of turning tool in a good range of shapes for specific turning needs. These tools can

also be used to score lines and other decoration on the surface of wares.
Range available: In both narrow and wide versions, these tools come with pointed, triangular, and pear-shaped ends, squared and rounded, and are approximately 6½ in. (158 mm) long.
Skill level: Basic to intermediate.

MISCELLANEOUS TOOLS
For the most part the tools in this section represent essential items required for a working studio, with the exception of a few items that have specific uses.

Bow harp
Technique: Slabbing.
Uses: The bow harp enables a stack of slabs to be cut from a single block of clay by repeatedly repositioning the wire up or down in the grooves on the frame before drawing through the clay.
Range available: In two sizes: medium (12 in./300 mm) and large (18 in./457 mm); replacement wires are also available.
Skill level: Basic.

Sieves and lawns
Technique: Preparation of slips, glazes, and colors.
Uses: Essential items for the pottery studio, these tools are used for processing hand-dug clay to remove stones, and for mixing slip and glazes so that the constituents are blended together properly and colors are properly distributed through a mix. Small cup lawns are ideal for sifting colors that are usually used in small amounts, as are flat slip sieves, which sit over a container.
Range available: In mesh sizes 20, 30, 40, 60, 80, 100, 120, and 200. In beechwood frames 8 in. (203 mm) or 10 in. (245 mm) in diameter.
Skill level: Basic.

Plastic measuring pitchers
Technique: Measuring ingredients.
Uses: For measuring water content when mixing slips, glazes, plaster, and other liquid mixtures. It is useful to have several pitchers in different sizes.
Range available: From pottery suppliers or general hardware stores.
Skill level: Basic.

Bowls, pails, funnels, and scoops
Technique: All areas of studio practice.
Uses: Apart from the obvious uses, large bowls are good for dipping plates or flatware in slip or glaze. Pails, especially with fitted lids, are used to contain dry materials and liquid mixtures like slip, glaze, and even plaster when mold making. Funnels are used to decant wet or dry materials into containers, and scoops are used for dry materials, usually when weighing.
Range available: Available in different sizes from pottery suppliers or general hardware stores.
Skill level: Basic.

Glaze dipping tongs
Technique: Glazing.
Uses: Dipping tongs are used to dip ceramic pieces directly into glaze. Generally made from heavy steel, they usually have sharp gripping points for minimal contact with the pieces being dipped for even coverage of glaze. They can be used to dip objects in other liquids where minimal contact is required.
Range available: Pottery suppliers all have different versions of the same thing.
Skill level: Basic.

Beam and gram scales
Technique: Weighing raw materials.
Uses: No studio can work without scales to weigh raw materials, because most recipes for glaze and slip preparation, plaster work, and the addition of colors and oxides to clay bodies require very precise measurement to be successful.
Range available: Triple beam balance scales accurate to 0.1 g are supplied with a weight set of 2 x 1,000 g and 1 x 500 g to increase the weighing capacity. Gram scales are useful for weighing minute quantities of stains and oxides, weighing up to 50 g in 1 g divisions.
Skill level: Basic.

HEALTH AND SAFETY EQUIPMENT
Health and safety in the ceramic workplace is of paramount importance because of all the potentially hazardous materials that are being used. Every studio requires the following basic equipment.

Dust mask
For mixing dry materials, as in glaze making, plaster work, and cleaning.
Respirator
For handling and preparing more dangerous materials and some forms of firing such as raku.
Heat-resistant gloves
For handling hot wares from the kiln and kiln furniture or raku firing.
Safety goggles
For grinding, mixing certain materials, raku, and smoke firing.
Apron
To protect clothes from dust and other dangerous materials; for this reason, aprons should be nylon and easily wipeable.

WHEELS
Wheels are available in many shapes and sizes, but the main consideration for purchasing one should first and foremost be comfort, because they can be a strain on the back. The electric wheel is the most versatile where great production is required, but many potters still choose a momentum wheel for aesthetic reasons.

Electric wheel
Technique: Throwing.
Uses: For production throwing and turning of tableware, kitchenware, and decorative items, and for turning clay models for plaster mold making. Set at very slow, the wheel can be used for banding slip or glaze onto greenware or bisque-fired forms.
Range available: Many electric wheels are available, from tabletop types to large wooden-framed versions with seats or for standing.

Skill level: Intermediate
to advanced.

Momentum/kick wheel

Technique: Traditional form of throwing.
Uses: The same uses as for electric wheels, but driven by kicking a treadle that operates a heavy fly wheel to build up momentum and torque to center and throw the clay.
Range available: Modern momentum wheels are constructed on a fabricated steel frame in either sitting or standing versions. Available from pottery equipment suppliers.
Skill level: Intermediate
to advanced.

Lining/banding wheel

Technique: Decorating or hand building.
Uses: Lining wheels are floor standing and adjustable to enable work to be set at exactly the right position. Use in the same way as a bench sculpting wheel for hand building, modeling, sculpting, and surface decorating.
Range available: Generally made from steel and aluminum, and available from most pottery equipment suppliers.
Skill level: Basic.

GENERAL STUDIO EQUIPMENT

The items listed in this section would generally be required to establish a ceramic studio for good and efficient working practice. Not all the items need to be purchased from dedicated suppliers because they are readily available from craft stores or can be adapted from other equipment.

Wedging bench

Technique: The preparation of clay.
Uses: Every studio needs a sturdy bench with a semi-absorbent surface, for wedging and kneading clay in preparation for hand building and throwing.
Range available: Different-sized benches are available from most pottery equipment suppliers, but they can be homemade by securing a paving slab to the top of a sturdy wooden table.
Skill level: Basic.

Blow-dryer

Technique: Hand building.
Uses: Useful for the hand builder, especially when coiling, because it allows the maker to dry the clay to a firmer state before adding subsequent coils. Also useful for firming up pinched sections before joining and any other processes where the clay needs to be firmer before it can be worked on further.
Range available: Use an old one preferably—but readily available from electrical suppliers in all shapes and sizes.
Skill level: Basic.

Large plastic bins

Technique: Clay recycling and storage.
Uses: Apart from the obvious use of storage, plastic bins are used for clay recycling. Use one to collect dry clay and another to slake clay down for pugging later. Keep different clays in individual bins and mark each appropriately.
Range available: Widely available from hardware stores; choose heavy-duty plastic for better durability, with well-fitting lids.
Skill level: Basic.

Gallon mixer

Technique: Preparation of glaze and slip.
Uses: An invaluable aid for the rapid mixing of glazes and slips. Best results are achieved by adding the required amount of water to the pail before adding the dry ingredients progressively as the machine is operating. The machine is designed to prevent a vortex or splashing.
Range available: Pottery suppliers have their own design of machine but all perform the same task.
Skill level: Basic.

Sedimentation tank

Technique: Safe water drainage.
Uses: Helps protect the environment from the potentially dangerous materials used in the pottery studio and prevents the blocking of drains with clay, plaster, or other residues. The tank fits under the studio sink and collects sediment but allows water to flow to drains.
Range available: Several types are available, but a portable system on wheels is best for emptying collected sediment.
Skill level: Basic.

Templates and profile formers

The templates on these two pages have all been used for projects in the book. They have been drawn to letter size, so if you copy and print to this size you will have the templates in the precise dimensions made. You can be experimental and enlarge or reduce the sizes to create the forms in different proportions if you choose, but the balance of the items may be changed by this, so be prepared to make small adjustments if necessary.

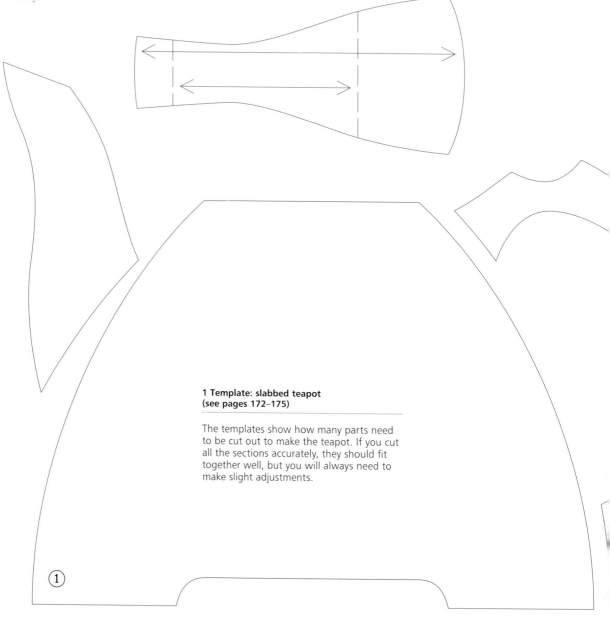

1 Template: slabbed teapot (see pages 172–175)

The templates show how many parts need to be cut out to make the teapot. If you cut all the sections accurately, they should fit together well, but you will always need to make slight adjustments.

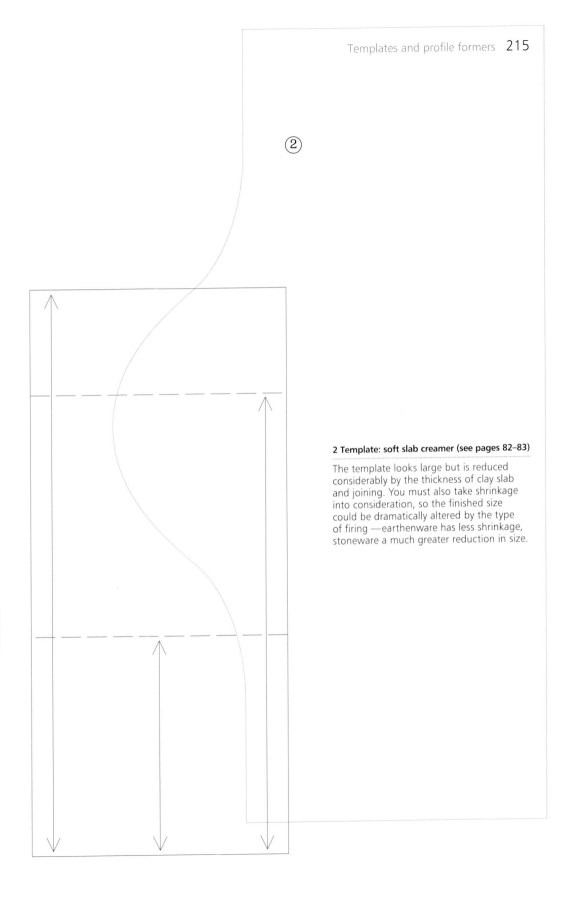

2 Template: soft slab creamer (see pages 82–83)

The template looks large but is reduced considerably by the thickness of clay slab and joining. You must also take shrinkage into consideration, so the finished size could be dramatically altered by the type of firing —earthenware has less shrinkage, stoneware a much greater reduction in size.

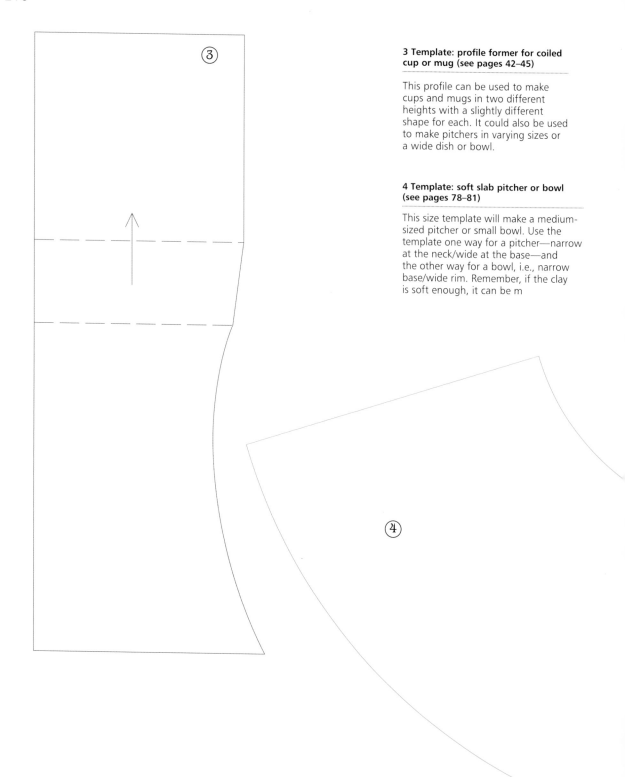

3 Template: profile former for coiled cup or mug (see pages 42–45)

This profile can be used to make cups and mugs in two different heights with a slightly different shape for each. It could also be used to make pitchers in varying sizes or a wide dish or bowl.

4 Template: soft slab pitcher or bowl (see pages 78–81)

This size template will make a medium-sized pitcher or small bowl. Use the template one way for a pitcher—narrow at the neck/wide at the base—and the other way for a bowl, i.e., narrow base/wide rim. Remember, if the clay is soft enough, it can be m

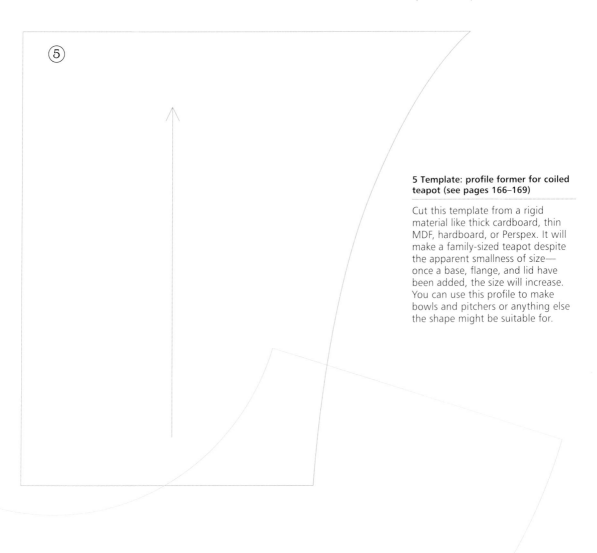

⑤

5 Template: profile former for coiled teapot (see pages 166–169)

Cut this template from a rigid material like thick cardboard, thin MDF, hardboard, or Perspex. It will make a family-sized teapot despite the apparent smallness of size— once a base, flange, and lid have been added, the size will increase. You can use this profile to make bowls and pitchers or anything else the shape might be suitable for.

Glossary

ASH Useful ingredient as the fluxing agent for a glaze. Wood ash is usual, but coal ash, and any plant ash, is also usable. Ash may also have a high silica content and combined with clay it will form a simple stoneware glaze.

BALL CLAY Clay of high plasticity, high firing, and pale in color. An ingredient of throwing clay and other bodies, as well as glazes.

BODY/CLAY BODY Term potters use for clay, especially when it is a prepared mixture and may contain other non-plastic materials such as grog and sand.

BENTONITE A plastic volcanic clay used for suspending glazes or increasing the plasticity of a clay body.

BISQUE (BISCUIT) First, low-temperature firing to which a pot is subjected. Moisture within the clay is driven off slowly in the form of steam, along with other organic compounds—clay becomes converted to "pot," a chemical change that is irreversible. Bisque firing is usually between 1,562°F and 1,832°F (850°C and 1,000°C), but can be higher if less porosity is required. Work is often bisque fired before being decorated in other ways.

CARBORUNDUM STONE A hard, dense stone used for grinding away rough patches on fired ceramic.

CLAY (Al$_2$O$_3$. 2SiO$_2$. 2H$_2$O) Essentially the product of weathered granite and feldspathic rock; a hydrated silicate of aluminum. The purest "primary" clay, china clay (kaolin), is found where it was formed. Transported "secondary" clays become contaminated, are colored, and due to the variable presence of fluxes, have a range of lower firing temperatures.

COBALT OXIDE/CARBONATE (CoO and CoCO$_3$) Powerful blue colorants. Used widely in ancient China, cobalt is said to have been first found in Persia. Blue and white decoration is one of the strongest traditions in ceramics.

CONES/PYROMETRIC CONES Compressed glaze material formulated to bend at designated temperatures. The structures are placed in the kiln where they can be seen through the spy hole. They provide an accurate indicator of the "heat-work" of the firing, i.e., the real effectiveness of temperature and time on the clay and glazes.

COPPER OXIDE/CARBONATE (CuCO$_3$) Strong colorant in ceramics giving green to black and brown. Under certain reduction conditions, it can give a blood-red color.

DEFLOCCULANT An alkaline substance, commonly sodium silicate or soda ash, which when added to a slip makes the mixture more fluid without the addition of water. The clay particles remain dispersed and in suspension, an essential quality required for casting. Also see Flocculant.

DELFTWARE Also known as Majolica and Faience, this tin-glazed ceramic ware was named after the town of Delft in Holland.

EARTHENWARE Low temperature ceramics, generally fired between 1,832°F and 2,156°F (1,000°C and 1,180°C). Earthenware pottery is fused but not vitrified and remains porous unless covered with a glaze. Naturally occurring red terracotta clays have a relatively high iron oxide content that acts as a flux and therefore will not withstand high temperatures. White earthenware is a manufactured clay body used widely for industrial production.

ENGOBE Prepared slip that contains some fluxing ingredient. It lies halfway between a clay slip and a glaze.

FETTLING Term used when cast ware is trimmed and sponged to remove excess clay and seams. Fettling is done at the leather-hard or dry stage.

FIRING Process that changes clay to ceramic (see Bisque). The usual firing ranges referred to are raku, the lowest

at around 1,472°F (800°C), followed by earthenware, then stoneware, and finally porcelain, which can be fired up to a maximum of 2,552°F (1,400°C).

FLOCCULANT An acid or salt that when added to slip has a thickening effect and aids suspension, delaying settlement. Calcium chloride and vinegar are commonly used flocculants.

FLUX An essential glaze ingredient that lowers the melting point of silica, the glass-making ingredient. A number of oxides serve as fluxes, each having its own characteristics.

FRIT Material used in low temperature glazes. Frits are made by heating and fusing certain materials together, after which they are finely ground to a powder. In this way soluble or toxic substances can be stabilized and made safe to use.

FUSED Melted together, but not necessarily vitrified.

GLAZE Super-cooled liquid of glass-like nature that is fused to the surface of a pot. The chemistry of glaze is complex but fascinating.

IRON OXIDE The most common and very versatile coloring oxide, used in many slips and glazes, and often present in clays, too. Red iron oxide (rust) is the most usual form but there are others (black iron, purple iron, yellow ocher).

KAOLIN (Al$_2$O$_3$. 2SiO$_2$. 2H$_2$O) China clay. Primary clay in its purest form.

LEATHER-HARD Stage during the drying process at which the clay becomes stiff and no longer pliable, but is still damp. In this state it can be easily handled while retaining its shape.

ONCE FIRING Firing ceramics without a bisque firing, usually with a raw glaze or pigment applied at the leather-hard or dry stage.

OPACIFIER Material used to make a glaze more opaque, often tin oxide, titanium oxide, or zirconium silicate.

PLASTER OF PARIS / PLASTER (2CaSO$_4$. H$_2$O) A semi-hydrated calcium sulphate, derived from gypsum by driving off part of the water content. Used in mold making.

PORCELAIN Highly vitrified white clay body with a high kaolin content. Developed and widely used in ancient China, its low plasticity makes it a difficult clay to work with. It can be fired as high as 2,552°F (1,400°C) and when thinly formed, the fired body is translucent.

PYROMETER Temperature indicator linked to a kiln via a thermocouple. Pyrometers can be analog or digital, the latter being preferred by many potters these days.

REFRACTORY Resistant to heat, and in terms of clay, one that can be fired to high temperatures without melting. Kiln bricks and shelves are made from refractory materials.

SAGGAR Vessel made of refractory clay used to contain pots during firing. In the ceramics industry, a "saggar maker's bottom knocker" would beat out the clay for the bases of saggars with a kind of flattened wooden mallet.

SOAK Time during the firing cycle when a steady temperature (often the peak) is maintained in the kiln to allow glazes to flow and mature.

SAWDUST FIRING Sawdust is the fuel most often used for smoking or reducing ceramics at low temperatures.

SILICA Silicon dioxide (SiO$_2$) Primary glass-forming ingredient used in glazes and also present in clay. Silica does not melt until approximately 3,272°F (1,800°C) and must always be used in conjunction with a flux to reduce its melting point to a workable temperature range.

SLIP CASTING Casting slip is made from clay and water, but also contains a deflocculant, allowing a reduced water content. Poured into a plaster mold, casting slip is then left to build up a shell on the inside of the mold before pouring out the excess. Remaining moisture is absorbed by the plaster.

STONEWARE Vitrified ceramics fired above 2,192°F (1,200°C). Stoneware is hard, dense, and waterproof (it has an absorption rate of less than 1%).

THROWING Clay is placed on a rotating potter's wheel and formed by hand in conjunction with centrifugal force. Wheel designs vary from momentum "man-powered" wheels, through pedal type "kick wheels" and belt-driven, handturned arrangements, to the modern highly powered electric version. Throwing is said to have been developed first in Egypt c. 3,000 B.C.

TURNING/TRIMMING After throwing, pots are often inverted, and put back on the wheel at the leather-hard stage. A metal cutting tool is used to pare off excess, cut details such as foot rings, and generally refine the form.

VITRIFICATION Process by which clay materials bond to become dense, impervious, and glassified during the latter part of a firing. The resulting pots are hard and durable. The vitrification point is the temperature to which a clay can be fired without deformation. *See* Stoneware.

WATER-BASED MEDIUM Carrier that allows a pigment to be applied in the desired way. Increasingly, water-based or "water-friendly" mixtures are being used in ceramics, for reasons of convenience and health and safety, and in preference to traditional oil-based materials, which are often rather pungent and also flammable. Various mixtures are available, often based on glycerine, and your supplier will advise on their application.

WEDGING/KNEADING Methods of preparing clay by hand to form a homogenous mix. It mixes clay of uneven texture and removes air pockets. Spiral kneading arranges the platelets in an advantageous way for throwing.

Index

Credits

Quarto would like to thank the following artists and agencies for supplying images for inclusion in this book:

Barnes, Christopher, www.morvernpottery.co.uk, p.155cr
Bloomfield, Linda (Photo by Bloomfield, Henry), www.lindabloomfield.co.uk, p.33cl
Bond, Sally-Jo, www.sjbceramics.com, p.125cr
Borrett, Cressida, www.cressidaborrett.co.uk, p.98
Campana, Jeff, www.jeffcampana.com, p.59
Cooper, Ann-Marie, www.kulshanclayworks.com, pp.42, 136
Daniels, Michelle, www.obypottery.co.uk, p.158
Dishaw, Dawn, www.dawndishaw.com, p.32
Dorf, Macy, www.macydorfstoneware.com, p.92
Greenwood, Annie, www.anniegreenwoodceramics.co.uk, p.123
Grigone, Laima, www.laimagrigone.com, p.66
Gulden, Tyler, www.tylergulden.com, p.153
Hageman, Vicky, www.vickyhageman.co.uk, p.33cr
Hayes, Todd, www.toddhayesceramics.com, p.61cl
Jarman, Paige, www.paigejarman.com, p.131
Lambert, Nigel, www.nigellambertpotter.co.uk, p.93cl
Lohrbach, Marina/Shutterstock.com, p.24tcr
Morales, Ray, www.rmpottery.com, p.36
Mulholland, Matthew, www.manifestmeditations.com, p.172
Neiditz, Marcy, www.marcyneiditz.com, p.93cr
Simonini, Susan, www.susansimonini.com.au, p.142
Svetislav1944/Shutterstock.com, p.24cr
Tajima-Simpson, Yasuharu, www.tajaporcelain.co.uk, p.31
Tian, Elaine, Studio Joo, www.studiojoo.com, p.124
Van Wyk, Crystal, www.vitreouswares.com, p.110
Vdimage/Shutterstock.com, p.24br
Von Krogh, Tone, www.tonevonkroghceramics.co.uk, p.61cr
Wightman, Gemma, www.gemmawightmanceramics.com p.102
Yamashita, Mayumi, www.mayumi-yamashita.com, pp.91, 155c

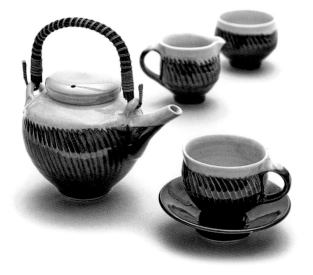

Wheel thrown in porcelain, this lovely tea set by Margaret Frith has perfect proportion and balance to function well. The fluted surface beautifully accentuates the qualities of the tenmoku glaze on the outer surface, while the celadon glazed interior allows the delicate quality of the tea to be seen readily. Fired to stoneware temperature in reduction.